MW01055694

GREENVILLE COUNTY

SOUTH CAROLINA

GREENVILLE COUNTY
SOUTH CAROLINA

FROM COTTON FIELDS TO
TEXTILE CENTER OF THE WORLD

RAY BELCHER

THE
History
PRESS

Published by The History Press
Charleston, SC 29403
www.historypress.net

Copyright © 2006 by Ray Belcher
All rights reserved

Cover image: The Camperdown Mills Company, both the old mill and the new.

All images courtesy of the author unless otherwise noted.

First published 2006

Manufactured in the United States

ISBN-10 1.59629.154.0
ISBN-13 978.1.59629.154.6

Library of Congress Cataloging-in-Publication Data

Belcher, Ray.
Greenville county, 1817-1970 : from cotton fields to textile center of the
world / Ray Belcher.
p. cm.
Includes bibliographical references and index.
ISBN-13: 978-1-54020-421-9

1. Textile industry--South Carolina--Greenville County--History. 2.
Greenville County (S.C.)--Social conditions--History. 3. Greenville County
(S.C.)--Economic conditions--History. I. Title.

HD9857.S6B45 2006
338.4'767700975727--dc22
2006025845

Notice: The information in this book is true and complete to the best of our knowledge. It
is offered without guarantee on the part of the author or The History Press. The author
and The History Press disclaim all liability in connection with the use of this book.

All rights reserved. No part of this book may be reproduced or transmitted in any form
whatsoever without prior written permission from the publisher except in the case of
brief quotations embodied in critical articles and reviews.

For my girls, Delaine, Carra, Abbi and Gracie, for Pete and in memory of my parents who, together, gave ninety years of service to the cotton textile industry.

CONTENTS

INTRODUCTION

The local cotton textile industry was a function of the "New South" mentality, the widely held faith that the South could make a comeback through homegrown industry. There were antebellum precedents for cotton manufacturing in the state, but these enterprises, with the exception of Graniteville, were small, isolated and founded by outsiders.

These first entrepreneurs experienced rough going with neither an established market for manufactured cotton goods nor a good way to get to one. Furthermore, an agricultural mindset prevailed among state leaders, which precluded much legislation favorable to industrial development. Until after 1865, the cotton textile industry struggled merely to exist. Lack of capital and long-term credit drove out some of the early industrialists, but a few of the tiny factories took root and persisted. Those that remained did not change much in terms of operations nor output for the next fifty years. The infant industry was, however, the vanguard of an industrialization that ushered out farming and concentrated the growing population of the state in the counties favored by waterpower and, later, rail lines. Greenville County had both, plus a handful of rare individuals who possessed a vision for the industry that stretched far beyond the local market.

The new mills post-1865 were constructed on a large scale, unlike their predecessors: two or three hundred or more operatives instead of twenty; a village of two hundred cottages rather than ten. Mills built after 1880 mimicked Northern patterns, a complete package of factory, operative housing, store, church and school. An international market for local products was identified in the 1880s and developed to link South Carolina's upstate to the rest of the world. Greenville's textile experience, acclaimed early within the industrial community, gained national prominence when the city sponsored the first Southern Textile Exposition on the eve of the First World War.

Social consequences of the cotton textile industry derived from an uneven prosperity that divided society along the lines of town and county, black and white.

Industrial progress also hastened the departure of traditional farming as hundreds of marginal farmers and their families, financial victims of cash crop farming, flocked to the mills in hopes of earning a living wage.

By the early twentieth century, cotton mill companies found themselves facing social critics and financial crises at the same time. Mill companies, in adapting methods of the Northern industry, were criticized for child labor and other paternalistic practices. Meanwhile, the influx of new money into new mill enterprises encouraged further growth and led to production beyond the needs of the markets. Even as the operative class experienced social upheaval and curtailment, the vast majority of mill hands swore by the system, proclaiming it provided them with a better life than they had ever known.

With time, the Greenville textile industry became more diverse. Mills had begun to diversify their product lines to include finer yarns and cloth; silk and rayon products were a part of the mix by the 1920s. Smaller companies—niche industries—manufactured a variety of industrial textile products including mops, carpet pile, tapestry, belting and batting. A mill dedicated to the manufacture of woolen products was built. Meanwhile, competitive pressures from within and outside the country, and the imperative of high efficiency, took a toll on the industry. The Second World War brought increased prosperity, but the days beyond were characterized by the dismantling of the old familiar ways of life with which the mill villages were most closely identified.

Just as the earliest antebellum factories had found themselves behind the times and their machinery obsolescent, mills in postwar Greenville had to come to terms with modernization required to stay in business. The industry as a whole was suffering by the 1970s. Plagued by an unending influx of foreign imports, new federal safety regulations, market whims and unions, companies faltered. What could not be solved through sale or merger was handled by closing the doors.

The evolution of another age of textile manufacturing saw, from the 1970s to the end of the century, in Greenville as well as the upstate, the abandonment of older mill buildings, mergers and buyouts, increased diversification of manufacture, automation with its consequential reduction of the workforce and in some cases, shutting down of operations. By the end of the twentieth century, a full generation of locals had reached maturity without knowing dependence upon or understanding the significance of the textile industry in the county's history.

This brief account is intended to serve as a primer of Greenville County's textile past. For the sake of consistency, mills are categorized within chapters as antebellum factories, New South mills and twentieth-century mills, those organized after 1910. Greenville's textile history is rich and little probed; it abounds with human interest and it is instructive in terms of business practice and inter-regional commerce. Although efforts have been made to account for a majority of important developments in Greenville's textile history, doubtless, omissions have occurred and for these and any other errors the writer assumes full responsibility.

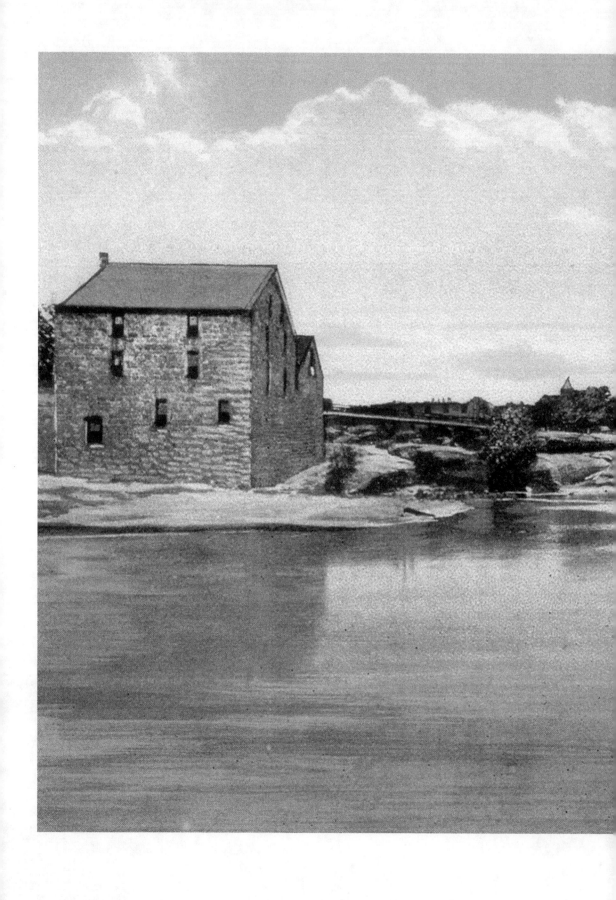

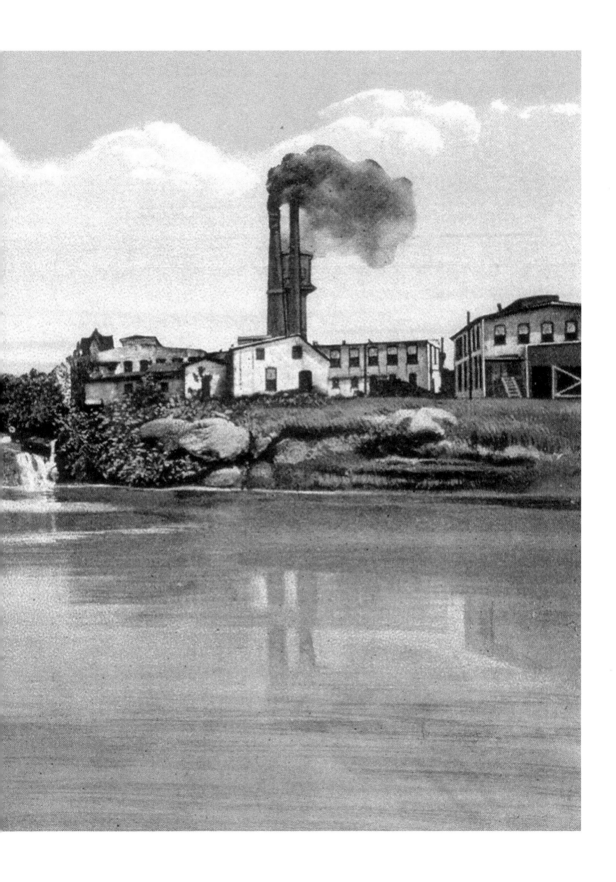

Chapter One

THE COTTON MILLS OF GREENVILLE—ORIGINS

The earliest cotton manufactories in Greenville County were located near the Spartanburg County line on neighboring streams. These belonged to Thomas Hutchings and William Bates, emigrants from New England. Hutchings built the first of these mills about 1820 on the Enoree River near the present-day community of Pelham.

Hutchings arrived in South Carolina after the War of 1812, migrating south with a group of skilled and experienced mill men who found themselves lacking work in the postwar New England economy. The United States had managed to win the war, in a manner of speaking, but had lost the business of its best customer—England. To escape ruin or find new opportunities, this handful of migrants made their way to South Carolina, carting basic machinery in search of a suitable site on which to set up one or more small cotton factories. The ideal spot would be a cheap parcel of land with rock shoals on swift water. Hutchings and Bates, Phillip, John, Wilbur and Lindsey Weaver, Thomas Slack and possibly others found such locations and initially set up small mills in Spartanburg District. By 1819, the group began to disintegrate, partly because of credit problems. Thomas Hutchings moved to Greenville District to start anew.[1]

THE HUTCHINGS FACTORY

Hutchings bought three hundred acres from Charles Dean on an installment plan in 1819. Acquiring the title in February 1820, he had agreed to payments spread from 1819 to 1822, payable each year on Christmas Day. He financed his machinery with money borrowed from George T. Sloan, giving him notes in March 1820. The description of the machines indicates this first factory was a yarn mill.[2]

By May 1821, Hutchings had taken a partner, John Courcier, and had expanded his enterprise with a second mill. By this time he already owed $16,000 to William Mayrant Sr. of Sumter who, himself, had probably been involved in an early textile operation.

Hutchings and Courcier mortgaged both factories, a sawmill and a gristmill for an additional $2,000. The first factory had the equipment necessary for manufacturing warp yarn; the second mill may have been planned as a cloth mill, although in 1821 the machinery did not include looms. The second mill was, however, set up to produce both warp and weft yarn with its six 60-spindle throstles and two mule frames of 180 spindles each.[3]

Hutchings paid part of his debt after completing the second mill, but remained on tenuous financial footing. One of the mills burned about 1825 and Hutchings rebuilt on the same site. Hopelessly overextended, he was unable to pay for the new building and lost a lawsuit brought by Andrew Johnson on April 27, 1827. Although the amount of the judgment was small, Hutchings lost his land and his mills when they were sold at public auction. Phillip Lester, a young farmer and likely one of Hutchings's creditors, was the high bidder at $500. He took possession December 1, 1828.[4]

Hutchings continued to be involved in the cotton textile industry for at least another decade. He became part owner of South Tyger River Manufactory, which was occasionally called "Hutchin's Factory." When that mill became unprofitable, he sold his interest and fell back upon another profession. Hutchings was an ordained Methodist minister. Founder of Ebeneezer United Methodist Church near his factory site, he departed the textile industry and preached in South Carolina and Georgia. Pastor Hutchings died in 1869 in Savannah, Georgia.[5]

Phillip Crymes Lester, new owner of Hutchings's mills, was a prosperous farmer and tavern keeper. Born in Lunenburg, Virginia, in 1794, he migrated to Greenville District with his parents and several other families shortly after 1800, where he married, bought land and became a leading citizen and first postmaster of Pleasant Grove, a community that had developed around the Lester property.[6]

Lester operated the factory with Josiah Kilgore, a Hutchings creditor and man of means who had financial stakes in several small industries across the upstate. (Apparently, Hutchings's two mills were either consolidated or one was lost or abandoned, because contemporary references to the Lester-Kilgore operation imply a unitary factory.) Kilgore's other interests likely kept him away from the factory. Day-to-day management fell to Lester, who moved his household to the Enoree River in 1833. Lester probably hired a knowledgeable superintendent to see to the mechanical operations while he himself kept the books and made the business decisions. By 1850, Lester & Kilgore's factory represented an investment of $20,000. It employed five men and twenty women, who were paid less than a third the rate of the men. Lester & Kilgore evidently produced a somewhat finer product than did William Bates, who by then had been operating a small factory less than a half-mile south of Lester's on Rocky Creek for over ten years. Spun cotton yarn was valued in 1850 at fifty cents per pound for Bates's product and sixty-seven cents for Lester & Kilgore's.[7]

The Lester & Kilgore partnership ended after the factory burned in 1853. Kilgore sold his interest to Lester, retaining a portion of the accounts payable from factory

transactions. Lester rebuilt the factory and, in December 1856, formed a new partnership with his sons William Francis, Archibald H. and George Washington Lester. He retained one-third interest in the business. Lester valued his factory at $6,000 at the time the articles of partnership were drawn up. The business name was changed to Lester & Sons and the partnership was valid until October 1, 1861. After Lester died in May 1862, his sons continued the business as Lester Brothers. George Lester was elected by his brothers to head the company after the first of the year, 1863, which then operated as Lester & Brothers.[8]

WEAVER'S FACTORY

John Weaver established Greenville County's second cotton manufactory about five miles north of present-day Greer. Weaver, born in Coventry County, Rhode Island, on February 11, 1797, was among the group that migrated from New England. The Weavers, Thomas Hutchings, William Bates and others built the South Carolina Cotton Manufactory in late 1816 at a site about six miles north of Cross Keys. That business changed hands several times by 1820, when Thomas Slack bought it and then sold it to Phillip and John Weaver.[9]

By this time, Hutchings had already left for Greenville District; William Bates followed him in departure a short time afterward. Then, John Weaver left in early 1820, moving to McCool's Shoals, where he set up a new cotton factory with Thomas Slack, supplying machinery from the South Carolina Cotton Manufactory when that enterprise collapsed in the latter part of 1819. The last owners of the Spartanburg factory, Phillip and John Weaver, were left holding the proverbial bag, heavily indebted. A suit was brought against the Weavers seeking $12,000. It was then that Phillip and Lindsay Weaver left the state to avoid responsibility for the debt they could not meet. John, already established at McCool's Shoals, remained and was held liable for the debt.[10]

Weaver and Slack had set up a small yarn factory at McCool's Shoals on Thompson's Beaverdam Creek. Also known as McCool's Shoals Factory, the mill, operating as Weaver & Slack's Factory, was powered by a water wheel that turned at eight revolutions per minute by an eighteen-foot fall, producing fourteen horsepower, sufficient for several applications from a single shaft. Weaver apparently borrowed more money during the late 1820s from Josiah Kilgore to buy out Slack's interest, putting the factory up as collateral. Unable to meet his combined liabilities, Weaver was foreclosed on by his creditor in early 1830, forcing the sale of Weaver's factory.[11]

When the property was auctioned in 1830, William Bates bought Weaver's mill for $1,235 and deeded back to Francis Weaver, John's son, a minor child, half interest in the land and machinery because he believed the Weavers should get something out of what their "industry and enterprise" had wrought. It was also an inducement to get John Weaver to remain and assist in the mill operations.[12]

Batesville receipt, 1864.

Two years later, Bates sold Francis Weaver his remaining interest in the land and mill for $1,000, retaining half interest in the machinery, which he reserved the right to move out whenever he chose to do so. The machinery was part of the same that had been brought down from the North years earlier. Francis Weaver sold the property back to his father in 1840. Once redeemed, John Weaver remained on the site and operated the factory until his death on November 24, 1862.[13]

Francis Weaver followed his father in the cotton manufacturing business, but independently. By 1862 he had become a partner in Cedar Hill Factory in Spartanburg District. Cedar Hill was originally known as South Tyger River Manufactory. When that partnership dissolved, Francis moved to Polk County, North Carolina, to another cotton mill venture. Not long before his death, John Weaver deeded back to Francis the property at McCool's Shoals, plus additional lands that he had obtained during the three decades of his mill's operations.[14]

John Weaver finally achieved a measure of financial stability by mid-century. He operated a gristmill and sawmill in addition to the cotton factory. In 1850, his capital investment stood at $3,000; three men and ten women were employed at his factory, which produced five thousand bunches of spun yarn a year valued at $4,500. Ten years later, his investment had more than doubled to $6,150 and his annual output was valued at $5,720. For reasons unknown, his investment did not return a proportionate increase in the factory's output. He still had significant debts. Perhaps to compensate for declining profits, he went still further into debt to obtain larger machinery. Weaver changed the wage distribution to his employees by 1860, suggesting the installation of mule frames. In 1850, both men and women were paid at the rate of $7 a month. In 1860, three men received $10 each per month while ten women received $5 each per month, a net reduction in labor cost of $11 per month.

Although Weaver owned seven slaves at the time of his death, he employed only paid help in his factory.[15]

Weaver was involved in his community, serving as a magistrate, school trustee and postmaster in the O'Neal community. He was an organizer of Milford Academy in 1844, a one-room school taught by Professor James K. Dickson. Weaver served as postmaster of the Caldwell post office and later, in 1851, Millburg, a post office established on Weaver's property. Weaver wrote his last will and testament on November 23, 1862, and died the next day, the will being filed December 3 of the same year. He was survived by his third wife, Martha, to whom he left the cotton factory and most of his estate.[16]

Martha Weaver operated the factory for a few years after her husband's death. She remarried in 1864 to the Reverend Richard Furman Whilden. The mill continued to operate for a time as Whilden's Factory. Weaver left behind a significant inventory of cotton and yarn. Upon his death he had cotton and yarn valued at $7,200 stored at the factory and at the Greenville and Columbia railway depot. Cotton was scarce and becoming scarcer, being hoarded and hidden as the course of the war spelled out the South's fate. Yarn for domestic consumption was in short supply as early as June 1862 and it also remained hard to obtain, as most of the mills' output went to furnish the Confederate government. Pertina Cannon said that about the time of Lee's surrender she had gone to Weaver's factory "and could not get a bunch of yarn for $100.00 [Confederate currency], they would not take it for yarn."[17]

SHUBAL ARNOLD-HUDSON BERRY COTTON FACTORY

Greenville County's third cotton mill was begun several miles south of the village of Greenville. Shubal Arnold borrowed less than $300 around June 1820 to set up a small cotton factory on the Reedy at present-day Fork Shoals. Four months later, he gave a mortgage to Hudson Berry on his machinery, including a throstle frame with seventy-two spindles, two cards, a drawing frame, a roaping frame and a finisher. Also included were a water wheel, cog wheel and window sash and "all the apparatus belonging to the whole machinery."[18]

When Arnold did not redeem the mortgage, Berry and his sons took over the factory. By 1850, it was consuming some three hundred bales of cotton per year, employed three males at seven dollars per month and five females who received six dollars per month. The factory reported a gross profit of 77 percent in 1850. Berry and his sons held it until 1852. The machinery was possibly conveyed to James Sullivan when the Berry enterprise ended.[19]

WILLIAM BATES AND COMPANY

William Bates of Pawtucket, Rhode Island, came south with fellow textile workers and worked at John and Phillip Weaver's factory on the Tyger River in Spartanburg

County from 1819 to 1821. He then moved to Hill & Clark's factory as manager for $1.50 a day and worked there until 1824, when he took partners Hugh Wilson and William F. Downs. He set up a small cotton mill on Rabun's Creek in Laurens County. (That enterprise fell through by 1827 and he returned to Hill & Clark's as an overseer for three more years to replenish his investment capital.) In 1830, he joined Francis and John Weaver for about two years before selling out to them. In 1833, he was employed at Lester's factory on the Enoree and owned an interest in the company. He bought land on neighboring Rocky Creek from partner Josiah Kilgore for $810 and built a small factory on the site, furnishing it with machinery he hauled the ten miles from Weaver's.[20]

Bates, a skilled mechanic, enjoyed considerable success in his operation. By 1840, the county's annual cotton goods product was valued at $72,000, of which most came from Bates's factory. He took on partners Thomas Cox in 1847 and son-in-law Henry Pinckney Hammett in 1849 and operated as William Bates and Company. Hammett had been a local schoolteacher before accepting the job of business manager at Batesville.[21]

By 1850, Bates had ten male and ten female employees; men on the average were paid at twice the rate of women. The factory prospered, increasing its capitalization 250 percent, to $50,000, between 1850 and 1860. This phenomenal growth superseded that of any other cotton mill in the state. William Bates apparently enjoyed the mechanical elements of the textile trade; he probably trained many of his operatives and mechanics. By so doing, he avoided having to bring in experienced employees from outside the region. On his workforce in 1860 he had only two out of fifty-five workers who were from out of the area.[22]

William Bates and Company in 1860 produced the largest portion of local cotton goods, with its twelve hundred spindles and thirty-six looms amounting to $108,070. During the War Between the States, the mill operated six days a week, producing shirting for the Confederacy five days a week and commercial cloth on one day. According to a local tradition, Batesville yarn was peddled from the back of a wagon during the Civil War era. William Thackston hauled yarn into the North Carolina mountains and traded it for produce and other goods, which were distributed to employees.[23]

Confederate demand required expansion; by 1862, Batesville was running three thousand spindles. On April 20, 1863, William Bates and Company sold the factory and 240 acres for $300,000 to a partnership composed of James Montgomery, James H. Taylor, E. Beach, Thomas G. Budd, R.W. Gale, Edward Sebring, John G. Milnor and John Frasier. After the sale of the factory, Bates lived his final decade in retirement, Cox left the textile business and Hammett, who had already acquired some property near Garrison Shoals, continued to work toward what would be Greenville County's most important cotton factory.[24]

McBee's Mill

Vardry McBee of Lincolnton, North Carolina, purchased a vast tract of land in South Carolina in 1815. He moved to Greenville District and set up a number of small industries on the Reedy River, including a sawmill, ironworks and a flourmill. In 1829, he had a stone mill constructed on the Reedy River in Greenville. He had an additional flourmill built some seven miles from the site of the first and constructed a paper mill, which supplied many small presses in Georgia and the Carolinas. At the paper mill, he enlarged the structure to operate a small cotton and woolen factory.

McBee ordered his machinery from the New Jersey firm of Rogers, Ketchem and Grosvernor. *DeBow's Review* reported that, despite his geographic isolation and the relative inexperience in the South with manufactured textiles, McBee's goods were well received in Northern markets and very profitable. Known variously as McBee's Factory and Reedy River Factory, it employed more than sixty operatives and supplied them with cottages in which to live. McBee operated a general merchandise store near the factory as well as one in Greenville, both of which served as company stores where his employees could make purchases on credit.[25]

In early 1838, McBee's Factory operated around the clock with shift changes at midnight and noon. McBee employed the firm of Greenway, Henry, Smith, Garret and Derrickson, a New York factory house, for the purchase of additional textile machinery in 1847. On a business trip to the North he visited Abbott Lawrence, a partner in Lowell Cotton Mills, and toured what was then considered the largest cotton mill in the world.[26]

Back in South Carolina, McBee became a promoter of the Greenville-Columbia Railroad Company. By 1850, his mill used 90,000 pounds of cotton, or about 180 bales per season, and employed nine men and twenty women in the production of 75,000 pounds of cotton yarn valued at $16,000. McBee's energetic pursuit of industry and transportation suggested a vision for the state far beyond the agricultural way of life that was, by the 1850s, becoming stale.[27]

McBee also invested in the Bivingsville Cotton Manufacturing Company of Spartanburg County, which, in 1856, at age eighty-one, he bought into with Simpson Bobo, Dexter Converse, John Zimmerman and Samuel Evins. McBee's Factory began carding wool during the 1850s although it was a minor project compared with his other interests. By 1860, his wool processing consisted of two laborers earning an unheard of dollar a day while earning McBee a hefty return of 33 percent.[28]

McBee sold the Reedy River Factory, a paper mill and 321 acres to the company of Grady, Hawthorne and Perry in early 1862 for $21,000. It was placed, like other mills, at the disposal of the Confederacy and was soon operating at full capacity to meet requirements of the Confederate Quartermaster Department. McBee died two years later at the age of eighty-nine.[29]

Chapter Two

Cotton Mills in
New South Greenville

Conditions after the War

In 1865 the South, having acknowledged the settlement of the constitutional issue of union, settled its focus upon rebuilding the economy. With cotton values at an all-time high, cotton farming, in place of the old plantation system, seemed to offer the best chance for a resurrection of the economy. Cotton could grow almost anywhere and, with a modest outlay or a small line of credit, a farmer could produce a crop that could be sold for cash.

Unfortunately, cotton prices spiraled downward as increasing numbers of farmers adopted the cash crop system. Even under optimum conditions, cotton farming could not have remedied the degree of devastation war had brought about; optimum conditions were rarities for farmers. There were a handful of promoters, the heirs to antebellum cotton manufacture or visionaries like William Gregg of Granitesville, South Carolina, who foresaw industry as the only real avenue to economic salvation. While the decline of cotton meant ruin for farmers, cheap cotton also aroused the interest of entrepreneurs who organized cotton mill companies and built factories larger than any ever envisioned by the antebellum mill builders.

The first mills of the postwar South tended to follow the patterns of antebellum cotton manufacture: small, simple production of coarse goods aimed at competing with Northern mills making similar products. By 1880, a larger vision of cotton manufacturing had taken hold. Greenville County's cotton textile industry evolved within this new perspective, which called for a "New South" based on industry. What eventually remade Greenville as a textile center of the New South was the exceptional leadership and foresight of a few entrepreneurs.

Greenville became, in less than thirty years, the site of seven large new mills, a shipping point for three others and one of the principal mill points in the South for

selling cotton to the industry. By 1904, Greenville ranked fourth in the South and second (behind Columbia) in the state in numbers of bales of cotton sold to the mill buyers. And, despite the volume of cotton, relatively little of it was shipped outside the region because of huge demand locally. Of 33,538 bales sold in Greenville in 1904, only 3 percent was shipped away.[30]

At war's end, Greenville County mills, which had experienced at least full-scale operation if not a degree of prosperity during the wartime economy, suffered an immediate setback with the collapse of the Confederate economy. Investment capital was scarce, although not entirely absent. Investors waxed conservative while the future of the state and the South remained uncertain.

THE ANTEBELLUM MILLS

McBee's Mill

McBee's Reedy River Factory continued to operate after the War Between the States. However, William Perry, concerned about debts accrued by the company during the hostilities, sold his interest to his partners in 1866 for $5 and their assumption of his share of any indebtedness. Some time prior to 1870, J.H. Ashmore, nearby landowner, became a partner and the factory operated for a time as Grady, Ashmore and Company. By 1870, the operation had $40,000 invested and employed eight males, twenty-four females and eleven children, processing 120,000 pounds of cotton to make 108,000 pounds of yarn in addition to shirting and carded wool. It was sold to J.D. Charles, J.A. David and other principals, who expanded operations further. By 1880, the mill employed sixty-five hands. It manufactured coarse yarn and sheeting at a cost of four cents a pound and paid its employees an average of fifty cents per day. It had new Lowell machinery and was capitalized at $47,500. Although small and with production limited to coarser goods, the mill still returned 23 percent annually to its stockholders. Two years later, ten more operatives had been added. The value of a share of stock in Reedy River Manufacturing was worth $125. The most recent dividend paid was $12. Joel D. Charles succeeded J.A. David as president. Reedy River Factory was reorganized in 1898 with authorized capitalization of $250,000; principals included William Edgeworth Beattie, Ellison A. Smythe and J.A. Finley. Beattie was elected president and treasurer.[31]

Weaver's Factory

Martha Weaver and Richard Whilden signed a prenuptial agreement on August 24, 1864, creating a trust for her benefit, which included lands, the cotton factory, three slaves (Elsey, Toney and Alfred) and $5,000 in Confederate currency. Business deteriorated rapidly after the end of the war. Whilden's Factory had ceased operation by 1867. A raid on the factory near the end of the war by a band of "bushwhackers," possibly outriders

of Stoneman's troops, may have resulted in damage, destruction or theft leading to a shutdown of operations. Equally likely, the factory closed because of general business conditions in the wake of collapse of the Confederate economy.[32]

Financial obligations remained. Despite hanging on to his factory for over thirty years, Weaver required sources of credit for various contingencies and emergencies. Weaver died as he had lived—deeply indebted, his final principal creditor being L.R. Agnew, who brought suit against Weaver's executors and forced the sale of his property. When the trust had been established for his widow, Weaver's estate had not been settled; she remained liable for her late husband's debts. The land was auctioned in April 1868. Much of the machinery in the factory was old and all of it likely sold for scrap. The trustee acting on behalf of Martha Weaver purchased part of the property with funds from the trust; other monies were supplied by Reverend Whilden.[33]

Part of the proceeds from the auction and sale of personal property was used to pay off notes, including some given to his late brother Lindsay Weaver, obligations dating back thirty years. The rest of it went to pay taxes and costs. The Whildens were again in financial straits in 1876. Unable to pay taxes, the property was again sold on December 8, 1876, consisting of a thousand acres and the closed factory, to W.T. Shumate for $125.79. Shumate, a Greenville investor, sold the land back to Whilden and Gibson, the trustee, in January 1878. The factory remained abandoned, a two-story wood-frame building sitting under the spreading limbs of hardwoods beside the creek until it rotted; its foundation was later used in the construction of a gristmill by a new owner of the land.[34]

Lesters and Pelham

The Lesters had dreams of returning to business as it had been before the war. In 1867 the factory had 840 spindles and 30 looms, and thirty operatives were employed. Plans were made public of the owners' intent to double the capacity of the mill. Financially unable to expand their manufacturing component, the Lesters instead bought two new gins for the 1870 picking season and offered to warehouse farmers' cotton, an almost unheard of service in this time period. The cotton would be protected by a watchman against thieves and a force pump was on hand in case of fire. Farmers had to agree to the conditions and Lester Brothers would dispose of all cotton so handled.[35]

Despite all their efforts to remain solvent, the company, which operated profitably during the war, fell on hard times. A suit brought by Martin L. Marchant, Batesville superintendent, in 1872 resulted in the seizure and sale of Lester & Brothers assets in order to recover damages in the amount of $450. Lands and tenements were sold by the sheriff; the purchaser was Carrie Lester, wife of George W. Lester, who bought the property for $200. She sold on October 7, 1872, half interest in the property to Edwin H. Bobo for $12,000. The following year a nationwide recession put a crimp on mill building and operations, which was felt for years, apparently seriously impairing any options left for Lester & Brothers. The factory was not in operation in 1876–77.[36]

A complaint presented in the Federal District Court about mid-August 1878 against the Lester Brothers, Carrie Lester and Edward (Edwin) H. Bobo was heard late the next year. The complainants, trading partners operating under the name Wyman, Byrd, & Company, forced still another sale of the mill. Short of necessary capital to keep the mill, the Lesters were put out of business. On February 10, 1880, Oliver P. Jackson purchased Lester's Factory for $13,400. It then contained two thousand spindles and forty looms but was not operating. The building was described as dilapidated, the machinery as "old-fashioned."[37]

Jackson and Arthur Barnwell, principals, organized a new company, Pelham Manufacturing Company, which was chartered on May 31, 1880, with a capitalization of $25,000. In 1882, the name was changed to the Pelham Mills and capitalization increased to $75,000. Pelham Mills expanded gradually but considerably under new ownership. A rumor made the rounds in 1889 that the mill would be enlarged to three stories. Instead, it was decided that the main building would be raised one story with several large rooms added adjacent to the ground floor. Jamieson Brothers were contractors for the mill that was expected to take over a million bricks, all to be made on site.[38]

A new and larger dam was built in 1891 to supply for the added machinery. When it was completed, the dam was three hundred feet long, topping off above the level of the first floor of the mill. Houses were added on the eastern side of the village during the 1890s. The company farmland lay west of the mill and was planted in corn and cotton. Corn fed the company mules and horses; cotton was ginned on the premises and went un-baled into the mill. William Barnett of Travelers Rest was the company farm manager.[39]

Pelham was a relatively small country mill; Greenville took little note of its development before 1893, when a dispute over the county line was settled with a new survey that placed Pelham inside Greenville County. The village lay in Spartanburg County, but the machinery, picker room, warehouse, old mill and bridge were over the Enoree in Greenville County.[40]

Batesville

Batesville survived the war. In 1867, it had fifty employees operating 1,260 spindles and 36 looms. James Montgomery, one of the partners, was superintendent. Business during Reconstruction was apparently marginal and the Batesville Manufacturing Company fell on hard times during the early 1870s when the country experienced nationwide economic panic. One source states the property reverted to William Bates and Company while another states that the Batesville factory was bought by the Lesters in 1972. Both Lester's and the Batesville factory came under control of Oliver P. Jackson at about the same time. He was appointed receiver at Batesville, and the mill shortly thereafter was sold at auction. George Putnam of Massachusetts, partner, director and superintendent of Camperdown in Greenville, bought the Batesville mill on November 3, 1879, for $8,000, planning to refurbish it for operation. At the time the mill consisted of the original structure with some additions; it stood two stories and contained ten thousand square

feet. Machinery included 1,152 spindles and 50 looms, all original equipment. There was also a complete machine shop, a blacksmith shop, twenty mill houses for operatives, a supervisor's home, company store and a dwelling house for the owner.[41]

Putnam added machinery; he hired his brother, Henry, who had been his assistant at Camperdown, to superintend operations at Batesville. Operating as Batesville Manufacturing Company, it soon became known as one of two mills in the upstate experimenting with the Clement attachment, a device that permitted the processing of unginned cotton. This short-lived experiment was as close as Batesville ever came to modernizing. The Putnams had the factory up and running by mid-February 1880. Forty operatives spun yarns of sizes seven to twelve; twelve hundred pounds of cotton were used per day to produce a little over a thousand pounds of yarn. Wages averaged eighty-eight cents per day. A year later, George Putnam had added another $12,000 worth of machinery, increasing spindlege to 1,444 regular and 628 twister spindles. Fourteen additional employees were added. He marketed his twisted yarns through a selling agent in Boston, Massachusetts.[42]

The mill caught fire on March 1, 1881. Caroline Fowler, a black woman who lived nearby, discovered it at about 3:30 in the afternoon. She gave the alarm and Henry Putnam and another employee, Elford Henderson, climbed to the roof where a small hole had been opened by flames. Both men fell through the roof that had been burned almost through. Neither man was injured by the fall and they fought the blaze but were unable to stop the fire's progress. Within a half-hour, the mill building had burned completely. The blacksmith shop and carpenter's shop in the rear of the mill were also destroyed; workers' homes were spared because the wind was blowing in a southerly direction away from them. The estimated $25,000 loss was partly covered by insurance and was rebuilt immediately. J.H. Haynes of Greenville was contracted to do the work; rebuilding commenced in late May 1881.[43]

Batesville Manufacturing operated for several years until the spring of 1886, when a storm destroyed a hundred feet of the roof. Sometime during those years, Putnam brought into the business two of his four daughters, Mary and Emma Baker. In October 1886, Mary, the eldest and the young widow of Confederate Lieutenant Isaac Gridley of the Sixteenth South Carolina Regiment, became her father's bookkeeper.[44]

Mary Gridley learned the business well enough that when George Putnam died in 1890, she became Batesville's new president. When her uncle, Superintendent Henry Putnam, resigned for health reasons about May 1897, she was left completely in charge of the mill, becoming one of the first female heads of a cotton mill in the South. Mary's sister, Emma, had married John W. Baker, a Greenville merchant. Baker closed his store in January 1880 and moved to Batesville, where he built a store across the road from the mill. Baker's store functioned as the company store for Batesville Manufacturing. Emma Baker, who clerked in the store, was also an officer of the mill. Batesville remained a family operation for the rest of its existence. It neither expanded operations nor renewed its complement of machinery.[45]

THE ANTEBELLUM MILLS were too flawed to remain viable in the business climate that developed after 1880. Major overhauling of their physical plants as well as adaptation to developing markets, competition and securing a dependable labor force would be required. However, the fact that three out of four Greenville County mills remained intact and attracted new investment not only demonstrates renewed interest in cotton manufacture but also reveals the positive reception the industry was given by the generation of businessmen who came of age after 1865. A succession of willing investors with a progressively broader vision for the industry stood by at each factory, ready to buy into the enterprise when an opportunity arose. Until 1880 or shortly thereafter, the scale and scope of the antebellum mills remained very profitable, or potentially so, despite limited product lines.

GREENVILLE AND THE COTTON MILL CAMPAIGN

Although 1880 is the generally accepted year marking the beginning of the cotton mill campaign, Greenville began to promote industry a decade earlier. When Dr. James Sullivan's factory began operations in 1870, the Greenville *Enterprise* hailed it "as an omen of good and shows there is life, hope and spirit in the land still." A year later, the local paper was still promoting the idea. "Manufactories of many kinds can flourish in Greenville…There aught to be additional cotton and woolen manufactories set going in this and adjoining counties."[46]

By 1880, the cotton mill campaign was underway across the South. Seizing upon the few successes of postwar Southern cotton mills, newspapers encouraged and hailed, provoked and dared investment in the industry. Independent newspaperman Henry W. Grady and others led this fifteen-year promotion. Grady of the *Atlanta Constitution*, Henry Watterson, founder of the *Louisville Courier-Journal*, and Frances W. Dawson, editor of the *Charleston News and Courier*, defined the New South in terms of states' rights, race relations and industry. Writing about the latter focused upon the logical placement of mills in the cotton fields and upon the likelihood of high profits. In 1882, mills reported an average of 22 percent profit. The cotton mill campaign was aimed at solvent investors, North and South, although Grady actively encouraged Northern investment.[47]

GREENVILLE AND THE RAILROAD FACTOR

Ten years before the Civil War, Greenville was a quiet but isolated resort town where Lowcountry residents often sought comfort during the humid and mosquito-ridden days of summer. Until the railroad arrived, there was little potential for Greenville to participate materially in the state's economy. The first railroad, the Greenville and Columbia line, completed in 1853, did not lure the county away from its agricultural economy. John Weaver shipped some of his cotton yarn by rail but was not dependent upon it. Nineteen years later the Richmond and Danville Air Line Railway arrived

in Greenville in a vastly different business environment and helped usher in rapid change. The timing was right for the development of a local cotton market. While the final price of cotton was still dictated by the Northern and international mill markets, merchants' markets developed all along the railway. The same year, 1872, Henry P. Hammett organized Piedmont Manufacturing Company and the next year, Camperdown was organized. By the time Greenville's third railroad, the Greenville and Laurens Railroad, arrived in 1882, Greenville County had its third mill, the Huguenot Manufacturing Company.[48]

The railroad hub at Greenville stimulated cash crop cotton farming; the local cotton market concentrated a substantial amount of wealth in the upstate among general merchants who, in turn, found new ways to profit from their trade. Merchants sold goods, became agents of the guano factories, bought seed cotton, ginned it and resold it down track for a penny or two on the pound, gradually building their fortunes, eventually becoming prosperous enough to invest in the mills that were being organized in every town along a rail line.[49]

NEW SOUTH MILLS OF GREENVILLE COUNTY

Sullivan Mills

The Greenville *Enterprise* announced on June 29, 1870, the start-up of a cotton factory at "beautiful and romantic" Fork Shoals. Dr. James Sullivan of Laurens was president; directors included George Sullivan and William Perry. Although the little factory likely had an antebellum precedent, it was not in continuous operation. Sullivan family tradition credits the origin of cotton manufacturing at Fork Shoals to Hewlett Sullivan, youthful leader of the Sullivan Scouts during the American Revolution. When Dr. Sullivan's factory started, it was the first new start-up mill in Greenville County after 1865.[50]

George Sullivan superintended operations until at least 1877. In 1880, John Matheson of Rhode Island became superintendent. Sullivan Manufacturing Company was capitalized at $25,000. The mill ran two thousand spindles and fifty looms driven by a sixty-horsepower water wheel. Sixty-five operatives earned an average of forty cents a day making coarse yarn and cloth. Three-quarters of a ton of cotton were consumed daily. The factory stood three stories tall, made from red brick, and returned between 15 and 20 percent to investors.[51]

The business was sold in July 1882 to a group consisting of Pascal D. Huff, Charles A. Parkins and John H. and James H. Latimer. By November 1883, the factory had reduced its workforce by more than half and was operating five hundred fewer spindles. That group, in turn, sold the business on July 24, 1883, to another Sullivan. John H. Latimer retained one-fourth undivided interest for the benefit of Dr. Joseph P. Latimer.[52]

Sullivan Manufacturing Company shut down operations and apparently remained closed for several years, possibly during the economic slowdown of the middle 1880s. In 1895, J. Rembert Hill of Greenville leased the mill to operate as a yarn mill

with upwards of fifty operatives. Four years later, John H. Latimer sold the mill, still known as Sullivan Manufacturing Company, in January 1899 to C.D. and W.P. Nesbett for $10,000.

Piedmont Manufacturing Company

The most significant development in the history of Greenville County's cotton textile history is undoubtedly the founding of Piedmont Manufacturing Company by Henry P. Hammett. Scholar Broadus Mitchell noted the degree to which Hammett's undertaking influenced the future of the South: "It is clear that Hammett's Piedmont Factory…was a 'critical experiment'" and that "the success of the mills of the south depended upon Piedmont."[53]

Henry P. Hammett, business manager, apprentice and son-in-law of William Bates, bought 567.5 acres on the Anderson County line at Garrison's Shoals between September 1862 and January 1873. He started organizing a company in early 1873 and hired Amos Lockwood in the same year to design the cotton factory, planning for a mill to be complete by the next year. The Panic of 1873 delayed construction, however. Piedmont Manufacturing Company was chartered in February 1874. In June, Hammett bought a right of way from John D. King to build a dam across the Saluda River. Construction began in late 1874. After some delay, the factory was completed by early 1876. A trial run of the machinery was held on the ides of March. Water powered up the spinning frames. The first bale of cotton, bought from merchant Silas F. Trowbridge at Grove Station, was opened by W.J. McElrath and his son. Finding the cotton up to standard, they then spun it into yarn and wove it into thirty-six-inch sheeting. Trowbridge bought the first bolt cloth to sell at his store.[54]

The mill had five thousand spindles and 112 looms starting up, which was more than doubled in 1877. Before the stock subscription was completed, Hammett obtained machinery from John C. Whiten's Machinery Company of Massachusetts. Between 1875 and 1877, Whiten provided over $80,000 worth of machinery, granting Hammett two years to pay off his note and accepting stock in the company as partial payment, likely the first time in Southern textile history this type of transaction was done. This pattern of business established a precedent and encouraged Northern investment in the Southern cotton textile industry.[55]

Piedmont was a success from its beginning, an example spurring investors across the South to establish similar factories. In August 1881, Hammett addressed the State Agricultural and Mechanical Society at the state Grange meeting in Columbia. Speaking of mill building, he noted investors could expect 15 to 20 percent net profit. Piedmont had paid a 50 percent stock dividend in January 1881. News of this astounding return on cotton mill investments attracted Southern capitalists to the cotton textile business, most without any knowledge or experience in factory management or operations. Two years later, Hammett less enthusiastically reported that already, too many yarn mills had been set up, overstocking the market with

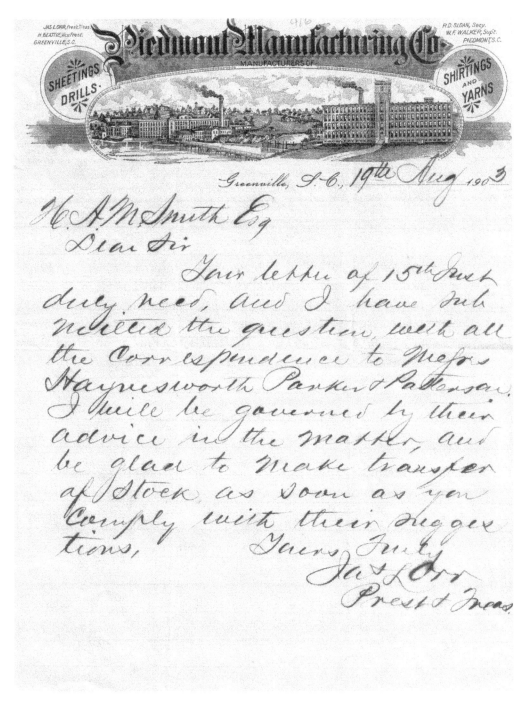

Letter from Piedmont President James L. Orr.

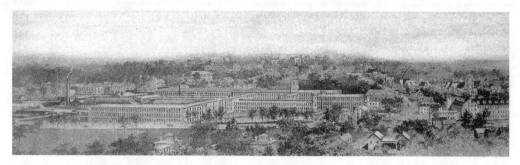

Whitin Manufacturing Company supplied Piedmont with machinery.

coarse yarn, the easiest product to produce.[56]

Piedmont was a boon for the county in many ways. It provided general economic stimulation, created jobs and increased the value of manufactured goods in the county from $350,000 in 1870 to $1,400,000 in 1880. Piedmont expanded three more times by 1895. It was a model enterprise and a center of learning. A Piedmont apprenticeship was like a college education for aspiring mill men. By 1900, Piedmont had produced a class of thirty-eight superintendents at mills in the Southeast.[57]

MILL BUILDING IN NEW SOUTH GREENVILLE

Camperdown

The great Boston fire of 1872 was instrumental in the building of Greenville's first cotton mill, which was also the only mill in the state within city limits. The fire, which burned over a square mile of the business district, destroyed the cotton commission house of Oscar H. Sampson and George S. Hall. Sampson and Hall, along with George Putnam, migrated south the next year searching for opportunity. They found it at the McBee property on the Reedy River in Greenville. They leased the old McBee gristmill in 1874, refitted it as a spinning mill and operated it as Sampson & Hall. A year later, prospects looking good, and planning to form a joint stock company, they renegotiated their lease for a period of thirty years on an increasing payment basis. The owners, in turn, made additional improvements to the property, including construction of a new mill across the river.[58]

The two mills, the old and the new, operated as Camperdown Mills Company, chartered in 1876. After construction of the second mill, the old mill and the new mill were commonly referred to as Camperdown No. 1 and Camperdown No. 2. Before the building of the new mill, the small spinning operation employed between 50 and 75 operatives. Oscar Sampson was president, George Putnam, superintendent. One of the early superintendents was an Irishman named Broyles; he likely succeeded Putnam in 1879 when Putnam left the company to open up Batesville Manufacturing. Camperdown was

Piedmont Manufacturing bills of sale for cotton.

The old mill and the new.

a large operation, second in the area only to Piedmont. A boarding house for operatives had been constructed. In 1880, the mill employed 260, of whom half were female, and a village of seventy-two rental houses had been constructed.[59]

The mill consumed a hundred bales of cotton or more per week and it provided investors with an 8 percent return. The annual return to the stockholders was not large compared to the experience of many other, earlier cotton manufacturing operations, nor in the neighborhood of Piedmont's returns. Changes in management had taken place by 1880. George Putnam had taken his brother into business, buying a small country factory at Batesville. Hamlin Beattie had succeeded Oscar Sampson as president.[60]

Business improved during 1881–82. The company had a backlog of orders to fill. By the end of 1882, Camperdown had hired almost another hundred operatives who manufactured products valued at $400,000; the company was able to pay stockholders a dividend of $12 per share.[61]

Labor had been a problem since the beginning. In 1876, Greenville was in the midst of recovery from the recent panic. At that time, Camperdown had been forced to hire "a rough class of help," including among the distaff segment those characterized as "disorderly women." Adding to the staffing problem, labor recruiters found mountain people reluctant to associate with the class of help working at Camperdown.[62]

Camperdown Mills failed by 1885; Hamlin Beattie was appointed receiver by the court and the business was sold to Henry P. Hammett of Piedmont and others on August 3, 1885. Reorganized as Camperdown Cotton Mills, the new firm was capitalized at $100,000. Among the dozen or more individuals and firms investing in the new Camperdown were O.H. Sampson and Company, J.L. Orr and C.H. Lanneau, suggesting

Camperdown Mills on the Reedy River.

that Camperdown's problems were not insurmountable. Their investments ranged from $500 to $30,000.[63]

Operating as Camperdown Cotton Mills, the company closed in 1894 because of legal problems between the McBees and the lessees. The mill had not proven as profitable as projected; the lease payments were scheduled to increase periodically and had apparently become significant to the continued operation of the mill. The question of liability for payments was fought both in and out of court among the McBees, the estate of the late Henry Hammett and the organizers of Camperdown Cotton Mills. A settlement was reached in spring 1895 after a comedy of errors involving the removal and reinstallation of the waterwheels and boilers.[64]

Huguenot Mill

Charles H. Lanneau, former treasurer of the Reedy River Factory and Charlestonian, organized the Huguenot Mills Company in 1882 with Charles E. Graham. The two-story twelve-thousand-square-foot structure was completed in the same year, producing cloth less than six months after it was organized. Although modest even by standards of the 1880s, the mill had modern machinery. It had 120 looms powered by a fifty-horsepower Corliss engine obtained from Providence, Rhode Island. One hundred twenty operatives manufactured gingham in the steam-powered factory. Twelve two-story, six-room cottages had been built for Huguenot operatives by the end of May 1882.[65]

Lanneau left the company within five years and later built another, smaller mill. Huguenot, in decline, was revived by Charles Graham, who brought in new money to revive the mill about 1890, when he bought controlling interest. Graham slowly built up the mill over the next several years. It almost doubled spindlege between 1897 and 1900.

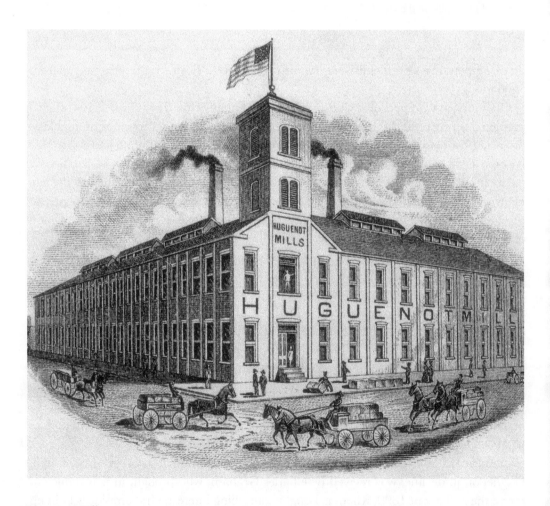

$300

Greenville S C. July 2, 1887

Received of CAMPERDOWN MILLS,

Three hundred ——————————————— Dollars,
in full for salary to June 30. 1887

100

Walker, Evans & Cogswell, Print.—82400

M.Patterson

Camperdown Mills check.

Huguenot Mills.

Its product line in 1900 consisted of colored goods, plaids, ginghams and cheviots, the yarn used being dyed in-house. He reorganized it in 1902 and operated it for five years before suffering a setback in 1907 when general economic recession occurred.[66]

Lanneau Mill

Lanneau's second mill, built in 1889, was a small spinning operation next to his residential property operated as Lanneau Manufacturing. It had a modest village of ten operatives' houses. The cost of construction was $45,000. Lanneau Mill ran from 1889 until July 1893, manufacturing hosiery yarns, consuming at a rate of 1,600 pounds of cotton per day. It had an original machinery complement of 1,500 spindles originally, to which 500 more were added. At its peak operation, the mill ran night and day, 115 operatives producing 21,000 pounds of coarse yarn per week while earning $500 in wages.[67]

Lanneau got in serious financial troubles by 1891 and put his property in the name of his wife and son to protect it from potential actions by creditors. He operated his mill until the last week in July 1893. A week earlier, Samuel C. Gentry, an employee of Lanneau's, lent Lanneau $900. Creditors foreclosed against Lanneau, forcing sale of the property. When the mill was auctioned October 1, 1894, it brought only $15,000, less than half what Lanneau estimated its value to be. Buyers were Thomas W. Earle and W.E. Touchstone. Earle was the cotton buyer; Touchstone had been a superintendent at Camperdown Mills. The new operation began under the business name of Greenville Cotton Mill. The mill burned in 1896 and was not rebuilt. Samuel Gentry sued Lanneau for his $900 the same year. Lanneau lost; his transfer of the house property was set aside, as he owed creditors $55,000.[68]

Sampson Mill

Oscar Sampson, a founder of Camperdown Manufacturing Company, bought a parcel of land from the Henry Hammett estate in 1891, which he held several years before using as a site for a new Greenville Mill. He formed O.H. Sampson & Co. in 1895, built and furnished a small two-story mill with older spinning machinery removed from Camperdown Mills after that mill closed in 1894. Sampson Mill, as the factory was better known, "was a beauty…from a cotton mill standpoint." By early April, the building, which looked "just like a big greenhouse," had been roofed; the tenement houses were expected to be ready by July. Sampson was powered by steam; the engine room contained four boilers and a five-hundred-horsepower engine formerly used at Newberry Cotton Mill. Powered up, the engine drove a flywheel twenty feet in diameter that, in turn, pulled two leather belts connected to drive shafts on each floor. On Saturday, September 7, 1895, the steam engine at Sampson Mill was tried out for the first time by engineer John Watkins. He was assisted by a "well known colored man named Harrison Johnson." It began to turn slowly but soon gained speed and turned almost soundlessly during the trial. Sampson reorganized his business as American Spinning Company, selling the

small mill to the new firm in 1895. American Spinning was capitalized at $125,000.[69]

Poe Mill

Francis Winslow Poe organized a cotton mill company in 1895. With two decades of experience in the mercantile trade and business connections in New York, Poe's expertise lay in marketing. Confident of his abilities, he left the mercantile trade and put his fortune into the company that bore his name. Capitalized at a quarter of a million dollars, the plant had begun with ten thousand spindles and three hundred looms. Poe Manufacturing specialized in tobacco cloth, cotton prints, sateens and lawns. By 1900, the mill was valued at four times its capitalization of $250,000. It operated two shifts, day and night, on a six-day schedule. Poe also had interests in Easley and Pickens Cotton mills.[70]

Heyward–Norwood Mill

The Heyward-Norwood Mill, also called the Economy Cotton Mill, was announced by organizers in early 1895. A commission to organize the mill included G.A. Norwood, H.W. Cely, J.L. West and Junius H. Heyward. The mill would be capitalized at $250,000 and start up with five thousand spindles. Subscription books were open and already 20 percent of the stock had been sold. Junius Heyward offered a special invitation to farmers to buy into the mill on an installment basis, paying $25 a year.[71]

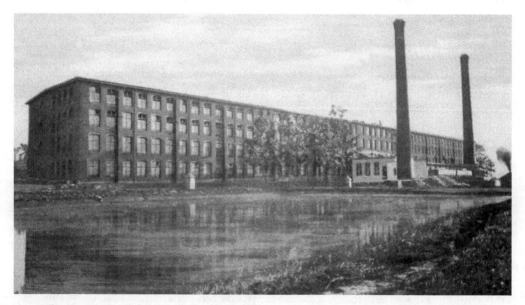

Poe Mill.

Mills Manufacturing Company

Mills Manufacturing Company was organized in 1895 by Captain O.P. Mills and his son-in-law, W.B. Moore of North Carolina. Six mills had been built or were under construction within twenty years. The *Greenville Mountaineer* commented that "So common has become the building of mills now that this custom has been dropped and possibly not a half dozen people in the city outside of those interested know that the first brick in Mills Mill was laid last week." It began operating in January 1897. Initially small in production capacity with only eight thousand spindles, and undercapitalized, Mills Manufacturing struggled to survive for several years. The management followed a policy of economic conservatism religiously.[72]

Victor Manufacturing Company

This company was organized in Greer, Spartanburg County, in 1895. It became significant to Greenville County when Lewis Parker became president in 1897. Parker turned the company around financially, gaining a reputation as a shrewd businessman.

Brooks Manufacturing Company

Mills Mill, circa 1900. *Courtesy of* Handbook of South Carolina: Resources, Institutions and Industries of the State.

Fountain Inn Manufacturing Company. *Courtesy of* Handbook of South Carolina: Resources, Institutions and Industries of the State.

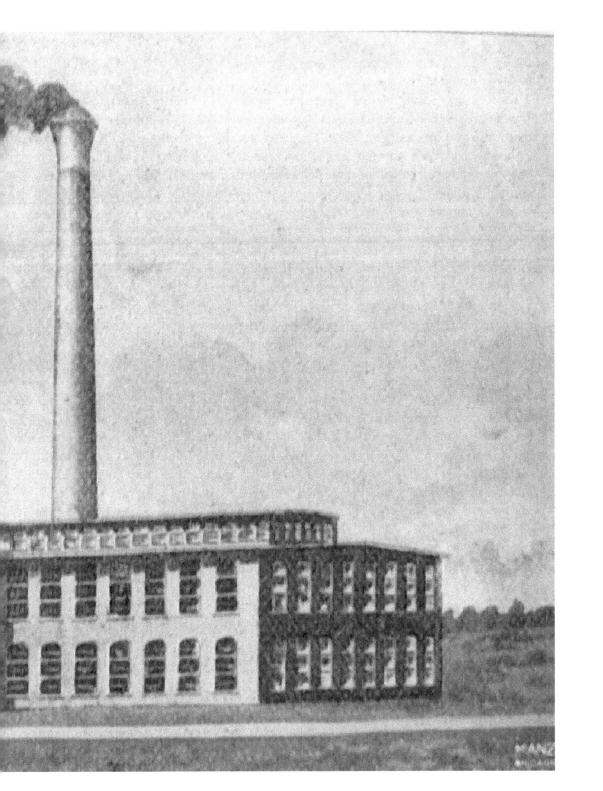

Brooks Manufacturing Company was chartered April 25, 1898. The principals involved included E.S. Brooks, L. Jackson Green, H.P. Moore and J.A. Robinson. This operation was a batting plant that opened up in the old Farmers Alliance Warehouse on Line Street in Greer. Batting operations included processing of clean mill waste and cleaning cottonseed for the tiniest fibers, which were used primarily in bedding products and for similar low-grade fill applications. The plant was in operation only briefly before shutting down in summer 1901. Cotton buyers Frank and James Burgess attempted to revive operations shortly thereafter. The small mill closed permanently by 1904.[73]

Fountain Inn Manufacturing Company

Fountain Inn Manufacturing Company was chartered in late 1898; capitalized at $50,000, it was founded by a group of investors headed by J.W. Shell. J.R. Young served as its first superintendent. After falling on hard times, the company's controlling interest was bought by the Woodside brothers, John T. and J.D., in 1906.[74]

Brandon

In 1899, John Irving Westervelt of Summerville, who gained his knowledge of cotton manufacturing as treasurer at Pelham Mills, organized Brandon Mills. Initial capitalization was $300,000. In ten years, it increased its spindlege by a factor of nine, operated over two thousand looms and was capitalized at $1,500,000. Brandon manufactured sheeting for the Chinese market as well as print and broadcloth for domestic consumption. Three years later, its capital value had increased to $2,300,000.[75]

THE LATTER HALF of the 1890s was fortuitous for mill building in Greenville. Greenville, by 1900, became known as a manufacturing center. By 1900, over 50 percent of the capital invested in Greenville area mills was local. Originally the figure had been much smaller, but the outside capital had been mostly in the form of stock taken by machinery companies from the Northeast, which had supplied local mills. When the profit potential of the local mills was recognized, Greenville investors increasingly bought into cotton mill stocks. A general prosperity was apparent. As expanding industry brought in more workers, stores were obliged to carry larger and more diverse stocks, rail travel increased and public works projects were underway. Profits in 1900 continued to bring investors a good return on their money; 20 percent was considered "a very moderate figure to realize."[76]

Chapter Three

EXPANSION, COMPETITION AND CONSOLIDATION

Three of the oldest mills in the county were still in operation at the beginning of the twentieth century. Lester Brothers' site had undergone extreme transformation and operated as Pelham Mills with some three hundred hands, Reedy River Factory operated more modestly and Batesville was virtually unchanged. The old mills depended heavily upon the local market. Those built later during the cotton mill campaign were suburban, generally had adequate start-up capital and convenient locations and employed selling agents to move their products, often located in the North. Even with these advantages, size of operation was no guarantee of commercial success. Across the South, the proliferation of mills all tooled up to produce similar products continued to result in sporadic market gluts of mostly Southern-produced coarse goods with consequential recessions within the industry. Some owners, notably the Parkers, were moving toward the production of fine goods, but there remained too many novice mill men, many making the transition from merchant to industrialist, who had no concept of the need to diversify. Product issues aside, local mill owners also had to be concerned with whether they could continue to sustain full production schedules. Labor shortages began to be felt early in the century. Another pressure came from muckrakers and reformers who had discovered the ubiquity of child labor and other industrial sins across the South.

While cotton mill companies had their concerns, they also had, in Greenville, a concentration of industrial knowledge and experience, which could mount a formidable defense against whatever threats were represented by the outcry of muckrakers and the variations of the markets. The railway system was prepared to maintain pace with the industry, and there was always on hand a cadre of expert builders, designers and engineers.

LABOR PROBLEMS

Early in the century, if any factor impeded Greenville's rush toward textile fame, it was sporadic labor shortages. When Camperdown was built, owners had to hire whomever they could, the area still adjusting to changes brought about by the recent war. Women and children may have constituted close to two-thirds of Camperdown's workforce. Mills built between 1875 and 1895 generally kept pace with the availability of the labor. By the mid-1890s, a full-scale boom in mill building was underway, requiring companies to use every means available to assemble their workforces. Flyers were mailed out, distributed by hand and posted; recruiters rode out into the countryside and mountains, far beyond the state line, in search of marginalized farmers and sharecroppers willing to move their families to the city to get regular work. One large farm family could provide several laborers.[77]

The mill-building boom continued after the turn of the century, signaling Greenville's arrival as an industrial town. With seven mills in operation and plans for more mills and additions to mills, companies competed with one another, especially for skilled mechanics, fixers and weavers. At a time when industrial wages were very low, a difference of a couple of pennies per hour was all it took for an operative to pack up and move into the next village. Between 1905 and 1907, employment in the state's cotton mill industry increased 47 percent.[78]

In 1906, the South Carolina Cotton Manufacturers' Association in cooperation with the State Department of Agriculture engaged in an experiment to remedy the labor problem. Workers from Western Europe were recruited and brought to South Carolina on the *Wittekind*, of the North German Lloyd Steamship line. On Sunday, November 4, some 476 passengers arrived in Charleston and were dispersed by train across the state to jobs waiting in the textile industry. Commissioner of Agriculture E.J. Watson had sailed to London, thence to the continent to arrange for the immigration. He sought particularly those in Belgium, Austria and Germany, those experienced in textiles.

In Greenville County, European laborers were initially employed at Greer and Monaghan; the greatest success of any mill that eventually hired *Wittekind* labor was Monaghan. Thomas F. Parker, president of Monaghan, was also chairman of the Commission of Immigration of the South Carolina Cotton Manufacturer's Association. He had between thirty-five and fifty Belgians at work, where they found his wages to be about double the standard to which they were accustomed in Europe. The *Wittekind* experiment demonstrated that foreign labor could function in the local environment; however, many of the Europeans did not remain in the industry or else chose to move from the state since they were not contract laborers.[79]

The ultimate solution to the labor shortage, however, remained those members of the farming class who came to the mills without too much enticement. Cash crop farming placed the farmer at the whim of weather, merchant and market. By the 1930s, farming occupations made up less than half the jobs in the United States. Greenville, as a

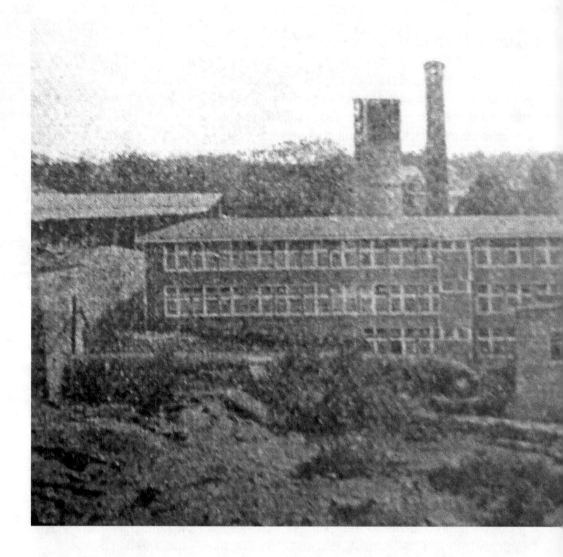

microcosm of the country, was not far behind in this trend. Farm ownership increasingly declined, keeping the mills supplied with labor, leaving no doubt about the industrial trend of the county's economy. Between 1900 and 1905, Greenville had the highest industrial growth rate of any municipality in the state, a 63 percent increase. The South Carolina Cotton Manufacturer's Association found that almost four thousand Tennessee and North Carolina mountaineers had been recruited between 1905 and 1907 and others came down of their own volition, mostly to upstate mills.[80]

THE RAILROAD FACTOR

Growth of the cotton textile industry required expansion and development of transportation systems. The Southern Railway System that had been created from the amalgamation of

Pelham Mill,
circa 1908.
Courtesy of
Handbook
of South
Carolina:
Resources,
Institutions
and Industries
of the State.

the old Richmond-Danville Airline and others announced a plan to double track its route in April 1906. A new railroad company, an electric system, was organized in 1909 to serve the major towns of the upstate and Charlotte, North Carolina. Initially formed as the Greenville, Spartanburg and Anderson Railway (GSA), it was completed in 1914. The GSA was renamed the Piedmont and Northern (P&N) the same year.[81]

The P&N became increasingly important to the cotton textile industry with time. The importance of the electric railway to the cotton towns that supplied the line with much of its short-haul business cannot be overestimated. By the peak of the cotton mill expansion during the 1920s, the P&N derived two-thirds of its revenue from freight, served 135 mills that represented three million spindles and advertised the line as having "one mill to every mile of track."[82]

For long-haul shipment, the Southern Railway dominated. In 1912–13, the Southern laid five miles of new track to nine Greenville Mills. The Charleston and Western Carolina Railroad laid two miles of siding to accommodate local industry and in 1913, both lines were in the process of enlarging their freight handling facilities.[83]

MILL BUILDING

The success of Greenville's cotton mill boom owes a lot to engineering concepts established largely after 1865. D.A. Tompkins, a South Carolinian, was almost legendary in his contributions to the industry. Possessed of profound technical knowledge, Tompkins also was perceptive of the trends in sales and marketing. He was one of the early advocates of product diversification. Tompkins belongs to the cotton mill belt. However, engineer J.E. Sirrine was the greatest Greenville contribution to the science of mill building.

Sirrine, architect and engineer, began business in 1903 after having been the Southern representative for Lockwood, Greene & Company. Within a dozen years, he employed a staff of twenty. Sirrine was the grandson of a Connecticut native and joined Lockwood, Greene & Company in 1895 when the company was designing its first Greenville mill, American Spinning Company. Sirrine was hired to survey the site for Francis Poe's mill. For the next three years, Sirrine worked on a contract basis before being offered a regular position. By the time he set up his own firm he had worked on the designs of perhaps twenty new mills in the upstate area. When he tendered his resignation, Lockwood, Greene & Company tried to persuade him to remain, offering a salary equal to the second highest paid by the company plus fifty shares of stock in the company. In 1947, after the death of Sirrine, Ned Greene remarked that Sirrine's decision to refuse was wrong, "and if it [Sirrine's decision] had been made the other way, we would probably be working for J.E. Sirrine today." By 1915, Sirrine had a list of clients including over two hundred cotton mills. Sirrine and Lockwood remained linked for decades through mutual association with Greenville-based Daniel Construction Company.[84]

THE ANTEBELLUM MILLS

Pelham

In 1900, Pelham Mills Company was prosperous and planning for expansion. Arthur Barnwell was president; the superintendent was Dan Sunderland, a mill man from Massachusetts. A new boiler had just arrived and the company was planning to add at least twenty more eight-room houses to the village. Pelham's recruiter, named Mulky, was scouring countryside and mountains to meet Pelham's labor needs. Pelham Mills was a closed corporation and did not often reveal its bottom line to the public, but in 1902 the

company paid one of the highest dividends in the area at 5 percent.[85]

Pelham was a large country mill sitting beside the Enoree River, with its village spreading up the hill along Abner's Creek Road into Spartanburg County. The village population numbered 600, including 179 operatives. In mid-summer the mill was running full shifts; operatives were prosperous; the company store required five clerks to handle all the business.[86]

A new company store, two stories tall, was built in 1911. McMillan C. King, secretary-treasurer, along with Ed J. DeCamp and J.H. Greer, directed operations of the store, which did business as The Peoples Store between 1911 and 1918.[87]

Pelham was modeled after older mills; its management did not keep apace with developing technology, as many other mills felt compelled to do. Pelham therefore enjoyed its greatest prosperity early in the century. One of the last water-powered cotton mills in the state and the last in the county, its wheel generated energy equal to 650 horsepower. Pelham produced yarn, cloth and hosiery but, unlike many mills, marketed its own products without employing a national selling agent. By 1906, Pelham had five hundred employees; the mill consumed cotton at the rate of almost three thousand bales of cotton yearly. The company decreased capitalization in August 1907.[88]

By 1910, the mill was operating at close to capacity for its level of technology. Around 1910, Pelham partly converted from waterpower to electricity; it retained a water wheel for another fifteen or more years as a precaution against power failure. The company installed new boilers and a small water wheel to run the lights when the water was low around 1916.[89]

The Enoree River that powered Pelham is not a large stream, but its narrow gorge made it prone to flooding during heavy downpours. The Enoree flooded the mill in the summers of 1903 and 1908. In 1903, the bridge across the river was washed out; mill damage was minimal. In 1908, water rose two feet in an hour after a heavy constant downpour on Monday night, August 24. By morning, water stood ten feet deep in the mill. Even the office, which was on higher ground, was flooded with four feet of water. Rumors spread over the village and surrounding community that the dam had burst. They were proven unfounded when the waters receded. The floodgates had been opened to prevent damage when flooding appeared imminent; the water was so high as to make the floodgates useless.[90]

Pelham enjoyed good business through the end of the First World War. Arthur Barnwell died September 9, 1918. His son-in-law, McMillan C. King, assumed control of the mill. Business continued steady the next year during King's tenure. Between August 1918 and August 1919, Pelham consumed almost thirty-five hundred bales of cotton. Although the war ended in November 1918, American troops were still deployed in Russia and uncertainty of American involvement kept the wartime industries operating for another year. With prospects the brightest they had been in some years, King sold the company. Buyers were C.S. Webb, a Greenville cotton broker, and J.E. Sirrine, textile engineer; they assumed control of the mill July 18, 1919. Anticipating continued business and expansion, the partners increased the capitalization to $400,000 at the end of 1919.[91]

DECLINE AND DEMISE OF BATESVILLE

The twentieth century was fraught with difficulty and tragedy for the tiny mill of Batesville. In 1901, with antiquated machinery and minimal waterpower available, Batesville Manufacturing Company had changed little in the scope or capacity of its operations since its founding. Out of the 144 village residents, 44 worked at the mill. Over a third of the workforce was sixteen or younger. The number of employees was less than in 1881. Clearly, the future did not look bright for the company, nor did the next five years offer much hope for the continuation of the business.[92]

Labor problems briefly beset Batesville in the summer of 1900, when a strike was attempted. Lightning struck the company store early on May 19, 1902, causing a fire that soon spread to a warehouse, which was destroyed, along with part of the three hundred bales of cotton it sheltered. The freshet in 1903 was inconvenient but did not damage the mill; at the gristmill, the steam boiler exploded December 1, 1903, killing the son of W.H. Greer, an employee. Rising waters burst the Batesville Dam on Saturday July 1, 1905. Then on an early December day in 1906, John Baker, while on a business trip to Atlanta, suffered a heart attack and died. At Batesville the same day, the company store he had managed for two decades caught fire.[93]

The store was rebuilt and the mill continued to operate for seven more years but required funds the owners either did not have or did not choose to spend. Indebted and lacking operating capital, Batesville closed its doors July 1, 1913. In early 1914, Mary P. Gridley and the officers and directors of Batesville Manufacturing, believing prospects were dim, voted to sell mill, machinery and real estate. Pelham Directors McMillan C. King and Ernest J. DeCamps bought the property for $12,000.[94]

REEDY RIVER FACTORY

Although several groups beginning in 1879 made valiant efforts, the cotton factory at Fork Shoals only persisted and did not prosper. Still, there was sufficient interest in the potential of the location that the property was reinvented for industrial purposes a half-dozen times. Fork Shoals Cotton Mills was chartered February 6, 1900, at $50,000 capitalization. Organizers were W.P. Nesbitt, Henry Briggs, James J. West and F.M. Austin. It was reorganized with a new slate of directors in 1911 as Katrine Manufacturing Company. William Goldsmith, Frank Hammond, Henry Briggs and J.M. and B.E. Geer were organizers. In 1920, the owners of Katrine Manufacturing sold the plant and the Cedar Falls Light and Power Company to Virginia Manufacturing Company, which had been chartered with a capital of $175,000 on December 17, 1919. J.H. Morgan was president.[95]

Reedy River Manufacturing Company was reorganized as Conestee Mills in August 1909 by Ellison Smythe and W.E. Beattie. Capitalized at $200,000, it was led by President Thomas J. Charles, son of the former president. It was severely damaged to the tune of

$50,000 by the flood of 1908 and was closed for four years. In 1913, it operated with over 16,000 spindles and 371 looms, producing sheetings and drills. By 1915, it had in excess of 20,000 spindles and over 400 looms.[96]

New South Cotton Mills

Piedmont village had a population of thirty-five hundred in 1907, of whom twelve hundred were employed as operatives, nineteen of whom were children younger than twelve years. It operated over sixty-seven thousand spindles and almost twenty-one hundred looms, consuming twenty-four thousand bales of cotton to produce products worth $1,800,000.[97]

The old Camperdown Mill property on the east side of the river was bought in 1903 by Charles E. Graham. Capitalized at $100,000, it operated twelve thousand spindles and three hundred looms. Chartered as Camperdown Mills, organizers were C.E. Graham, Allen Graham and S.J. Graham. By 1915, this incarnation of Camperdown was operating partly on steam and partly on electricity; it had a bleachery and facilities with which to dye yarn. Finished products were ginghams and plaids.[98]

The refitted gristmill, which was operated as Sampson & Hall on the west bank of the Reedy River, stood idle for several years after O.H. Sampson removed the machinery to his new mill in 1895. The eastern Camperdown property was sold in 1903. In 1906, Luther McBee organized Vardry Cotton Mills and started a spinning operation in the old mill. McBee was president and treasurer and C.H. Lanneau was secretary. Capitalization was $71,000. The mill employed seventy-five hands who produced coarse yarns, both white and colored. In 1916, the president was W.H. Gray, who was also the president of Gray Cotton Mills in Woodruff.[99]

When the Panic of 1907 swept the economy, Mills Manufacturing Company was on firm footing. The company expanded its productive capacity by 400 percent while reducing its outstanding stock to 50 percent of the mill's value. Captain O.P. Mills held the presidency until his death in 1915. In 1918, Alan Graham and S.A. Burts reorganized Mills Manufacturing as Mills Mill. Shortly thereafter, Reeves Brothers bought controlling interest in the company that became the foundation of Reeve's Brothers' corporate interests.[100]

American Spinning Company constructed a second mill in 1900 and began weaving cloth in 1901. Two more additions were added in 1902 and 1909. Capitalization increased almost 500 percent between 1895 and 1903. Sampson and the three subsequent enlargements of the enterprise were as up-to-date as possible. Based on Northern standards and designed and built by specialists in cotton mill construction, American Spinning was updated to the latest technology as improvements in machinery developed. By 1909, the company operated over fifty thousand spindles, employed at least six hundred operatives and owned a village that was built piecemeal in three distinct phases over a fourteen-year period.[101]

By 1912, Brandon employed seven hundred operatives. Capitalization stood

at $900,000. Sheetings, shirting and sateens made up the company's product line. Stockholders' returns were not exceptional at 5 percent. Because of "adverse circumstances," Westervelt resigned as president, although he retained a significant financial interest. He was succeeded by Augustus W. Smith of Spartanburg.[102]

NEW STARTS

Organized by G.A. and Joseph Norwood, Carolina Mills was small by many standards during Greenville's mill boom. It was chartered in May 1900; its authorized capitalization was increased in 1912. It began as a 26,000-spindle, 750-loom operation in 1915 but, as a casualty of the wartime economy, it was in receivership. It was reorganized in early 1916 by A.G. Furman, B.E. Geer, John C. Simonde, W.A. Baldwin and W.C. Beacham. Chartered with an authorized capital of $600,000, it was later purchased by Augustus W. Smith of Spartanburg and renamed Poinsett Mill.[103]

William W. Burgess and other local investors organized Franklin Mill in Greer in 1900. The second mill in Greer, it was much smaller than Victor Manufacturing in capitalization and in physical size. Located west of Emma Street, the mill stood two stories tall. By 1912, J.M. Greer was president; the mill operated 10,000 spindles and 288 looms. It employed 200 operatives and manufactured sheetings and drills.[104]

In 1900, Lewis W. Parker and his cousin Thomas F. Parker organized Monaghan Mills. The question of where to locate the mill pitted Greenville against Greer and the Southern Railroad against the Carolina and Western Railroad. In late 1899 or early 1900, Lewis Parker and H.J. Haynsworth, his law partner, took an option on the Goldsmith property on the C&W Railroad, but were still considering other sites. The fact that a final decision had not been made encouraged Greer leaders to make what at first appeared to be a successful pitch for the plant to be located there on the Southern Railroad and in the vicinity of the Victor Manufacturing Company, of which Parker was the president.

Within a week, however, Greer was eliminated from consideration and the Parkers considered other sites in collaboration with the patriarch of Pelzer, Ellison A. Smythe, railroad officials and others. Thomas Parker had the deciding vote and offered to build the mill near Greenville, provided he could depend upon $100,000 in local capital. Monaghan was named in honor of an Irish locale, the home county of the Parkers' grandfather, Thomas Fleming. Thomas Parker served as president of the mill that was located on what was once J.A. Finlay's "Cedar Farm" on the Cedar Lane Road.[105]

Like Francis Poe, John T. Woodside spent his early years in other pursuits before organizing, with his brother J.D. Woodside, a cotton manufacturing company in 1902. Woodside Cotton Mills began operating in 1903. The mill was capitalized at $200,000; it was initially equipped with 11,000 spindles and 300 looms. The company tripled its spindlege the next year. In 1912, the Woodsides began an expansion that, when complete by

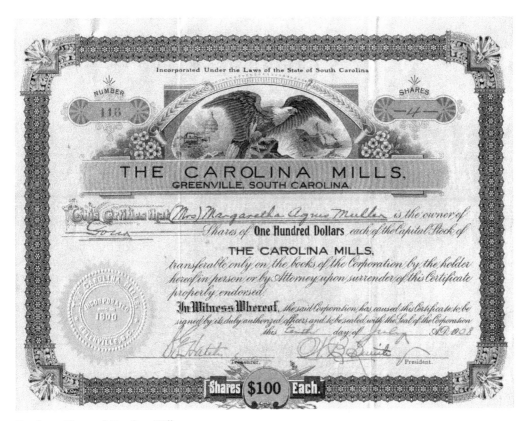

Stock certificate of Carolina Mills.

1915, with 112,000 spindles and 4,700 wide looms, made their enterprise the largest cotton mill in the country under one roof. Its capitalization at the time stood at $1,750,000.[106]

Henry P. McGee, an Abbeville County merchant, moved to Greenville after thirty years in a store and caught the "Greenville manufacturing fever." In 1903, he organized McGee Manufacturing, initially capitalized at $100,000, to manufacture coarse yarns from the yarn waste of cotton mills. His partners included Lewis W. Parker and James L. Orr. The mill, located east of Greenville on Laurens Road, represented an investment of about $175,000 with $91,000 in outstanding stock. One hundred operatives were employed. The mill was a two-story brick structure with thirty-four thousand square feet of floor space. The village was modest, made up of twenty cottages for operatives and houses for the superintendent and two overseers. McGee, also president of City National Bank, continued to operate and expand his textile enterprise. In 1907, the company became the only woolen mill in the state, processing the fiber from its raw state to the finished product, woolen blankets and blanket cloth. The company continued to process lower-grade cotton cloth for industrial applications.[107]

E.F. and John T. Woodside organized Simpsonville Manufacturing Company; it was chartered in 1908. The mill was small, with only eight thousand spindles, but significant

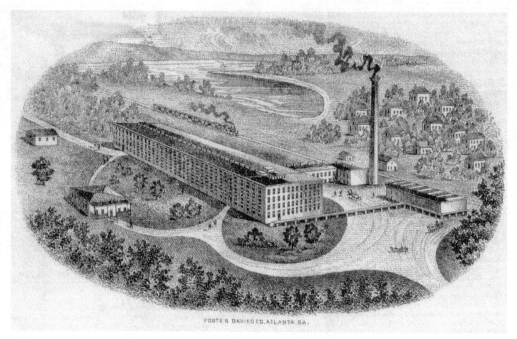

Monaghan Mills village, plant and office from letterhead.

to Simpsonville. By 1912, it was operating twenty-five thousand spindles and six hundred wide looms. It was capitalized at $500,000.[108]

Kerr Wilson operated under his own name and as Wilson Cotton Mills Company briefly in part of Huguenot Mill in 1910. He moved to River Street and later joined with Allen Graham, a partner in the Huguenot Mill, to form a thread manufacturing company.[109]

J.I. Westervelt organized a fine goods mill in 1911. Westervelt Mills was chartered in January 1911 with a capitalization of $1 million. Certain difficulties forced Westervelt's resignation both here and at Brandon, which he had founded twelve years earlier. Westervelt Mill was renamed Judson Mill in honor of Furman University President Dr. C.H. Judson. B.E. Geer, a former professor of English at Furman, succeeded Westervelt as president.[110]

Dunean Mills was organized March 4, 1911. Capitalized at $1 million, it became the first mill in the South to use individual motor drives. In 1915, it produced madras shirting. J. Adger Smythe, son of E.A. Smythe, was president. It was named for an Irish village, home to ancestors of the Smythes.[111]

Chartered June 25, 1914, Prospect Mills, with a capitalization of $25,000, under McMillan C. King and Ed DeCamps was a yarn operation with just over 3,000 spindles in the former Batesville Manufacturing plant. The same machinery and power plant long in operation continued to be used under the new name. The boiler exploded just before the workday on March 25, 1916, injuring three but causing no damage to the mill, the boiler being housed separately. By 1917, the firm was handling waste yarns and continued to process waste through midyear 1919, consuming cotton at the rate of 488

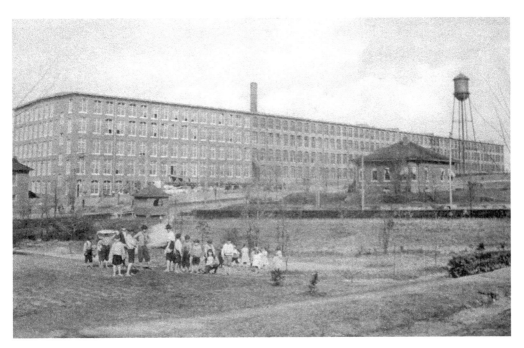

Woodside Mills, circa 1910.

bales per year. King left the company in 1918 to succeed Arthur Barnwell as president at Pelham. Prospect Mills operated until early 1921.[112]

Beaver Duck Mills, headquartered in Atlanta, succeeded McGee Manufacturing, purchasing the Greenville company September 28, 1918. It produced cotton duck cloth; W.D. Couch was president. Beaver Duck Mills operated the mill on a full-scale basis for more than a year. A small school was provided for the children in the village. Ethel Wynn was principal in 1919. Okeh Manufacturing was chartered in June 1918 with a capitalization of $75,000. F.H. Cunningham was president.[113]

In June 1919, J.I. Westervelt, founder and former president of Brandon Mill, secured options he held on controlling interest in the company and sold it to Woodward-Baldwin of Baltimore. In the terms of the transaction, Westervelt received $210 per share, which was $70 to $90 above what the stock had been trading for recently. Augustus W. Smith remained as president.[114]

OTHER TEXTILE OPERATIONS

Greenville's first finishing plant, Union Bleaching and Finishing Company, commonly called Union Bleachery, started up in September 1903. Capitalized at $250,000, the company was organized in 1902 by outside investors. The Greenville location was selected over Fayetteville, North Carolina, when a majority of the investors convinced

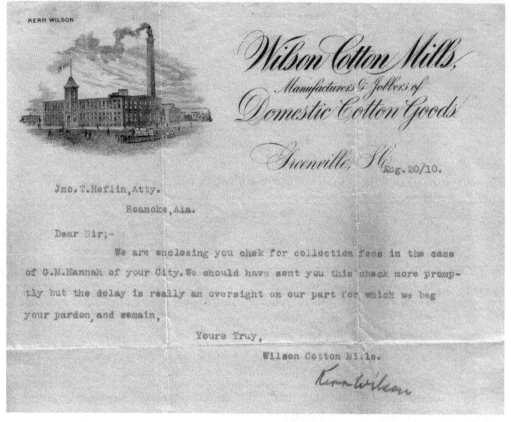

Kerr Wilson billhead.

skeptics that a finishing plant could succeed here.

Construction began in October 1902; floor space was added to accommodate future expansions. Business did not immediately accelerate because area mills had long-established ties with Northern finishing mills and their agents. Union Bleachery demonstrated its commitment to the area by increasing capitalization and by bringing in John Arrington as president. Two Southern bleacheries had recently failed and it was up to Arrington to save this one. Arrington, a textile executive from Reidville, North Carolina, convinced owners that business could improve if local mills could participate in ownership of the bleachery. Within three years, the board of directors represented mostly Southern mills totaling over a million spindles, guaranteeing business for Union Bleachery.[115]

Nuckasee Manufacturing Company was chartered in September 1910. Capitalized at $50,000, it occupied the former Huguenot Mill after 1913. Frederick W. Symmes was president. Nuckasee was one of the first garment plants in the South.[116]

Saluda Manufacturing Company was organized by F.H. Cunningham in late 1916. Located at the end of Ninth Street in Woodside Village, it was capitalized at $15,000,

which increased to $35,000 the next year, at which time it operated just under thirty-six hundred spindles. A hose manufacturer, it continued to operate until 1922.[117]

EARLY CONGLOMERATES

As in the North during the big business era, Southern cotton mills eventually underwent multiple transformations as their owners tried to achieve consolidation and a degree of monopoly over segments of the market. In South Carolina by 1916, five major mill consolidations had occurred, one each in Dillon and Union Counties and three in Greenville County.

The Parker Group

In 1910, cousins and business partners Lewis W. Parker and Thomas F. Parker had known nothing but success in the cotton textile business for over a decade. Late in the year, Lewis Parker announced a plan to merge a number of mills. He was not specific as to which companies or how the plan would be carried out and the rumor mills began to grind, fueling the interests of investors and politicians.[118]

To accomplish the planned merger, the Parkers formed a new company, the Parker Group. Chartered March 20, 1911, the organization was a holding company with the rights to acquire, own and dispose of stocks of manufacturing concerns. As information became available, the public learned that the Parker Group's plan called for a multi-county merger of fourteen existing mills across the state. Stockholders had previously been notified of the plan and conditions of the merger.[119]

When sufficient stock had been acquired in three major cotton mills, they would form the basis for ownership and management of the other mills involved in the plan. In its initial form, the Parker Cotton Mills held controlling interest in three corporations: Monaghan Mills of Greenville; Hampton Cotton Mills, a collection of eight factories located in Columbia, Chester, Camden and Edgefield; and the Victor Manufacturing Company, which was composed of three Greer mills, Otteray at Union and Wallace at Jonesville. The mill corporations were intended to be "flagship" plant operations. Monaghan and Victor had been molded by the Parkers and were widely considered to be "model mills."[120]

When the acquisitions were completed, the Parker Group controlled 11 percent of the industry in South Carolina. Capitalization was increased to $3.5 million on June 24, 1912. The Parker merger developed into a controversy when Governor Cole Blease opposed the cotton mill merger on the basis that it would keep cotton prices low. Parker disagreed publicly but politely, while Blease made no attempt to act.[121]

The Parker Group's mills had a history of regular dividends and strong leadership. The Hampton Mills were mediocre as a group, with only Olympia Mill proving consistently profitable. Nevertheless, stockholders anticipated a turnaround of fortunes for the weak mills, given Lewis Parker's track record, beginning with Victor in 1896. What investors did not anticipate were the affects of the European war and Lewis

Parker's terminal illness.[122]

Lewis Parker resigned as president on November 4, 1914, amid a declining market. He continued to participate as a member of the board of directors, but in two months, the company verged on failure. Reorganization and receivership were followed by dissolution of the original company.[123]

Woodside Cotton Mills Company

Woodside Cotton Mills was chartered in September 1902. Capitalization of the company was authorized to $200,000. John T. Woodside, president, and his younger brother, J.D. Woodside, were organizers. The eleven-thousand-spindle startup was tripled in two years. In 1906, the brothers bought controlling interest in Fountain Inn Manufacturing Company and expanded the capacity of that plant. In 1908, John T. and another brother, E.F., organized Simpsonville Manufacturing Company. Chartered in March, it was capitalized at $150,000. The Woodsides announced the fourth cotton mill merger in the state at the end of June 1911. Coming on the heels of the Parker consolidation, Woodside Cotton Mills Company consolidated their three mills into a single corporate entity, which was capitalized at $3 million. John T. Woodside was president.[124]

Victor–Monaghan Corporation

With the loss of Lewis Parker's leadership, the Parker Group was reorganized by W.E. Beattie and M.C. Branch. Branch, a Richmond banker, succeeded Parker as head of the corporation. Beattie, president of Piedmont Manufacturing Company and heavily experienced in mill operations, assisted Branch and the Parker Group to restructure.[125]

The Hampton Group, consisting of eight mills, mostly unprofitable, was sold at a bargain price of $10.80 per spindle. The Victor and Monaghan groups were combined into the Victor-Monaghan Corporation. Cash from the sale of the Hampton group plus a half-million-dollar life insurance policy on Parker put the new Victor-Monaghan Corporation on firm financial footing and made it attractive to investors. Capitalization was authorized to increase to $7 million in mid-1916 when the company name was changed to Victor Monaghan Mills on June 30, 1916.[126]

"There is something dead up the creek," claimed House of Representatives member John W. Crews in 1917, referring to the business practices of the former Parker chain. Crews believed the speculation on the market to be unethical and that, further, it had been improper for M.C. Branch to both serve as a company official and sit on the Board of Hannover National Bank, which was a Parker creditor. There was also the question of whether full information as to the condition of the Hampton Mills had been given to the new buyers. The attorney general was ordered to investigate these matters. No prosecutable crimes were discovered; the reorganization and subsequent liquidation of assets were valid.[127]

Chapter Four

L. W. PARKER, President & Treasurer
J. M. KEELS, Secretary

H. F. MOODY, Superintendent
H. E. BATES, Ass't Supt.

Victor Manufacturing Company

COTTON MILLS

Greers. S. C., Feb 9 – 1906

Mr. J. M. Jenkins,
Gaffney, S.C.
Dear Sir When I
was at Gaffney I spoke
to you something about
a job here. I have a job
open now. It will be
48 32" looms over head belts
at $1.50 per day. If you
would like to change
for this job let me hear
from you at once.
Yours Truly
R. R. Woodside

Job available: run forty-eight looms for $1.50 a day.

GREENVILLE ON THE MAP

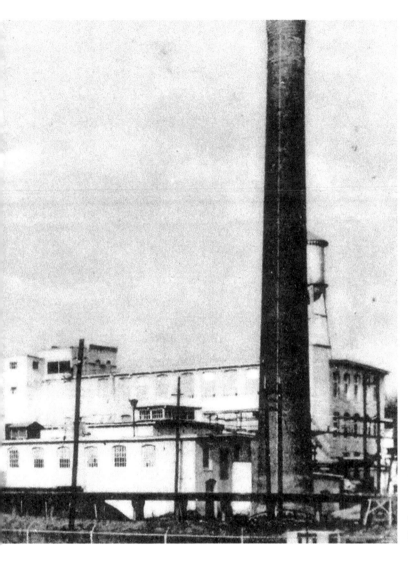

Victor Manufacturing Company.

By 1900, Spartanburg, Greenville and Columbia were, unsurprisingly, the leading textile towns of the state. Spartanburg, with the largest number of operating spindles, the standard measure of industrialization, led, with Greenville ranked second and then Columbia. According to a *New York Times* story, Greenville, compared with Spartanburg, had the greater potential, being more advantageously located for future improvement.[128]

Greenville was also moving toward becoming the largest textile-manufacturing city in the South as measured by other characteristics. Ten percent of the supplies for the entire industry were bought in Greenville; purchasing departments for fifty-six mills were located in Greenville. Forty-three mill presidents lived in Greenville. Greenville was also all business and no frills with respect to textiles. Joseph J. Smith, a machinery manufacturer of Boston, noted that "Greenville is the logical place for holding a textile exposition in the south because it is a

The mills of Victor Monaghan Company.

small city without other attractions to take the mill men away from the exposition."[129]

THE SOUTHERN TEXTILE EXPOSITION

What first put Greenville on the map was acknowledgement by Northern businessmen of its centrality in the Southern textile belt. This happened at Greenville's first textile trade show in 1915. Machinery manufacturers observed a shift of the industry from the Northeast to the Southeast. It was their business to identify the location of future markets. Northern mill executives also recognized the increasing significance of Southern textiles. For too long the South had been largely ignored as a factor in the nation's economy. Without a proper recognition of each section by the other, there had remained, even fifty years after hostilities, a certain enmity between the North and the South. Then, finally,

> *at last the two sections are so closely welded that the Union forms the mightiest, the richest, the most powerful nation on earth…the followers of Grant stand shoulder to shoulder with the descendents of Lee's gallant army and hear in the hum of the dozens of textile machines…that there is now no North, no East, no West, no South, but one union, a hundred million brothers, all Americans.*[130]

The Southern Textile Exposition achieved more good will between opposites in less than a week than the application of the old adage "pass and re-pass" had in five decades. It had taken years to make the exposition a reality.

A perennial topic raised at Southern Textile Association (STA) meetings was the

possibility of bringing to the South the textile machinery exposition, which had been anchored in Boston. When exhibitors were approached by the STA and found agreeable to the idea, the issue became *where* to hold it. Both Charlotte and Atlanta were logical contenders for hosting the show and both sought it. The state between them, however, was ranked first in textile production in the South, second in the nation only to Massachusetts. Greenville had five hotels and considerable ambition. A group of Greenville mill men in concert with the chamber of commerce approached the STA, guaranteeing floor space. Once the STA agreed to sponsor the show, the Greenville group took the initiative, formed an organization—the Southern Textile Exposition, Incorporated—and received formal endorsement of the STA by the end of 1914. There remained, however, significant obstacles to the show's success, most of which were beyond the control of the exposition's organizers.[131]

The summer shutdown of area mills, July 31 through August 10, coincided with the breakout of war in Europe. Initially considered contraband, cotton declined in value, causing a shakeup of the larger economy. A 500-pound bale of cotton could be processed to yield some 375 pounds of cloth and the rest turned into gun cotton or nitrocellulose, an unstable but effective explosive several times more powerful than black powder. The decline in price favored the mills, at least temporarily, but there was concern over the future of textiles.[132]

By late fall there remained abundant concern over the war's impact on the cotton market and related industries. Cotton exchanges had ceased trading; low cotton prices continued to keep much cotton off the market, unavailable for the mills. To protect cotton prices, in October the state legislature enacted legislation requiring farmers to reduce cotton acreage the following season. Conflicting information led to increased unpredictability of the markets. New Orleans spot cotton dropped to a bid of .0735 cents per pound for lint cotton on October 10, despite the government's assurance that cotton and cottonseed oil would not be considered contraband when transported on American ships. Weeks later, England seized the American ship *Denver* with a load of cotton bound for Germany, again threatening the cotton market.[133]

The mills, for the short term, had plenty of cotton to keep operating. The long term was uncertain. Mill owners had to consider a number of hypothetical situations. If cotton became too expensive to grow, that is, if the cost of growing it exceeded its market value, what would happen? Farming was already in decline. Would farmers cease production and drive the market price beyond reason? Would that, in turn, result in more cotton growing and another market decline? Fortunately for the mills, the ban on cotton was lifted and wartime demand remained strong.

In December 1914, only a dozen or so exhibitors had committed to participate in the Greenville show. By the end of January, the cotton market had stabilized; the next month the state repealed the cotton reduction act. J.E. Sirrine volunteered his drafting room for the show space. Over the next nine months, the executive committee had to continually revise plans upward to accommodate the continuous stream of exhibitors who wanted to participate; 90 percent of the available floor

space was contracted two months before the show. The final location was the P&N Railway warehouse. As time for the exposition neared, in order to accommodate visitors, space in private homes and some dormitory space at Chicora College was obtained after the hotels were booked. When the show was held November 2–6, 169 exhibitors participated and an estimated 40,000, almost three times the city population, attended the show. For good reason did the county celebrate; this was the largest single event in Greenville's history. On opening day, mill whistles sounded throughout Greenville as the First Regiment Band of the Williamston Guard played for opening ceremonies. Governor Richard I. Manning addressed the exposition via long-distance telephone. The morning paper contained a map of Greenville titled "The eye of the South"; a footer accorded Greenville the title of "textile center of the south."[134]

The executive committee, thrilled with its tremendous success, decided the exposition would be a recurring event. To be held biennially, the exposition required sufficient floor space; a permanent exhibition hall was planned and in place for the next show. Located on the north side of West Washington Street, Textile Hall was begun in 1916 and completed in time for the second exposition. Greenville was selected as the site of the Southern office of the *Textile World Journal*. The question of moving to a larger city such as Atlanta came up in 1918. James A. Greer, southern manager of the periodical, had this to say: "I would not seriously consider any other city in the South as a competitor with Greenville."[135]

The United States was finally drawn into the European war in April 1917. During the initial buildup of the military, the mills were burdened by loss of manpower. To meet wartime demand, work schedules increased and more women came to the mills. Primarily working as machine operators performing non-skilled tasks, women in higher positions were almost unheard of until the Victor Monaghan Mills announced in August 1917 that the first woman in the South had been named overseer of the cloth room of one of the Victor Monaghan mills. Locally, 376 men were scheduled to leave for training within a month. If the war was of long duration, the company expected that "hundreds of women in this section will be replacing men in the more responsible positions leaving the men free to enter the ranks." And enter they did. David Clark, a Charlotte, North Carolina mill executive addressing a meeting of the Southern Textile Association in June 1918, said that data showed that "the cotton mill boys of the South have gone to war in larger proportions than any other one class…and they stood better examinations than any other class in the South." In May 1919, soldiers returning from the war were guests of honor at the third Southern Textile Exposition.[136]

THE COTTON MARKET AND THE ECONOMY

During the 1920s, although cotton was the organizing principal behind the South's

economy, its position had weakened. The abbreviated style of clothing worn during this decade compared with styles in the past required much less fabric. Rayon had been introduced and was en route to eventual competition with cotton. Cotton farmers found their efforts now thwarted additionally by a new obstacle: the boll weevil. Cotton mill owners perceived but couldn't do much about the delicate balance between too little and too much cotton, one resulting in prices too high to sustain manufacturing and the other in prices too low to keep farmers in the game. Mills sought security in diversification: garment manufacture, specialty fabrics and yarn and novel uses of cotton. Wool and silk processing were options as well. During the late 1920s and early 1930s, a statewide promotion of cotton encouraged its use whenever and wherever possible. In August 1932, Clemson College moved to support cotton by switching from wool to cotton shirts for cadets' uniforms.[137]

The decade of the twenties, while roaring for much of the American economy, remained less certain for the cotton textile industry. Expanded capacity to meet wartime demand resulted in overproduction and uncertainty in the domestic market. The price of raw cotton was on its way down to an unknown bottom after wartime highs of over forty cents a pound. Although forty-eight thousand bales of cotton were made in Greenville County in the 1920 season, county agent Chapman believed as much as five-sixths of it was being held for higher prices. It had dropped almost thirty cents a pound in a matter of months.[138]

Industry reaction to these conditions was to press onward. Cotton stabilized near prewar prices. Competition was fierce; mergers, new technology and efficiency expertise characterized the textiles during this decade. Nor was there any shortage of new startups. A number of textile projects were in the works by August 1923 within a twenty-mile radius of Greenville, all together totaling some $10 million in new building or improvement to existing enterprises. The new startups tended to reflect the sought-after diversity that had escaped the older, larger operations. Because of its central location, Greenville became the site of many regional offices of mills, textile suppliers and textile products jobbers. The textile expositions of the 1920s expanded and were adjudged highly successful by exhibitors and mill men alike.[139]

CORPORATE DEVELOPMENTS

Victor Monaghan, the company that emerged after the death of Lewis Parker, produced large dividends every year, attracting the interest of larger investors who mounted an attempt to take over the company in 1923. Of nine dividends declared since 1917, including four in 1920–21, the company had returned an astounding 116 percent in stock and cash to its owners. In the summer of 1923, Edwin F. Greene of Boston's Lockwood-Greene offered shareholders $148 a share.[140]

President Tom Marchant countered with a letter to stockholders, explaining why management opposed the offer. The offer was too low; on a per spindle basis, it would

Textile Hall.

cost almost three times what Greene was offering to build a new plant. Furthermore, there had been better offers for some of the mills in the chain. Additionally, Marchant reminded stockholders of the company's dividend history. Stockholders agreed with Marchant and held on to their shares. To further protect the company from future attempts at a takeover, the company used cash reserves to retire a fourth of its stock. The Victor Monaghan Company was probably as strong as any similar textile chain in the South during the 1920s, but the perennial problems associated with growth had weakened the appeal of cotton mill stock to investors. By 1926, the appraised value of a share of Victor Monaghan stock was 90 percent par value.[141]

Henry T. Crigler of Spartanburg, previously associated with Gossett Mills in Anderson, succeeded McMillan C. King in 1922 as president and treasurer. Crigler had been in the mercantile trade before getting into textiles.

The company enlarged and improved the village during the 1920s. When the village was originally built, the houses were spaced widely, giving villagers a spot to plant gardens or raise chickens. When more housing was needed, new construction was done between the earlier houses. A community house was built in 1920, the same year that electric lighting came to Pelham. New drinking fountains and toilet facilities were placed in the mill in 1922. Six houses on the village were remodeled that year.

Crigler and J.C. Stewart formed Enoree Converting Company, a subsidiary operation of Pelham Mills, in early spring 1927, which bleached, dyed and packed sewing thread

manufactured by Pelham Mills. A building on the property was fitted with the machinery. Vardry Mill, which once housed Sampson & Hall, located on the Reedy River, ceased manufacturing operations about 1923.[142]

Judson experienced dynamic change during the 1920s. In 1923 it became the first mill in the South to use rayon. Judson had woven silk-cotton blends as early as 1916. Judson expanded its silk production to a separate plant on the Easley Bridge Road in 1925 and constructed fifty houses for operatives. It became the first mill in the South to produce both warp and weft silk yarns. Judson was acquired by Garish Millikin of New York in 1927.[143]

About 1920, Nuckasee Manufacturing Company expanded its operations. It was sold twice in 1928 and the following year, becoming a part of the Union-Buffalo chain. As Nuckasee, it continued to operate into the mid-1950s in the Huguenot Mill. Carolina Blouse Company was its successor, also in the Huguenot Mill until a plant was later built.[144]

Beaver Duck Mills was transferred to Couch Cotton Mills June 26, 1920. S.A. Burts was president and B.J. Boddie, who had been superintendent for Beaver Duck Mills, continued in the same capacity. It remained in operation until 1923. Some time after that, the property fell into the hands of the National Bank of Charleston, which sold it to the Lullwater Syndicate of New York City. After doing business as Lullwater Manufacturing Company, it was sold to Westboro Weaving on a five-year installment basis in September 1934.[145]

J.H. Jenkins bought out Prospect Mill in 1921. Jenkins bought the real estate, the mill building and machinery, but Ernest J. DeCamps retained ownership of the dam, power plant and lines, leasing these to Jenkins. Jenkins Mill was incorporated August 1921, principal officers being J.H. Jenkins and W.H. Gray of Woodruff. It was initially capitalized at $25,000; the authorized amount was doubled by the end of October. Ernest J. DeCamps moved to Beaufort, where he became manager of a large truck farm.[146]

Jenkins and Gray had hoped to produce cloth but were unable to raise enough capital to equip the mill; only $5,000 was ever raised toward the authorized capitalization. Jenkins Mill continued to process wastes into low-grade yarn. During the mid-1920s, G.H. Scruggs, one of the directors, took the mill and manufactured industrial mops. Finally, beset by debt and impossibly low revenues, the mill petitioned for bankruptcy, which was granted July 19, 1928.[147]

Union Bleachery's charter renewed with a capitalization of $400,000, increased to $1,200,000 in December 1922. In 1929, the physical plant was in the midst of being enlarged. Completed, it was the largest finishing plant in the South with a capacity of two million yards of gray goods per week. It employed three hundred workers.[148]

NEW OPERATIONS

Okeh Manufacturing Company was renamed Riverdale Mills in January 1920. Located

Greenville Cotton Mills Company, distributor's billhead.

on the Cedar Lane Road north of Monaghan, it had twenty-five hundred spindles and its authorized capitalization had been increased to $200,000. F.H. Cunningham continued as president through 1922.[149]

Taylors Station, located about five miles east of Greenville, was farmland largely belonging to the Alfred Taylor family. The tiny business section of the community was almost entirely devoted to the cotton trade. By the 1920s, sufficient land there became available for industrial development. In 1922, the Southern Bleachery Company bought property adjacent to the Enoree River as well as railroad property, where it built the county's second bleachery. Operations began May 14, 1924, and Taylors began to evolve as a cotton mill town, the influence of the mill slowly taking precedence over the community's identity as a farmers' town. Forty-eight houses were built, as were churches and a company store.[150]

Brandon Duck Mill was completed in November 1922. It was the only mill of its kind in the South, producing heavy woven cotton duck cloth at the rate of fifty tons per week. River Mills, organized in late 1924 by Claude Ramseur and J.R. McDonald, processed clean work waste of all types, jute, cotton and wool. It advertised custom willowing and likely contracted for wastes from various mills. It

JOS. B. WARNE
SALES AGENT
40 WORTH ST., N. Y.

SOUTHERN BLEACHERY
———INCORPORATED———
TAYLORS, S. C.

Clifton Mfg.Co.,
Clifton, S.C. Dr. Nov, 3 1933.

CLAIMS WILL NOT BE CONSIDERED ON FINISHED GOODS THAT HAVE BEEN CUT. ALL AGREEMENTS CONTINGENT UPON STRIKES, ACCIDENTS
OR OTHER REASONABLE CAUSES BEYOND OUR CONTROL. CLERICAL ERRORS SUBJECT TO CORRECTION.
FOR FINISHING FOLLOWING GOODS. TERMS: CASH, ON OR BEFORE 15TH OF MONTH FOLLOWING DATE OF INVOICE

LOT NO.	NO. PKGS.		COLOR	YARDS	PRICE				
		Baling Ties	–	3660#	.005				18.30

Southern Bleachery billhead.

was capitalized at $20,000.[151]

Southern Weaving was organized in 1924 by J.W. Burnett and F.D. Murdock to produce narrow fabric. Between forty and fifty employees ran looms in the old Shambo Shuttle Plant. Burnett brought years of experience from positions he held at Tucapau, Gaffney and Chesnee mills; Murdock recognized the untapped market for webbing and tapes. Southern Weaving expanded its operations in 1928 and again in 1931.[152]

Piedmont Plush Mill was established by Frederick Symmes and Clifton Corley as the first plush mill in the state. Located on the Easley Bridge Road, it manufactured high-quality velvet fabric for use in the upholstery market, one of the earliest well-defined niche market manufacturers in Greenville. It began operations in spring 1926. Capitalized at $225,000, the mill was approximately twelve thousand square feet.[153]

Piedmont Print Works was established in February 1928 on a tract of land adjacent to Southern Bleachery in Taylors, bought for just over $20,000. The company constructed a processing plant and remained in business until it merged with Southern Bleachery in 1936, becoming Southern Bleachery and Print Works.[154]

St. John Manufacturing Company was organized in 1928, chartered November 19. J.M. St. John was president. Capitalization was $25,000; the company was a tubing and garment manufacturer. Southern Pile Fabric Company was organized in 1928 by W.H. and Marshall A. Brooks of Philadelphia and James Cullen of Greenville. It had thirty-two looms for upholstery, velour and plush. Capitalized at $100,000, the company bought

cotton and rayon yarns and produced the finished product. Brooks Brothers Company opened with fifty-six looms.[155]

Palmetto Print Works, organized by John W. Arrington of Greenville and John R. Hart of York, was capitalized at $500,000; it filed a certificate of dissolution by 1939. Wilson Thread Company, a yarn manufacturer, was organized by Eugene Bryant and F.D. Rainey in 1927. Capitalized at $5,000, its directors included Kerr Wilson and Allen J. Graham. Franklin Process Mills, a Rhode Island company established in 1900, built a plant between Dunean and Mills Mill off Green Avenue in 1922. Not strictly a textile company, it was a yarn-dying operation. However, it created a small village of twenty houses or so on McGarrity Street to house employees who probably numbered around fifty at start up.[156]

The first woolen garment-quality cloth woven in the South was produced just outside of Greenville at Paris on the old Camp Sevier property in early May 1924. Southern Worsted Corporation's plant was located beside the Piedmont and Northern Railroad. Bennett E. Geer, president of Judson Mills, led the organization of the woolen mill in 1923. Construction of the fifty-thousand-square-foot mill plus forty six-room houses for operatives was complete within the year. The number of houses was later increased to eighty-four. The plant was one story tall, encompassing over a hundred thousand square feet of floor space. At full operation, about one hundred thousand pounds of wool would be required in the plant at all times. Projected sales from the plant were estimated at $50,000 per week; goods were produced by about two hundred employees.[157]

Nuckasee Manufacturing Company increased capitalization for the third time in 1924, to $200,000. Controlling interest in the company was sold to Hampshire Underwear and Hosiery Company about 1928; the plant again changed hands, becoming a part of Union Buffalo Mills in 1929. American Spinning was sold in 1927 to Florence Mill of Forest City, North Carolina. J.H. Morgan, superintendent for the past thirty years, was forced into retirement because of his age (he was seventy-eight). He had an exemplary record of renewing the machinery and earning sufficient profits to repay the original invested capital 600 percent.[158]

Slater Mill formed the center of the community that outlived the mill north of Travelers Rest, beginning in late 1927. Built as a "community experiment" at the inspiration and under the guidance of H.N. Slater III of Webster, Massachusetts, the Slater Community was based upon variations of the old New England model mill village. The mill, constructed in 1928, had a start-up capacity of fifty thousand yards of cloth per day. Original village housing consisted of 110 units, increased to about 170 units by 1940. Slater had a small silk mill in operation by late 1932. J.R. Wood was overseer.[159]

Brandon Corporation was organized in 1928 with four plants: Brandon Mill of Greenville, Brandon Duck Mill, Brandon Plant of Woodruff and Poinsett Mill. Augustus W. Smith was president. The corporation constructed a bleachery, Renfrew Plant, at Travelers Rest. The selling agent for Brandon Corporation was Baldwin &

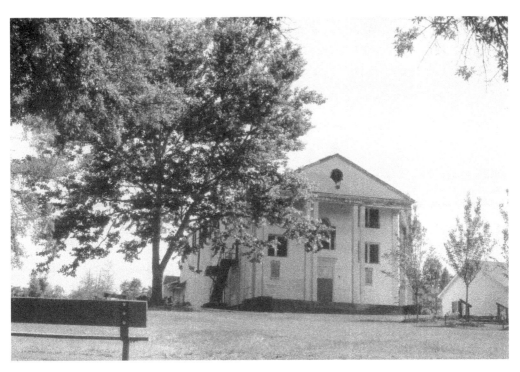

Slater Hall.

Company of New York.[160]

Renfrew Bleachery was the final mill built in Greenville County before the Depression. It began operation in 1928 with two hundred employees. Production began in January 1929, under Superintendent C.T. Turtelot. Renfrew, built by the Brandon Corporation, was a move toward complete vertical integration, thus solidifying its base for marketing.[161]

THE SOUTHERN TEXTILE EXPOSITIONS

The Southern Textile Exposition continued to attract thousands more to Greenville than the hotels could accommodate. In 1920, Mrs. W.G. Sirrine, wife of the president of the exposition, headed up a housing committee that secured about four thousand rooms in private homes for visitors otherwise unable to find a room. Two hundred exhibits valued at over $2 million were displayed. A group of Chinese financiers and manufacturers contracted to buy $50 million worth of machinery for Shanghai factories.[162]

The expositions mirrored the industry in that each one outdid the previous one. As they grew in number of exhibitors and attendance, attention of the directors focused on how to accommodate larger events. Even in 1922, Textile Hall was cramped for space. For the 1924 show, a permanent annex was constructed. The eighth exposition, in November 1926, was attended by twenty-five thousand people, some of whom booked

advance hotel accommodations for the 1928 show. The theme of the ninth exposition was cotton processing; a working cotton gin was displayed with all other phases of the manufacture through the finished product.[163]

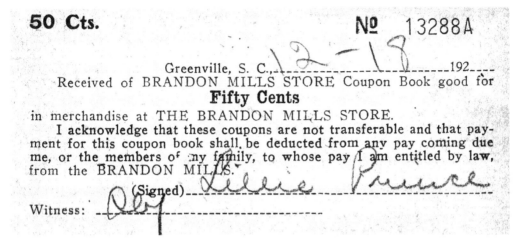

Brandon store scrip.

Chapter Five

LIFE IN THE MILL VILLAGE

In one respect the cotton mill communities of Greenville County did not change appreciably from the earliest days of the industry through the mid-twentieth century. Earliest mills were located where waterpower was available and adaptable to a mill shaft. If the proprietor managed to get a toehold in local commerce, he remained in business long enough for a road to develop and perhaps some settlement of the countryside. Once viability of the factory was established, the owner might construct necessary shops, perhaps a store, other needed buildings and cottages, which is what William Bates and Vardry McBee did near their respective mills. The earliest mill communities more or less came together when all the requisite factors were present, unlike the post–Civil War mill villages, which were constructed in a package, according to the Northern model. The early mills drew labor from the farms in the countryside and did not require village housing. John Weaver's mill

community was so scattered as to be unidentifiable as such.

Housing increasingly became the responsibility of the company, as did churches, schools and stores, but the relative isolation and self-sufficiency of the village persisted, even when more dependable sources of power permitted locations nearer established centers of commerce. By 1900, when Greenville had acquired a semicircle of impressive mills built just outside the city limits, their villages remained isolated, self-sufficient and possessed of a society quite distinct from that of their host city.

Later mills provided a place of work, a place to worship, to buy goods and to send children to school, all within walking distance of the cottage that the mill provided for a nominal rent. There was little need for an operative or his family to venture out of the village. The village was safe from crime and safe from outsiders. Since virtually all villagers shared a common race, background and economic status, intruders were easily identifiable, immediately suspect and carefully watched when they happened into the village.

In time, the second generation was born into the village, heirs to the same values, outlooks and prospects of their parents. The second and third and later generations knew nothing of the old ways, the farming life nor the expanses of trees and fields except what they had been told by their elders. What had brought their parents and grandparents to the mill village had been lives of desperation, so there were few elements of nostalgia among the villagers. The later generations established the distinctive cotton mill culture, for they had little to build upon save their own experiences. The mill villages were places of refuge for a majority of the inhabitants of the first generation. As long as they lived, there remained significant and, occasionally, consequential links to the old life: family who chose to remain on the farm; the church and burial ground; the whiskey so common in the previous culture.

Eventually, the pressures of assimilation took a toll on the mill village culture. Almost from the beginning, mill owners, town folk, reformers and politicians encouraged, urged and legislated change in the mill ways of life. Assimilation became fact, but much later, and in ways not foreseen by its promoters.

JOB, HOUSE AND WAGE

In Greenville County mills, jobs were easy to come by most of the time between 1874 and 1920. Labor shortages combined with almost constant growth of the industry created this situation. Informality of hiring procedures prevailed at most mills, meaning that a job applied for could often be started the same day. Applicants approached the superintendent or departmental boss directly. Overseers often hired "spare hands" beyond the actual number of jobs available in order to deal with a high rate of transience among operatives. Generally, if hired as a spare hand, however, the employee had to work up to a regular job before he had a chance to rent a house.

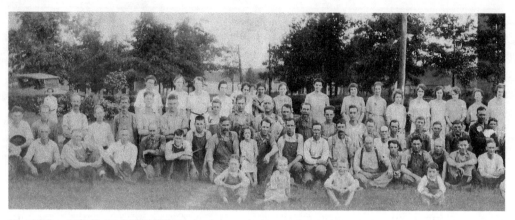

Part of day shift, Greer Mill, 1918.

Housing was reserved for families; single operatives were expected to board with a family that had sufficient room. Houses were rented at nominal rates, usually around twenty-five to fifty cents per room per week. There was a tacit understanding between the company and the workers that each household would supply one operative per room rented.

A typical village house in 1910 was constructed of rough lumber put together in the form of a box. The high-pitched roof aided in ventilation, especially in summer, but the un-insulated houses were drafty in cold weather. The exterior was weatherboarding and most often unpainted. A privy was in the corner of the yard and was constructed of the same materials as the house. It was cleaned as needed by men who drove the "honey wagon." Water was piped in cold, to the back porch or kitchen. Lighting was most often a single bulb on a long cord dangling from the middle of the ceiling in one or two rooms. The company generally did not charge for electricity unless monthly usage exceeded a few kilowatts. Warmth in winter was supplied by a wood heater centrally located, plus the cook stove in the kitchen. Fuel was available through the company store at between two and three dollars per cord. Cooling was accomplished by raising the windows and opening the doors. It was simple, it was strong and it was home. It belonged to the family as long as they worked in the mill. For the majority of mill operatives, it was a better house than they had ever known. Housing was usually in short supply and for large families, conditions could be crowded. Monaghan village, in 1907, averaged 8.57 residents per house.[164]

Often the house lot was sufficiently large enough that a small garden could be cultivated and space was available for a cow or chickens. Some mills, like Greer Manufacturing and Pelham Mill, provided a common pasture for all livestock except fowl. Monaghan's village population of 18,000 supported 125 cows. At Piedmont, two out of three operatives owned a cow, including one man who had 9 cows grazing in one of the company's four pastures. Piedmont furnished stables for livestock and room to raise hogs. Near the boiler

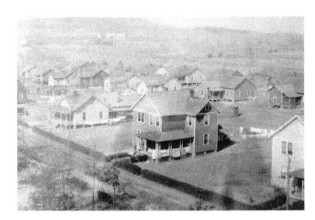

Greer Mill village, 1919.

room of the mill, in the fall of the year at hog-killing time, the company provided a shallow steel tank with steam and hot water to process the carcasses.[165]

Promise of a regular wage drew men and women from the country and the hills. Whereas the farmer had a single payday each year at harvest, the mills paid off weekly, biweekly or monthly. Pelham paid off in cash at the paymaster's window; Poe Mill paid off on the first and the fifteenth of the month using pay envelopes; Victor Monaghan mills paid weekly, also using envelopes. Pay rates reflected the skill and the sex of the worker. In 1917, the lowest paying jobs at Victor Monaghan mills earned a nickel an hour while skilled loom fixers made a quarter. The average operative earned between $1.10 and $1.75 per day while the boss spinner or weaver in a large mill could expect $1,500 a year or $4.00 to $5.00 a day. Women, as a rule, continued to earn at a lesser rate than men, although technology had virtually eliminated the distinction in machine departments between "men's" work and "women's" work.[166]

When payday came, payment received reflected any credit transactions the operative had with the company store since the last payday. Mills with a company store extended credit during the interval and some employees used their credit entirely before payday arrived. For company record keeping and to satisfy auditors, all employees were given pay envelopes with hours, wages earned, debts and net paid. Workers generally signed or put their mark on a receipt to the company showing they had been paid. This was especially important when employees received nothing on payday. Employees who received empty envelopes on payday had a squiggly line in the net box and they were said to have "drawn a worm" instead of money. Children's pay was most often given to a parent, who signed the child's name on the receipt. Operatives were typically paid in arrears. When an employee first came to work, companies typically held back a week's wages to assure the employee would give notice before quitting and to give the store time to catch up accounts.[167]

CHURCH AND SCHOOL

In Greenville County, churches were associated with cotton mills from the beginnings of the industry. Hutchings, Bates and Lester supported community churches where operatives attended services. Bates's successors continued to do so. August Kohn found that Batesville Manufacturing Company, the smallest and weakest cotton mill in the county at the turn of the century, still managed to support, in part, a school and a church, maintain a small library and give an additional twenty dollars a year to the pastor of the church.[168]

It was in the interest of the mills to find ways to attract and keep dependable and skilled operatives. Piedmont Manufacturing Company set the earliest standard for mill communities by seeing to it that the basic needs of operatives were met, if at all possible. Additionally, the presence of a church added the potential for uplifting and enriching the lives of operatives as well as bringing to the village a symbol of authority and stability that was universally respected.

Practically without exception, the mills dating from Hutchings Factory through Refrew Bleachery provided a church or two for operatives. Many mill companies continued some form of support after the Second World War and up to the point when the villages were sold. If the company could afford it, both a Baptist and a Methodist church were provided, as at the Brandon and Victor Monaghan Mills. Where funds or social conscience were more limited, a union church was built and shared by the congregations represented in the village until one of the congregations raised enough money to pay for its own building, which was still most often located on company property.

Whether the mill churches were intended by mill owners to be completely independent of company influence is hard to say. All of the early mill village churches were Protestant and deeply aligned with the doctrine of free will. Between 1880 and the sale of the villages during the 1950s, it was frequently the case that church leaders were also mill bosses. A possible measure of independence is survival; of the mill churches organized in the county since 1880, virtually all still exist in 2006.

Education was presented as an opportunity, not a requisite, on the mill village. Most of the larger mills constructed substantial elementary school buildings, staffed them with competent teachers who were often paid at a higher rate than public school educators and left it up to parents whether or not children would attend. Smaller mills supported more modest schools or none at all. Greer Manufacturing's original school was held in an empty village house. Franklin had no school of its own but the free session of the local public school was a quarter-mile away.

Many mills also provided alternative and additional educational opportunities in the form of classes in non-academic subjects, night classes and libraries. At the turn of the century, Piedmont had a lending library of 3,316 books with a monthly circulation of 634. Reedy River Mill had a library of 5,000 volumes. Beginning in 1914, the Textile Expositions held in Greenville added a dimension of knowledge to any operative who was interested. And by 1916, general adult education and specific

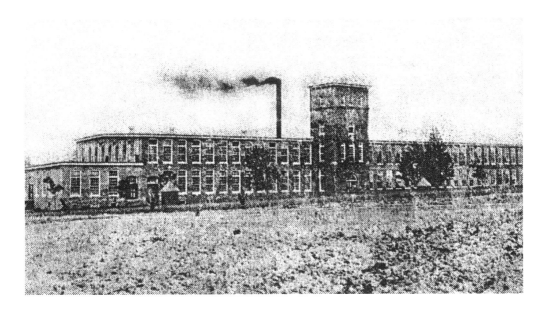

Franklin Mill. *Courtesy of the* Greer Citizen.

mill-related courses were offered at many mills across the upstate, Victor Monaghan Company leading the way.[169]

One of the greatest social initiatives arising in the South during the 1920s occurred in Greenville and gained notoriety for its controversy and for its successes. The boldest implementation of progressive education in the South occurred within a school district formed from the villages of nine mills abutting the city limits of Greenville. Parker School District, under the leadership of Lawrence P. Hollis, superintendent, brought into the district leading advocates of the sweeping educational movement based upon John Dewey's pragmatic philosophy. Here the traditional curriculum was revamped to reflect greater emphasis upon individual learning and citizenship.

The grand experiment may have been partly inspired by the success of the Textile Industrial Institute created by David Camak in Spartanburg. A friend of Hollis's, Camak approached Thomas Parker in 1910 with a plan for a part-time school system. Parker thought the plan would demoralize full-time help and declined. Camak found a sponsor in Walter Montgomery of Spartan Mills and the school opened in September 1911, oriented at educating the mountain folk recruited to the mills.[170]

In the Parker District, students attended school on a regular schedule but at the same time prepared through their studies for the world of work. Students received instruction in vocational technologies along with a reasonable amount of purely academic subject matter. Focusing upon the child's interests, the highly experimental program attracted national attention. Academic studies focused upon the language arts and fundamentals of mathematics. Practical subject matters including shop

techniques, electricity and home economics were supplemented by physical activities. Well before the soccer moms of the county became a political force in the 1990s, Pete Hollis introduced the sport throughout his district. The unique approach of the Parker program continued for some three decades until the Parker District was absorbed into the unitary Greenville County District in the early 1950s. Only then did the curriculum undergo considerable change.[171]

The Parker District educated children for a life not too unlike the one they had known; it was anticipated that a fair number of children would continue to live at the local village and work in the mill, as had their parents. In a real sense, the progressivism of the Parker District might be described as paternalism wearing a mask. However, the idea was a rage among avant-garde educators for many years. The Parker District completed a child's education for roughly 80 percent of the cost of the Greenville city schools.[172]

The Parker District was more than an educational experiment; it was nothing less than a consolidation of the Greenville mill villages, at least in spirit. The petty competitions that had marked the villages of a generation earlier gave way to cooperation and a deep sense of the larger community. It was a step, it can be argued, toward the final assimilation of the sometimes rough-hewn mill class into a Greenville that had undergone reciprocal change from having endured industrialization. The school district brought the youth of the villages together on one level; the newspaper, *The Parker Progress*, aided the process of unifying the adults. *The Parker Progress* was published only three years under that name but it was continued in substance as the *Greenville County Observer*, the *Greenville Observer* and the *Observer* through 1967.[173]

CAMARADERIE AND RECREATION

Before organized sports became synonymous with recreation in the mill villages, camaraderie was served through the fraternal orders that proliferated on the mill villages. Fraternal organizations were popular, especially in the larger mill villages. Membership was largely but not exclusively drawn from the village. Pelham during the 1880s had several such organizations, including the International Order of Odd Fellows, the Grange and the Good Templars. The company built a social hall exclusively for meetings. Masonic lodges were popular in suburban Greenville villages. Secret orders proliferated on the villages after 1900. Monaghan had a large Masonic chapter and order of Eastern Star. Brandon and Poe also had Masonic lodges. Redmen chapters were organized at Sampson, Monaghan, Victor and Poinsett. The Woodmen of the World were represented at Monaghan and Brandon. The Junior Order of United American Mechanics had chapters at Brandon, Poe, Monaghan and Victor.[174]

Sports became an important feature of mill village life by the 1890s. Many of the earliest workers were unfamiliar with organized sports, having arrived from the mountains. Competitive spirit, however, was not lacking and it was short order before

baseball games were played at the newest mills, with teams made up of the most recent migrants from the mountains. By the 1890s, teams were organized and sponsored by the mill companies. Serious competition among the mill teams led to mill league baseball as a semi-pro sport. The best players received wages for their ability on the diamond as well as their work in the mill.

The Greenville mills produced some exceptional players over the years; most notable was "Shoeless Joe" Jackson. Jackson played for Brandon and other teams on the mill circuit before he was signed to play professional ball. His batting average has withstood the test of time, although he was tainted in the "Black Sox" scandal of 1919 and barred from the professional game.

The mill leagues underwent several reorganizations. Each came with a different set of rules and there was considerable discussion over what constituted professionalism in the mill leagues. The best players had always received a salary, special job or other consideration. Outstanding players like Jackson regularly pocketed more for baseball in a week than in mill wages. When the teams were reorganized in 1919, some caps on salaries were imposed as follows: thirty dollars for catcher, twenty dollars on infield and outfield and no limit on the pitcher's salary. The 1919 season lasted from April 19 to July 19.[175]

Sports were a powerful unifier of a community. Baseball was so important to Pelham social life that a team from the community played in the various mill leagues and, later, the Industrial League from 1899, when Pelham won a league championship, to almost twenty years after the mill closed down. Sampson continued to do likewise, playing in the Piedmont Textile League as late as 1955.[176]

THE "Y"

The Young Men's Christian Association (YMCA), organized in England, was introduced to the United States in 1851. For over a half century, the YMCA or "Y" was closely associated with town life until 1904, when the organization was introduced to mill villages. Lewis W. Parker had, in 1898, employed two representatives of the YMCA to conduct welfare work on the mill villages in which he had an interest. Impressed with their work and dedication, he arranged to have a YMCA established at Monaghan. A Young Women's Christian Association (YWCA) followed at Monaghan and other villages. That was the first such organization at a Southern cotton mill. The Monaghan YMCA was three stories tall and had a library and meeting rooms. The aim of the YMCA was to provide wholesome recreation, entertainment and educational experiences to young men in a Christian environment. But the mill village YMCAs provided even the basics. Running water was not available to all mill houses until the 1920s and then it was only cold water; however, by about 1910, most of the mill YMCAs provided shower rooms for the men. Mill YMCAs before the Second World War were used to further YMCA philosophy but also as entertainment centers, and became increasingly secularized after the Second World War. On the village, the

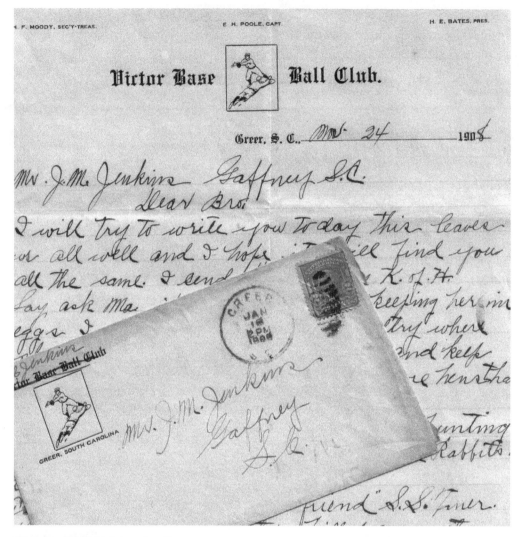

Victor Base Ball Club letterhead.

recreation building continued to be called the "Y" long after the affiliation with the parent organization ceased.[177]

Sports became an integral part of the offerings of the mill YMCAs after the arrival at Monaghan of a "slender young fellow" named Peter Hollis. He was brought to Monaghan by President Thomas F. Parker shortly after the opening of the Young Men's Christian Association as assistant secretary to Mr. I.E. Umger, who resigned unexpectedly that fall. Hollis was asked to take his position. The agreement between the mills and the National YMCA gave the organization final say in approving local leaders. Hollis was required to take additional training at the YMCA training center in New York for two summers. There he met Lewis Naismith, an instructor, who also

Women's basketball
team, Greer Mill,
1922.

happened to be the inventor of basketball. Hollis brought the game back to Monaghan, where it was enthusiastically adopted. Hollis was not exceptionally oriented toward sports but rather toward the whole concept and program of the YMCA. He was described as energetic, creative and charismatic. In 1911, he was named director of welfare for the newly organized Parker Group.[178]

BASKETBALL

After Hollis introduced the sport, it caught on like wildfire. The Southern Textile Athletic Association was formed October 22, 1920, to promote amateur athletics to Southern cotton mill villages. The organization was developed at the Southern Textile Exposition, where thirty-two teams committed to participate in a basketball tournament the next year. W.V. Martin of Spartanburg was the first president; L.P. Hollis was vice-president. Basketball mania proliferated during the late 1920s and early 1930s. The Textile Basketball Tournament began in 1921 with a dozen teams taking part. The only non-local team was from Danville, Virginia. Over the next twenty years, teams from North Carolina, Virginia, Tennessee, Alabama and Georgia participated. By the 1940s the tournament had grown to attract large crowds, many of whom had no direct connection with the industry. If the mill hills of Greenville had any advantage over the towns besides schools, it was in the area of equality of the sexes. Women made up a significant part of the workforces. When, by the 1920s, women received the right to vote, they were expected to participate in the organized sport of basketball. Textile basketball, though, was not without controversy. Perceiving the uniform shorts to be too immodest, the North Greenville Baptist Association in February

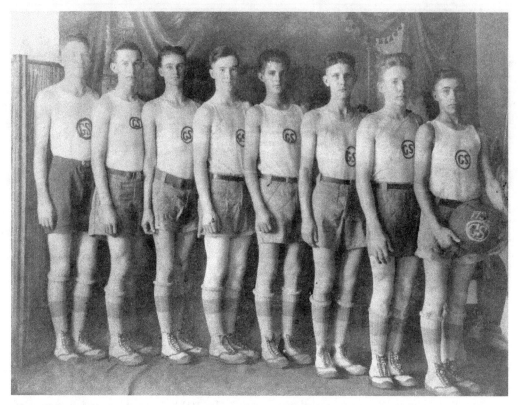

Men's basketball team, Greer Mill, 1922.

1934 voted to condemn the Textile Tournament and the formal dress of its players.[179]

OTHER SPORTS AND RECREATION AND HOLIDAYS

Company acknowledgement of community values was an important factor in the building of loyal villages. Christmas celebrations had been minimal for most of the mountain and country recruits to the cotton mills. As the holiday became increasingly significant, mill companies often gave the day off and arranged a meal or a party. The Victor Monaghan Company instituted the tradition of giving fruit bags to village children. Each child received an individual bag that contained, in addition to apples and oranges, a variety of nuts and hard candies. Union Bleachery held a Christmas party for operatives' families in the community building.[180]

Independence Day was one of the largest celebrations in the mill villages. Sometimes but not always coinciding with a summer shutdown for maintenance and repairs, the Fourth was filled with activity at most of the Greenville villages. The Fourth was celebrated at Monaghan in 1904 with patriotic observances, including the raising of a

flag to the top of a new eighty-foot yellow pine pole placed atop the mill the week before. At Reedy River Factory, the Greenville Sluggers played the Reedy River Kids in a game of baseball, Greenville winning six to five. There were also races, clay pigeon shooting, a tug of war and a meal, after which Greenville attorney L.O. Patterson addressed the crowd. Poe Mill celebrated with a combination of speechmaking and fun. Field sports, speeches and free lemonade rounded out the celebration sponsored by Lodge 52 of the Junior Order of United Mechanics.[181]

Community fairs had been a part of the farming tradition since the 1870s. At the mill villages, these seem to have originated after the turn of the twentieth century. The prototype that was used as a model for later fairs by the Victor Monaghan Company was the Victor Fair and Exposition. The event held in September 1910 was organized around exhibitions from and contests between ten departments, each of which exhibited its product in the mills; prizes were awarded. L.P. Hollis liked the idea and the village fair concept was exported to other mills in the Parker chain, beginning in 1912, scheduled and organized by operatives. Other mills adopted the idea and continued fairs for many years.[182]

Other sports competitions included swimming and golf. Swimming competitions did not involve the whole community of mills because of its requirements and limited scope. Golf had become popular by about 1930 among some textile workers. The first course in the area for mill workers was located at Taylors and owned and operated by Southern Bleachery. It had nine holes and fifty-two members from mill villages in Greer, Greenville and Spartanburg. Greer Mill constructed a golf course by 1934; it was laid out in the common pasture, which, still populated with a few cows at the time, offered a variety of hazards unseen on other golf courses. The Piedmont Golf Association, composed of Poe, Union Bleachery, Southern Bleachery, Slater and Greer, was formed in the spring of 1934.[183]

The two largest Greenville textile companies encouraged camping and outdoor recreation. Woodside Mills, as early as 1920, and the Victor Monaghan Company provided resort camps near the mountains for employee use during the 1920s. Wildwood was the camp for Woodside employees, several hundred acres located in Saluda Township. Camp Reasonover, the Victor Monaghan camp at Cedar Mountain, North Carolina, was also used for company retreats and holding seminars. Tent camping was free; cabins were available to employees for three to five dollars per week.[184]

MILL VILLAGE POLITICS

Mill village residents regarded elections seriously and they usually registered a good turnout. Not that casting a ballot mattered much in terms of party politics. The Democratic Party had solidified the state and cotton mill operatives had as much reverence for Democratic solidarity as any other class of citizens. For those mill hands who had come of age on the village, their first participation in the elective process was likely influenced by opinions of overseers, supers and managers who voted in the interest of the mill. According to Lawrence P. Hollis, the "super" and the boss weaver had large

Cow in millhouse yard.

influence on how operatives voted. If "that persuasion wasn't enough there was always the dollar bill." Management ideas trickled down to the greenest citizens, who perhaps didn't see the big picture but did observe how their bosses voted. Evidence of bloc voting can be seen in the results of elections.[185]

Politicians became aware of the mill class and its significance in 1908. Coleman Blease, a former supporter of Ben Tillman turned reactionary, appealed to the mill operatives in his first bid for governor. He was elected the next time around in 1910 and continued to try to maintain mill village support throughout his political career. Although his popularity among the mill classes waned, even in textile Greenville during the 1930s, he established the precedent for pursuing the mill vote. Others followed.

J.J. McSwain gained his seat as representative of the Fourth Congressional District in part through his connections with fraternal organizations. He was an Oddfellow, Redman, Mason and Knight of Pythias, and possibly affiliated with other lodges. The fraternal groups were important to politicians as a means of access to the voters of the village. Much of McSwain's male and, no doubt, some of his female constituents were members of one such group or another. In April 1906, Mayor G. Heyward Mahon, to further his bid for Congress, picked a team of ball players from Greenville teams and challenged Tucapau as a publicity stunt.[186]

Clarence Erbin Sloan was one of the more colorful, if unsophisticated, elected officials who actively sought the mill vote. A farmer from the Jordan community, Sloan was outspoken and held strong opinions. Better known as "the Mountain Lion," he presented himself as a friend of the working class. He promised voters in the campaign of 1924 that "if I am elected, I'm going down there [Columbia] and get mine and if there's any left after I get mine, you all can have it." Sloan was a true Democrat, campaigning wherever he could find a crowd, the streets, cafés and even at cockfights. While outwardly colorful and loquacious, Sloan's serious side reflected deep, almost puritanical values. He was

Baptist, conservative and close to the electorate in its popular conception of how politics functioned at the state level. After overcoming a certain naïveté, Sloan supported bills designed to prohibit operation of public swimming pools on the Sabbath, to guarantee that Greenville county tax money was spent in the county and he opposed additional regulation imposed on the private citizen. Following this last principle, he fought the licensing of chiropractors, hunters and fishermen. He worked for legislation to aid the mill, supporting measures aimed at requiring ventilation and fire protection and fixing the hours of labor in textile mills. In 1932, he defeated Joseph Bryson for a Senate seat. That campaign included a fistfight with Representative J. Harvey Cleveland at a stump meeting near Renfrew Bleachery at Travelers Rest.[187]

T.E. Christenberry, running for the office of clerk of court in 1928, strolled over Greer mill village talking to individuals, shaking hands and passing out cash to supply "drinks for the boys." He was elected. When W.T. Snow ran unsuccessfully for sheriff, he was escorted through the mill during working hours to meet prospective supporters and voice his views.[188]

The Company Store

The earliest cotton mill company store in Greenville County appears to have been that of Vardry McBee at his Reedy River factory, operating as early as the 1830s. Other company stores showed up after the War Between the States at Piedmont, Batesville and Pelham. The function of the company store was originally to provide the basic necessities for operatives at factories located a distance from a town or country store. Employees could make purchases against future wages and have the debt settled on the next payday. Stores varied in their size, ownership, selection of goods carried and additional services provided.

Across the cotton textile belt, about 70 percent of the mills operated stores for their employees. Stores were generally one of two major types: company-owned and company-operated or company-sponsored and privately operated. In Greenville County, most company stores were the first type, although the first type sometimes evolved into the second, as was the case at Pelham. Vardry McBee owned stores at two locations for the benefit of his operatives, one at the mill site and one in Greenville. At Batesville, J.W. Baker retained ownership of the store that cooperated with the mill management, Baker's in-laws. Pelham's original store was company-owned and large enough to keep a staff of from three to six clerks. Stores at Dunean, Judson and Woodside are examples of the second type. At Dunean, the store operated as the People's Supply Store. The Judson Mills Store began operations in 1915. Organized by T.C. Cleveland and F.R. Rice, it was capitalized at $5,000. At Woodside, the Crosswell brothers, H.M., Gower and G.C., organized an ambitious general merchandise store in 1920. Authorized capital was $100,000. It operated branches at each of the plants in the Woodside Mills Company.[189]

The Poe Mill store was typical. It stood two stories tall and was long and narrow. A covered front porch with chairs suggested a relaxed atmosphere. A large variety of merchandise was available including fresh meat, produce, canned goods, drugs and hardware. Most stores also offered a selection of work clothes and shoes and tobacco products. Coal, kerosene and wood were available to operatives at the company's cost, or so it was said.

Company stores varied in size and attractiveness. Older stores such as Poe, Brandon and Monaghan were constructed in a nondescript, economical and box-like manner, in anticipation of doing business with a large workforce. The last of the company stores, the Brandon Corporation's Renfrew, was also volume efficient but with attention given to the exterior. Shrubs were planted along the side and rollout canvas awnings shaded the large show window in front. Renfrew's interior was well lighted with windows on three sides and contained oak and glass showcases for non-grocery merchandise.

For decades the earliest company stores kept accounts for each employee and reported all transactions to the company paymaster. This practice required considerable and accurate bookkeeping time. By the teens, mills began to experiment with other methods for conducting business. Brandon and Dunean issued coupon books, each coupon good for a purchase of a certain amount. Coupons signed by employees were collected and the face amounts deducted on payday. Monaghan, Poe, Southern Bleachery and Woodside issued tokens in various denominations, which could only be spent at the company store, like ordinary coinage. Problems cropped up almost immediately. Coupons were lost or stolen. A black market trade dealing in tokens developed in most mill villages. Critics of the cotton mill culture saw the use of scrip as a paternalistic restriction levied on the employees.

Critics of the company store prompted the American Cotton Manufacturer's Association to respond in 1934 by issuing a report answering charges of overpricing, wage docking, forced transactions and others all committed through the company store. Comparisons of prices were analyzed and found to be in line with private stores offering similar goods in nearby communities. In addition to countering charges, the document notes that after curtailment peaked in 1932, a result of the Depression, many mills simply cancelled employee accounts, something no merchant could have done.[190]

Chapter Six

REALITIES OF THE
MILL VILLAGE

The mills of Greenville reshaped local economy and provided an alternative way of life for a class of increasingly impoverished farmers and sharecroppers. Presence of the mills with their growing village populations restructured society and, to an extent, politics. The textile experience was vastly different from the life the mill operative had formerly known. Operatives found themselves concentrated with a group of their peers in a small but adequate environment where they retained as much of their old ways as possible. Time and new generations brought about final assimilation.

The cotton textile industry brought varying degrees of prosperity to each class; overall, the economic effects were positive. Greenville benefited from the presence of the mills. In retrospect, the tendency is to proclaim that the cotton mill experience was good and leave it at that. But there are legitimate questions about this era that center upon the actions of owners and managers. What were their motives; why did they operate in the particular ways they did? Were their successes rooted in methods and techniques that were regressive, which prevented the natural acculturation of their employees? What was the nature of paternalism that seems so well to characterize the cotton textile industry?

PATERNALISM

The cotton mill campaign and the era of progressivism overlapped from approximately 1890 to 1907. The larger progressive movement targeted reactionary institutions for change to be attained, when appropriate, through legislation. In general, and ironically, the Southern textile industry found itself in the sights of reformers and critics. At the heart of the progressive philosophy lay nothing less than the goal of reforming the human race in every way possible. The broad-based progressive movement never found a single

voice or even a few powerful advocates who supported a comprehensive agenda. It was left to the various special interests to expose the wrongs and lobby for correction within their chosen sector. Mill owners were generally not a part of this movement that swept over the country. They were, as a group, less interested in the progress of society as a whole than the progress and stability of their own mill village.

Severest criticism leveled at the Southern mill culture compared the life of the operative with that of the medieval serf living under feudalistic bondage. Paternalism robbed the operative of a future, as he became increasingly dependent upon the village for all his needs. Mill owners saw their program in a different light: a system of labor and welfare that raised the living standards of employees.[191]

In 1881, Henry P. Hammett, president of Piedmont Manufacturing, freely admitted that mills were built for profit first and "any benefit to the community...is always incidental and secondary." But he also considered of the greatest importance the proper "supervision of the operatives with reference to health, comfort, morale, efficiency and intellectual culture." He clearly demonstrated this interest by the diverse provisions he made for his employees, ranging from cow pastures to a lending library.[192]

Hammett's sentiments were echoed over the next thirty years; his approach to the higher needs of his workforce gave foundation to the generalized "welfare" philosophy that was adopted by many Southern mills and was prominent in mills based in Greenville County. Welfare capitalism was neither new nor was it restricted to the South, but it seems to have succeeded locally in both improving the condition of operatives and engendering their loyalty without, at the same time, provoking resentment or repressing their sense of independence. The social perspective of the mill owner was reflected in the type of welfare extended to the operatives. President Mary P. Gridley of Batesville was no doubt largely responsible for Batesville's sobriety; a temperance advocate and defender of traditional womanhood's associated values, she brought a chapter of the Band of Hope and the Loyal Legion to the village during the 1880s. The qualities that made a good mill hand also made that individual a good citizen.[193]

By 1900 the most ambitious welfare program in Greenville County had been in the works for several years under the guidance of Lewis W. Parker. Parker never discussed his personal philosophy directly; perhaps he had no strategic social vision. Perhaps through his "wisdom and goodness" he had come to agree with the common sentiment that industrialization would raise up the mountaineer, who made up the bulk of the workforce in Greenville and the Piedmont.[194]

When he created the Parker Group of cotton mills, Lewis Parker presented a plan to the Victor Mill Board of Directors that would have allowed operatives to buy their homes on the village on an installment basis. The directors voted it down. However, the company did subdivide part of its real estate and offered building lots to employees for several years beginning in 1912. Parker's motivation may have stemmed, in part, from his desire to run an efficient operation, but when he was asked about losing control over his people, he replied: "I cannot consider that; home ownership makes for good citizenship,

and I'm concerned for that first."[195]

William P. Few, dean of Trinity College, suggested model mills could become typical in the South if mill owners shared the philosophy of Lewis Parker. "All these reforms have been inaugurated not solely to increase dividends but on the theory that in the end they will pay, that the output will be larger and better as the quality and character of the laborer is improved."[196]

Thomas F. Parker, cousin and business partner of Lewis W., saw welfare not as an option but as a responsibility of the mills. In 1910, one out of every three people in the Greenville area lived on a mill village. This laboring class was naïve and unsophisticated and lacked sufficient welfare, which was the mills' duty. Thomas Parker suggested that if 1 percent of the capital of mills was spent on buildings and welfare programs to benefit the laborers, that expenditure would be paid back in terms of employee loyalty. There was no other source of financial aid to the operative class.[197]

The term paternalism is, at best, imprecise because mill owners held a range of attitudes toward their workforces. Paternalism in the basic sense, fatherly guidance, has degrees of application just as there are degrees of parental control of children. When Narciso Gonzales took Lewis Parker to task over child labor, he had a legitimate but singular focus. He failed to acknowledge the larger scene; he overlooked the fact that Parker created jobs, built churches and built schools that otherwise would never have existed, for better or worse. While some progressives saw their agendas wax and wane in the political climate of the early century, progress was being steadily accomplished on the mill villages through, if the term must be applied, benign paternalism.

The diversification of the welfare programs within the Parker chain increased dramatically after 1910. And with the passage of time, many of the programs that were common during the teens were phased out or became superfluous as schools or other organizations took on the responsibility. More formal adult education programs replaced lectures and slide shows. Village fairs and individual mill exhibitions had their season and disappeared as other forms of entertainment became available. Those activities strictly tied to the mill villages and available only to employees became fewer and the new programs increasingly were generated spontaneously by the workers and caught on with little or no help from the management.

FACTORY DISCIPLINE

For the majority of the people who populated the work floors of cotton mills, there was little alternative: grow cotton and grow poor or get regular cash wages at one of the factories springing up all over. The cotton farmer began the year usually in February and ended it in November. He toiled from first light to last six days a week, seven if necessary. During lay-by he had a few weeks before first picking to finish up with his vegetable garden, dry apples, catch up on mending, shoeing and perhaps get up some fodder. After the last picking and hog killing he often had some weeks to sit, visit family and friends or

go to town. The cotton mill operative worked each day without regard to weather, where the work did not change; there were neither decisions nor priorities. The farmer hoped to earn in proportion to his effort but rarely did. There were bad years and bumper years. When he made a good crop, the cotton market punished him with lower prices. The operative earned either a set hourly wage or he worked on production; that is, he earned in direct proportion to his labor.

The horns, whistles and bells of cotton mills set the pace for life in the villages. At Pelham, it was a bell mounted in the main tower, which for over fifty years kept the village on schedule. When the workday was eleven hours, the five o'clock bell awakened the village. Forty-five minutes later the bell started workers toward the mill in order to be at the job when the six o'clock bell sounded. That bell set them in motion until the lunch bell signaled an hour's break at midday. At day's end, the bell sounded again; the day's final bell tolled at nine o'clock, the village equivalent to taps.[198]

Factory discipline took its toll among the independent-minded, the stubborn and the bored. Horseplay on the work floor was not tolerated for safety reasons. In the spinning room, a fast doffer could catch up his work for thirty minutes or more of rest time. In some departments it was possible to gain two hours on the job. Younger operatives, fighting boredom while waiting "on a side to come off," would often tag each other with a quill or bobbin when the overseer was looking elsewhere. The penalty for this sort of thing was a whipping for a child and discharge for an adult. Improved technology helped to eliminate horseplay by speeding up the jobs. By 1930, production pay and the efficiency studies had eliminated the likelihood of catching up on the job for longer than time to eat a quick meal or have a smoke.[199]

CHILD LABOR

Child labor was a fact of life in the cotton textile industry from antebellum days until 1917. Reformers and muckrakers were often frustrated that their columns and articles had so little influence upon this, one of their favorite themes among cotton mill problems. Mill owners explained, as opposed to justified, child labor in several ways. First of all, it was legal. Working in the mills was not materially different from the farm life from which most workers came. And it would be an infringement on parental authority to remove the child from the mill or place him in school. But there was a nagging insufficiency in these responses. Child labor was cheap labor. Was it necessary to employ children to reap the fantastic profits that had lured money into Southern mill investment?

There were various attempts to sort out the truth of the matter. In 1906 Gertrude Beeks, representing the National Civic Federation, studied conditions in Southeastern mills. Regarding child labor, she found that mills correctly identified it as a country tradition. Furthermore, the farming class, dominant in the legislature, provided inadequate school funding. Nor were child labor laws effective. Without factory inspection, they were practically unenforceable owing to the demand for labor and competitiveness of

factories. Self-policing by the mills did not work under those conditions.[200]

A handful of inspectors oversaw the mild regulations imposed by the state upon the industry during the early years of the century. Three years after Beeks's study, South Carolina had two inspectors to investigate the industries for possible violations; it required six months for inspectors Sloan and McDougal to visit the factories in about a third of the state. The scope of their work was to check complaints, investigate violations and write reports on the results of those investigations. Alexander McKelway and other members of the National Child Labor Committee were unable to relate the profit margin directly to child labor. After lobbying Congress and the president for twelve years, federal restrictions were finally imposed on the practice. However, the resistance to the legislation was concentrated in the Southeast, the textile belt.[201]

Parents exercised the final decisions for their children, but with some assistance from the company. Thomas Belcher moved his family of eight from the mountains in 1913 to a three-room "shotgun" house on Greer Mill village. He and three daughters went to work right away. To stand a chance of getting a larger house, he would need to supply another hand from his household. The eleven-year-old son went to the mill, learning from his father the craft of making and mending harnesses for the weave room. The child brought in fifty cents a day for a ten-hour shift; the family got a larger house the next year. Minnie Kirby's family moved from Motlow Creek to American Spinning village when it started up; she began her working life at age eight, also at the rate of a nickel an hour, which was paid to her parents.[202]

CONFLICTING VALUES: TOWN AND VILLAGE

By 1900, townsfolk recognized a class split between themselves and the increasing number of mill hands who sometimes and clumsily tried to mingle with the established society. There had been a hint of class division a quarter-century earlier at Camperdown.

A cultural gap was installed with the arrival of the first recruits from the mountains, which began in Greenville during the 1890s with a surge in mill building after the Panic of 1893. Neither group could quite figure out the other. Awareness of differences led to continued separation, made convenient given the concentration of countrymen on the outskirts of town and scattered about on county mill hills. Estrangement begot an atmosphere of distrust and alienation between town and mill populations. In the worst cases, forms of social discrimination were characterized by derisive comments, name-calling, discriminatory commercial practices and even occasional low-level violence. Much of the time it was the outside class, the mill class, who bore the brunt of ostracism. To be fair, however, the mill village by 1900 had become defensive and gained a reputation as a place to avoid. It was not the wisest course for a young man from Dunean village to wander into the Mills Mill village without good cause.

Occasionally, an outside force such as military threat temporarily united Greenville

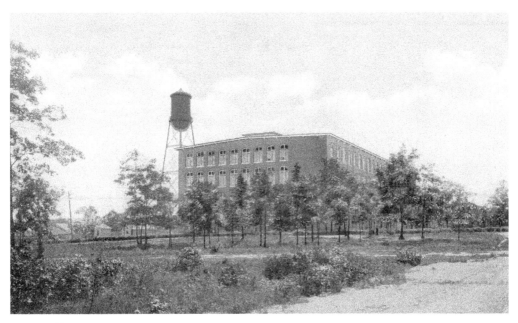

Greer Mill, circa 1930.

with its mill villages. After Reconstruction no single source of more authentically patriotic men could be found outside the South. The war had not settled matters entirely, but the indivisibility of union was accepted and hallowed; Southerners were ready to fight—die, if necessary—to preserve it. For thirty years, no opportunity to prove their loyalty had availed itself to Southern manhood. The Spanish-American War gave such opportunity. In Greenville, the Butler Guards, made up of whomever felt the call, shipped out for Columbia to await transfer to the front lines in Cuba in the spring of 1898. While at camp, Wade Hampton Parker, a twenty-two-year-old mill hand from Poe Manufacturing, became the first Greenville hero of the war when he contracted pneumonia and died in a Columbia hospital. Corporal Parker was returned to Greenville, where he was buried with both civilian and full military honors.[203]

Shortly after the war with Spain, Alester G. Furman estimated that 60 percent of Greenville's increase in property value could be attributed to the rise and expansion of the mills. Furthermore, he detected somewhat of a trend toward the assimilation of the mill class into the community, noting that within an eighteen-month period prior, just after the turn of the century, some eight hundred residential lots had been sold outside cotton mill villages. The realty business was particularly active near Poe, Woodside, Brandon and Monaghan Mills. The assimilation Alester G. Furman anticipated in 1904 was generally longed for by townspeople, but it did not occur then.[204]

Collectively and derisively labeled "lintheads" for the crown of dust and cotton lint they wore at day's end, the workers fit in well only on the mill village. Taylors Station

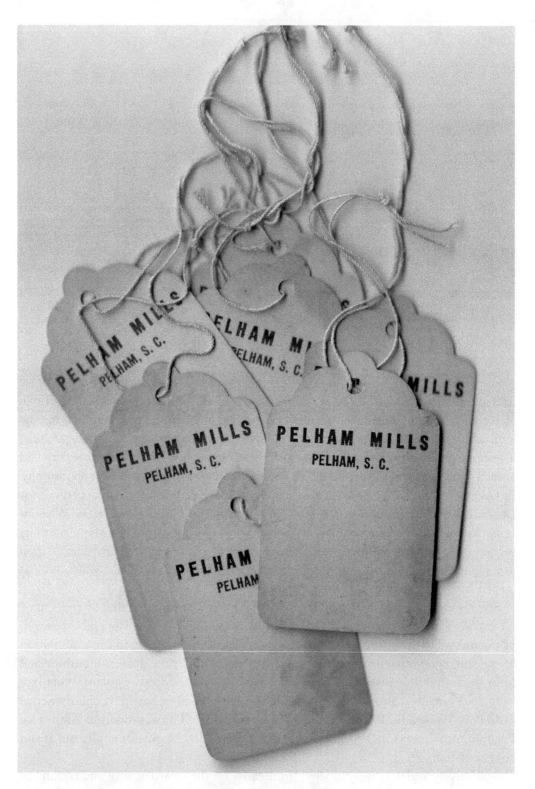

Tags for Pelham twine.

Pay envelope with company store deductions.

remained small and undeveloped until the 1920s because Alfred Taylor refused to sell his land, opposing an influx of the mill people. Even in Greer during the mid-teens, a superintendent's daughter felt that "we were not a part of the town. We only shopped in town if we went to Greenville or Spartanburg."[205]

And while the mills seemed like beacons of hope for the country and mountain people, some of them found that certain doors even in the cotton mill community were closed to them. Rarely did operatives ascend to the mill offices or upper management. Instead, young men with some education, townsfolk, often kept the books, supervised the outside department, clerked and managed the company store. Superintendents and general overseers were often brought from the North until provision was made to educate mill managers instate.

The country continued to supply help for the mills as long as farming continued to self-destruct. In late 1926, Thomas Marchant wrote to Commissioner of Agriculture J.W. Shealy concerning the farm situation and its relationship to textile labor. His tone suggests little compassion for the tiller of the soil:

> I believe that the year 1927 is going to be a much more satisfactory one for the textile industry than we have had for several years. Labor has been plentiful, and lately, with the failure of the crops in the upper part of the state, we find more labor than we can employ.[206]

Except for labor shortages just after the turn of the century and again during the world war, manufacturers found it increasingly easier to fully staff their mills during the twentieth century. Development of laborsaving technology also meant that mill hands had fewer options.

THE HUMAN CONDITION: SICKNESS AND DEATH

Sickness, accidents and childbirth a given, mill owners often provided some form of health care for the villagers. A common pattern followed by many mills was to contract with a physician, most often a local general practitioner who provided employees with certain limited services; any individual treatment beyond the company's agreement policy was borne by the employee and deducted from his pay. One of the earliest insurance programs was introduced by the Victor Monaghan Company by 1917, although company-funded insurance benefits were not generally provided until much later.[207]

An epidemic could easily overwhelm the resources of the mill and village. In mid-February 1898, smallpox struck Pelham village. By February 18, almost 100 cases had been documented. The Greenville Board of Health declined to become involved in treating the epidemic, although Chairman Jones thought it a serious problem. The board was reluctant to set a dangerous precedent, unsure of its authority to become involved in mill health matters. Mill physician Dr. J.A. White, son-in-law of the Batesville Manufacturing Company superintendent, contacted the State Board, requesting a Board of Health be appointed for Pelham with authority and responsibility to deal with the epidemic. He recommended officers of the mill and Greer physician Dr. Robert L. Marchant serve. By February 26, 150 cases had been documented in the community. Dr. James Evans of the State Board of Health appointed Dr. White health officer with authority to disinfect the houses and workspaces of ill operatives at state expense if necessary. A Board of Health for Pelham was appointed, composed of Dr. Marchant, J.I. Westervelt, Dan Sunderland and T.M. Bennett. Dr. White asked the State Board on March 5 to provide a pest house for the ill.

On March 7, Chairman Jones recommended to the governor the construction of a pest house and that it be supplied with a guard if necessary, to help Dr. White control the spread of the disease. The pest house was built immediately and housed thirteen active cases by March 10. By March 22, although twenty cases existed on the village, health authorities considered the epidemic under control; a majority of those not taken ill had been vaccinated. The strain of smallpox had been mild; only two deaths in Pelham village were reported. There had been somewhere in the neighborhood of three hundred cases or more. As a follow-up precaution, Governor Ellerbe appointed three sanitary inspectors commissioned to enforce health regulations in both Greenville and Spartanburg Counties, visiting every home within several miles of Pelham and vaccinating those who had not received the vaccine or ordering those who refused inoculation to leave the state.[208]

Between epidemics, the influx of country and mountain people to the suburban mills brought a greater awareness of health problems most commonly found among this population. Hookworm and pellagra were almost ubiquitous; pellagra, until its nature was understood, was most dangerous because death could occur if untreated. The disease was associated with the "white diet" of Southern mountaineers, heavy in pork and corn products that excluded the nutrient niacin. The United States Public Health Service in early 1917 conducted broad surveys to determine the extent of pellagra and other diseases among mill villagers in the area.[209]

A pandemic of Spanish influenza followed the First World War; it struck in late 1918. This strain of the flu produced rapidly developing, almost plague-like symptoms; weaker patients succumbed, sometimes within a day. The flu struck mill villages first, early cases appearing in October. Camp Sevier supplied medics to help treat the ill, especially those at the mill villages where the sickness may have been more general.[210]

KEEPING ORDER

Cotton mill owners, for tax purposes and other advantages, located their operations outside town or city limits. This meant that law enforcement responsibilities for the mill villages fell to county sheriffs. During the cotton mill campaign and for many years afterward, county sheriffs' departments were small and had few deputies. The Greenville County sheriff's office was isolated from mills out in the county, including Simpsonville, Fountain Inn, Greer, Pelham, Piedmont and Batesville. Train, buggy or horse were the only options for answering a call, all three of which were very slow.

The state legislature enacted a remedy in 1898, authorizing the appointment of officers who had jurisdiction within each community with a population of one hundred or more. These mill deputies were approved and commissioned under the county sheriff and their salary borne by the local mill. Their term of office ran with that of the sheriff, who also had power to remove any deputy for cause. Until the towns and cities annexed the villages, approximately a half-century later, these officers kept the peace in the mill villages of the state.[211]

Mill deputies were authorized to act in the same capacity as regular deputies but with jurisdiction restricted to the area of the village. Their primary orders were to keep the peace, protect mill property and guard cotton warehouses against theft. At the smaller mills, the earliest officers often held a mill job as well, patrolling the village before and after their shift. They lived in the village and were considered to be on duty around the clock and could expect to be awakened from sleep or called out of the mill to deal with situations. Mill property was rarely challenged, except by children or drunks, who sometimes entered parts of the mill or warehouses against company rules. Most of the deputies' work consisted of breaking up fights, settling family arguments and escorting inebriated operatives to their homes. Uniforms were not provided nor expected; a deputy carried a shield or badge and had the option of carrying a firearm or other weapon at his own expense. Some officers preferred blackjacks or a nightstick, which were rarely used. One Greer Mill deputy carried an unloaded "horse pistol" in his back pocket in case he "needed to hit somebody."[212]

At the larger suburban mills near Greenville, deputies worked full time. They cooperated with town and city police when offenses involved other jurisdictions. All were approved and appointed by the sheriff; training came only in the form of advice and comments from the sheriff, other officers and magistrates. Under the circumstances, mill deputies performed their duties well.

While most duty was monotonous and routine, occasional serious violence disrupted village life, requiring the attention of an officer. At Mills Mill, T.S. Williams was shot on February 18, 1901, attempting to "cowhide" another man for making "indecent overtures" to a married woman. The sheriff arrested some eighteen vigilantes in an effort to get to the bottom of the complicated case. A shooting occurred at Franklin village on June 21, 1902. No one was killed but several were wounded. At Southern Worsted, Mill Deputy J.L. Sanders killed seventy-two-year-old J.W. Whipple, who attacked the deputy with a knife when the officer responded the second time to a complaint of wife beating in the summer of 1928. At Greer Mill in 1930, Will Barton's throat was slashed during an argument over the honor of a woman.[213]

At the time the mill officers were first appointed, the Greenville cotton textile industry was growing rapidly. The New South mills of the 1890s, American Spinning, Francis Poe, Brandon and Mills Manufacturing, had concentrated, by 1900, approximately six thousand people in villages lying just outside the city limits. Most of these people were new to the area, many new to the state, from the distant countryside and mountains. Many, no doubt, were unsophisticated in the ways of even a modest town like Greenville. Each village was distinctive and presented challenges to law enforcement officers.

Eli Pittman patrolled American Spinning, with a village population of about two thousand, in 1906. Born near Glassy Mountain, Pittman was thirty-five years old and had been an officer for several years. Sheriff J.D. Gilreath appointed him to the American Spinning precinct after other deputies resigned, finding it a dangerous place to work. Pittman took his job seriously but he also made friends among the people. He helped organize a chapter of the Oddfellows and served as president of the village literary society. Sheriff Gilreath later said, "Conditions were pretty bad in his precinct until I sent Eli there as Deputy Sheriff." In the summer of 1905, Pittman shot and killed Newman Burns when Burns and George Rigdon resisted arrest and wounded Pittman. Pittman was seriously injured but managed to subdue Rigdon and bring him to jail. Pittman was cleared, as he had acted in self-defense.[214]

The spring of 1906 had been a hard one for bootleggers and moonshiners who frequented the mill villages of Greenville. State and county officers had made numerous raids against "blind tigers," liquor houses in the area. A number of stills had been cut. Traffic in whiskey was a mountain tradition now brought in abundance to Greenville with the building of mills. Considerable tension had developed between officers and those who saw nothing wrong with the trade in spirits.

On Saturday, April 28, Pittman was working in cooperation with State Constable James Altom to locate blind tigers in the vicinity of American Spinning and the Buncombe Road. Earlier in the day Altom had received a tip from an informant that a wagon containing illegal whiskey was in the area. Altom didn't believe the report was accurate and returned to town. About an hour later, Pittman, unaware of the report, either walked up on the bootlegger or into a trap prepared for Altom. Pittman was fired on and he returned fire. When it was over, Ben Wells lay dead and Pittman was severely wounded. Pittman died twenty-six hours later, having suffered seven bullet wounds. Eli

Pittman was buried near his birthplace. Of his life his pastor said: "The name of Officer Pittman may soon be forgotten by some but no braver officer nor truer man ever lived. Truly he was a man without fear." Pittman, one of Greenville's forgotten heroes, left a wife and two children.[215]

DIVISIONS OF LABOR

Race only became an issue during the last forty or so years of cotton textile history. Antebellum industrialists, except for short terms and experimentation, did not use slaves in the mills because of doubts about blacks' suitability for that type of labor. Although both Phillip Lester and John Weaver owned slaves, they hired paid labor to work in their factories. Throughout the cotton mill campaign and well into the twentieth century, the question of employing African descendants other than as auxiliary labor never appears to have been discussed. During times of labor shortages, the industrialists remained committed to the concept of a white workforce in the mills, so much so that South Carolina sponsored a program to import labor from Europe.

Yet, it was almost twenty years after the Supreme Court established the doctrine of "separate but equal" before a piece of "Jim Crow" legislation appeared on the books regulating industrial workers by race. The act of February 1915 prohibited blacks from working on the same floor as whites. Specific prohibitions were spelled out requiring separate facilities for the races, including entrance doors and even pay windows. Common assumptions that Negroes did not need much and could suffice on little missed the essential truth that many blacks had grown accustomed, out of necessity, to making do on the simplest foods, cheapest cuts of meat, poorest housing and few worldly possessions. Black men continued to be employed in a few capacities on the periphery of the cotton manufacturing industry. Jobs available for blacks included positions as openers, scrub men, machine shop helpers, batten room workers, janitors, outside crew, village and/or farm maintenance laborers, warehouse men and sanitation workers. No mill in the country could have operated without its complement of black workers in various foundational capacities.[216]

Women were never excluded from the textile factories; they constituted a significant proportion of the workforce in many mills and occasionally were the majority. During the earliest phases of development, sexual divisions of labor in the industry were based upon the relative strength of male and female that was required to operate certain machinery. The wages were theoretically commensurate with production achieved. In spinning mills, the size of the machinery varied from a spinning jenny to a mule frame. The jenny could load a dozen or more bobbins while the mule could do twenty times that number. The jenny required less effort than the mule, which involved pushing a heavy beam across the floor. Men ran the mule, women, the jenny. From those earliest days there were, until the twentieth century, wage differentials paid between men and women. As technology improved, particularly after the cotton mill campaign was underway, many of the jobs

once described as man's work or a woman's job became so similar in terms of effort required that union organizers identified wage differentials as a point of contention. Long before federal law sorted out those issues, the work of the mills came under union scrutiny to determine whether it was suitable for womankind.

By the end of the nineteenth century the Victorian value system was as entrenched as it could be in society, demanding a level of respect be accorded to women as the gentler sex. The notion contained elements of myth but the public absorbed it and it was reflected in some of the writing of the day. In 1911, the *Edgefield Advertiser* deprecated the fact that women had to work in the mills at all. "And, those who worked are forced to for want of sufficient family income…often young girls of…tender years shut up for nine or ten hours daily in a mill, become the mothers of the next generation and nothing also so unfits them physically and mentally for the duties of the years to come as passing their early life in the atmosphere of a factory."[217]

On the other hand, "The women who work in the mill are relieved of the family washing and ironing and can put in a full weeks work and receive in one day enough pay for the cost of two weeks wash" in a modern village, which had a co-op laundry. Perhaps going a little to the extreme was Brown Mahon, vice-president of Judson Mill, who commented in print that "if you want to see real contentment just take a look into the cozy, happy homes of textile employees around Greenville."[218]

The question of the appropriateness of millwork for women was not decided by reformers nor set in law except that their decision was protected by the Constitution. The simple fact was that many women had to work. The villages had their share of widows and unreliable menfolk. Absentee husbands left the grass widows in a less-certain position, forced to work or allow her children to work, or otherwise be left with children to be fed in almshouses.[219]

CURTAILMENT

Curtailment, the temporary closing of one or more departments of a cotton manufactory, was an accepted fact of life for the earliest antebellum operatives. Reasons could include natural occurrences such as drought or flood, insufficient supply of local cotton, decreased demand for cotton yarn, or the unavailability of help or necessary machine maintenance. Rarely would curtailment result from quality of available cotton or its cost. Coarse yarn could be produced from practically any staple length of cotton and the cost was largely determined by the mill owner, who set the price he was willing to pay.

The work schedule of small early operations such as Weaver's, Hutchings's and the Arnold-Berry mill was likely dictated by the local cotton crop. These yarn mills bought raw cotton locally and marketed their products in the same area, within a radius of a few miles. Expansion beyond the immediate locale required cash or credit that was hard to come by in a state with a strong agricultural mindset. So when a

season's cotton was exhausted, the mill shut down and the operatives, for the most part children and women from nearby farms, went home to other chores. Cotton was generally harvested, depending upon particular weather in a given year, between September and November. Mills could then operate a few months until the cotton supply was exhausted.

Vardry McBee, William Bates and Phillip Lester, on the other hand, were able to operate factories more consistently despite sharing some of the same limitations. Bates was recognized for his mechanical genius while Lester and McBee had considerable money to invest in putting their products out for public consumption.

Regional and national market forces increasingly determined the schedule of mills. Haphazard growth of the industry led to a glut of similar products from time to time, requiring the shutting down of operations to allow the market to absorb excess inventory. Diversification of textile products was an obvious approach to the problem but the mills that had been built between the 1870s and 1910, the largest operations in Greenville County, could not easily, quickly and inexpensively diversify product lines.

For curtailment to succeed, it was necessary for most or all of the mills affected by market conditions to effect curtailment cooperatively. Mill owners formalized their understandings through meetings and resolutions of the South Carolina Cotton Manufacturers' Association (SCCMA), formed in 1905. It had no means to enforce member discipline nor did it necessarily influence mills in the region that were out of state.

Additionally, there was the question of how best to apply curtailment. Cooperation among companies was necessary in order to have a net effect on the market and also to give mutual assurances that no abstaining company would build up a surplus ready to dump on the market when prospects brightened. As to shutdown or short time, when possible, area owners chose to go on short time to avoid demoralizing their help.[220]

Despite planning and making allowances for conditions, curtailment remained common for a variety of reasons through the 1930s. Facing the gold panic of 1893 and its consequences, local mills closed for the month of August. The 1903 cotton crop was small; prices were so high that mills were forced to curtail for two months between August and early October. Cotton prices were high again in October 1909. Lewis Parker noted the decline in value of cotton cloth and predicted general curtailment if the markets remained unchanged. The SCCMA recommended curtailment but left schedules up to the individual mills. Pelham, hit harder because of its smaller size and narrow product line, curtailed for about six months in 1909. To assist employees, Pelham extended credit at the company store and provided free housing to employees during downtime. Unscheduled or emergency curtailment often affected the later generations of mill hands adversely because of their dependence upon regular wages. The second and later generations of mill workers, without a direct link to the farm, had nowhere to return during work stoppage. During these times, the welfare of the operative and his family depended upon spending and saving practices.[221]

The Greenville

Greenville, S. C., 2 —

This Certifie

W. A. Cunin...

is a member in good stand
tion, and that his dues a
the first, 193 3

Lou Trut...

In 1911, when Ellison Smythe was president of the SCCMA, he announced a five-week curtailment due to poor markets for finished goods. The curtailment, announced on January 17, was flexible and could be implemented any time between April and September. The SCCMA at the time represented four million spindles. A slump in the markets developed more profoundly than had been anticipated. The association voted to close all South Carolina mills for two weeks in July–August 1911. About a quarter of all spindles were idle and had been for some time. A power shortage caused by a midwinter drought forced curtailment in January 1923; mills idled one day out of six to permit recovery of resources. A power shortage again forced stoppage in late October 1923. High cotton prices forced a curtailment in early 1924. The curtailment remained in effect for much of the year. American

xtile Club

193 2

at

in this organiza-
aid until March

Secretary-Treasurer

Textile club membership card.

Spinning and Poe, both of which had been operating on a curtailed schedule, were running full shifts by the end of May 1924. The Victor Monaghan Mills in Greer were operating forty hours in late August and hoped for a full-time schedule of fifty-five hours by September 1. Victor Monaghan Company notified its help a few days ahead of time that it would idle two days a week until further notice to help stabilize the cotton market. Victor Monaghan plants curtailed Friday and Saturday work indefinitely beginning May 7, 1926.[222]

ISSUES OF LABOR

By 1900, Greenville could still boast of having no labor problems in terms of irreconcilable differences, strikes or protests. There were few, if any "walking delegates" within the workforce and had they tried to convince their fellow workers to strike or complain, they would have failed. As a matter of fact, the high sheriff of Greenville County was warned by telegraph in January 1900 by Lonsdale and Manville Unions of Rhode Island to be on the lookout for recruiting agents attempting to hire away local labor.[223]

The idea of "production" or piecework had been in use in Northern and European mills for decades before the mill-building mania brought these ideas to South Carolina. When Northern industrialists seriously began to examine the phenomenal level to which mill construction had risen in the South, by the mid-1890s, they justifiably tried to protect their industrial base. As competition with the South increased, Northern mills turned to Taylorism, increasing worker productivity through the application of efficiency techniques based upon analyses of time and motion data. Machines in use were sped up, movements reduced, jobs better defined and production increased. Along with production quotas came newer, more efficient machinery enabling workers to produce even more in a given shift.[224]

The record of labor unrest in Greenville County before 1934 is sporadic and modest. When the Knights of Labor stirred in the locale during the 1880s, South Carolina mill owners Henry Hammett, Ellison Smythe and Dexter Converse took action to prevent labor organization within their respective provinces and shared intelligence about the course of the movement. Hammett, a leading opponent of such "Yankee-inspired" activity, probably overestimated the threat; nevertheless, he stood firm against unions. Superintendents at Piedmont and Camperdown were instructed to fire any employee engaging in organizational work. The National Union of Textile Workers (NUTW) held organizational meetings in Greenville in June 1899. The influence of the NUTW was minimal.[225]

The next year, a handful of Batesville workers staged a strike. On June 19, 1900, six men apparently left their jobs; others may have been encouraged to do so but did not follow. It is uncertain what the strikers were protesting, however; they represented only about 10 percent of the Batesville workforce. When the strike failed to develop further, the strikers attempted to return to work. Management questioned the men, determined that Tom and Will Stewart had been the instigators and fired them. Hampton Jones, Will Cox and Henry Knight were permitted to return to the mill; Lee Taylor's case was left pending.[226]

A wildcat strike occurred in July 1914 at Monaghan in reaction to instigation by visiting International Workers of the World (IWW) leaders. Monaghan Mill closed Thursday July 9, 1914, over a conflict between the rules of the mill management and the rules of the IWW, better known as the "Wobblies." A strike began in the weave room on July 8 when the mill had some trouble with its electrical power. Operatives were idle for a time. Management required the time be made up. Some four hundred members met at their meeting hall on the corner of McBee and Main

over Rothschild's store on July 11. Lewis Parker barely budged on the issue but finally announced if the policy was incorrect, it would be changed in all the Parker Mills. The IWW members settled for no time make-up and deduction for time lost.[227]

On October 22, 1915, at Judson, a strike broke out in the weave room over the firing of certain individuals involved in union activity. It is unclear how many initially supported the strike, but it spread to other departments and the mill closed briefly. Union members formed a relief society wherein one could join for two and a half cents per week. B.E. Geer, president, met with union leaders and with John Golden, president of the United Textile Workers of America (UTWA), who came to Greenville to investigate the strike. Tensions in the community ran high for two months. Thirty heads of households were evicted; the strike may have brought about turmoil in the local church. Sheriff Hendrix Rector was instrumental in keeping the peace in Judson village. The sheriff demoted the mill deputy and assigned a half-dozen deputies to be on hand when the mill reopened in mid-November. Still, in late November, David Freeze, a non-union man, was stabbed in a fight outside the mill and later died. At a trial in January, five were convicted of manslaughter and in Judson, the mill having been operating since late October, the union members accepted defeat and labor unrest subsided.[228]

At the Victor plant of Victor Monaghan Company, what began as an attempt to foment a wildcat strike left one man dead in 1921. Around the first of March, a wage reduction went into effect for employees in the card room at Victor Mill. Several men quit or walked off their jobs in protest. One of those protesting was James "Pete" Newman, a well-known member of the Victor Mill Baseball Club. Boss Carder P.A. Bolt and Second Hand Charles Smart believed Newman was the leader of the strike. Newman was fired upon their recommendation. Smart and others later reported that Newman had threatened them and a peace warrant was issued for Newman. The superintendent then advised Newman to leave the village, which he did. Newman returned to the village four days later and encountered Smart on the street. Witnesses said Newman asked Smart for money; an argument ensued ending with Smart drawing a pistol and firing five bullets into Newman's body, killing him on the spot. Smart surrendered to mill deputy W.T. Wood. At the inquest that followed, Smart testified that it was a matter of self-defense. The walkout, limited to the carding department, ended.[229]

Labor trouble developed among a larger segment of Greenville mill hands in spring 1929 in response to increased workloads. Hundreds of operatives were affected at several area mills by spontaneous strikes. Although the numbers of apparent strike supporters were large (ranging into the hundreds), there was no evidence of conspiracy or cooperation. Each walkout was settled independently. Twelve hundred workers struck at Brandon in March 1929. A walkout also occurred at Poinsett Mill, a Brandon Corporation property. The issue was the stretch-out, the assignment of more machines per worker to increase efficiency; a compromise heavily favoring the company's position was reached by May. By this time, however, Brandon Corporation

was financially weak and this fact was generally known. Mills Mill workers struck for recognition of their organization, an end of the stretch-out and a 20 percent raise in early June. That strike ended a few weeks later without result, other than the dismissal of thirty-two union members. The sense of area-wide solidarity among mill hands had not yet evolved in the South. Nor did it in Greenville during 1929. Brandon strikers wanted no outside help; it was a private matter between the management and several hundred operatives. While a sense of solidarity lay in the future, a sense of community did arise. Brandon strikers suffered hardship during the strike and to some extent depended upon the charity of others while issues were being considered. At the end of the strike, Robert Hudgens, head of the workers' relief committee, thanked the individuals and firms that had contributed, including several mill companies.[230]

The budding Greenville labor movement was not typical when measured against similar efforts in other parts of the country. Local strikers were as dead set against labor organizations as they were against being pushed around by mill management. Whether this feature was derivative of the independent spirit of the mountain and country folk who populated Greenville's mills or merely reflective of mill owners' preachments against outside labor agitators remains to be determined. Ten years earlier union membership practically guaranteed the loss of a job if found out. Union presence and influence remained in Greenville after 1929 but at a subliminal level until 1934. The United Textile Workers of America continued a year after the strike to push for reinstatement of fired operatives The Communist-led National Textile Workers Union had rented a headquarters at 560 Honour Row just beyond West Greenville on the Pendleton Road by late August 1929.[231]

Chapter Seven

GROWTH OF THE TEXTILE INDUSTRY AND ITS CONSEQUENCES

TEXTILE CENTER OF THE SOUTH: THE 1920S

By the 1920s, Greenville had a firm hold on the claim of textile center of the South. In 1915, twenty-nine mill presidents resided here. Five years later, fifty-six mill presidents called Greenville home. Numerous firms ancillary to the textile industry had agencies located in Greenville. Attorney William G. Sirrine, president of the Southern Textile Exposition, organized and carried a Southern Exposition to Grand Central Palace in New York City in May 1925, which was acclaimed for its novel approach in attracting business in *Manufacturers Record*. Neighboring Spartanburg County had also laid claim to the title, being geographically blessed almost as well as Greenville; but in terms of executive power and investment capital, there was no contest; it was Greenville hands down. To a degree, Greenville County represented management and Spartanburg, the labor, a parallel that became more poignant in 1934.[232]

Conditions within the cotton textile industry were often frustrating for owners, investors and operatives alike during the 1920s. Most investors retained their shares in cotton mill companies, partly out of loyalty and partly because they believed they understood how the textile markets worked. The textile economy, like the larger economy, had always had its booms and busts due to the natural law of supply and demand. The textile segment of the economy, much smaller and well defined by product, could be controlled to a degree through the cooperation of manufacturers. Throughout the first quarter of the twentieth century, manufacturers associations provided guidelines and recommendations aimed at keeping cotton prices, wages and freight rates in line. To maintain reasonable market prices associations scheduled

necessary curtailments.

Operatives experienced periods of frustration when plants went on short time or closed, often without much advance notice. Production per employee had increased steadily as technology improved while rates of pay had not kept pace with rate of production. Nor had the ideas of "thrift" and "saving" yet caught on among the mill class. But for many cotton mill workers, the period from the end of the First World War to the Depression was "the good old days." The village was "home"; neighbors were also friends. When curtailments occurred, "they'd carry you at the store until times got better," according to L.C. Pearson of Victor. Or, as some operatives did, one could find other work to supplement mill income. Dennis Grubbs of Pelham owned one of the few automobiles on his village; during curtailment he drove it as a "public car." Luther Hester of Dunean painted in his spare time; Grady Belcher at Greer Mill apprenticed himself to a barber.[233]

The ninth Southern Textile Exposition, held in 1930, was as yet untouched by the economy despite the fact that the stock market crash had occurred a year earlier. Two hundred exhibits were shown and forty thousand attended.

INDUSTRIAL WOES AND DEPRESSION

Expanded production capacity plagued the mills with excessive inventory through the 1920s; by the 1930s, apparel style became an increasingly significant factor in determining which and what quantity fabrics were profitable. Some progress had been made in limiting mill output but not everywhere. The forty-eight-hour industrial workweek was generally applied in all states; South Carolina law, however, permitted textile firms to operate on a fifty-five-hour schedule, an enticement to attract more mills to the state. Additionally, both Greenville City and County offered generous tax breaks to any new industries locating therein. Essentially, the problem was the inability of manufacturers to agree to regulate themselves; the manufacturing bloc consisted of some seventeen hundred mill owners, none of whom had managed to gain significant control of production. The largest controller of spindles operated less than 2 percent of the total.[234]

Despite fundamental issues within the industry, the public word from the heads of companies was always optimism. Harry Stephenson, head of Southern Bleachery, returned from a business conference in New York in 1927 and reported that better days lay ahead. Recent curtailments had been limited to manufacturing processes; the Union and Southern Bleacheries were operating at near capacity. All optimism aside, just prior to the stock market crash two years later, all Greenville County mills were curtailing.[235]

When the stock market crashed there was no immediate effect upon the local mills. Coarse goods mills slumped during the winter of 1929–30 but mills that produced

Next page: Poinsett Hotel advertising card.

THE POINSETT HOTEL

GREENVILLE, S.C.

Carolina's Finest

"TEXTILE-CENTER OF THE SOUTH"

J. MASON ALEXANDER, MGR. DIR.

finer goods, including Dunean, American Spinning and Judson, operated on a regular basis. Dunean, for example, could produce yarns as high as 96s, which were so fine that a pound contained 80,640 yards. Dunean, like Judson, produced silk-cotton blends. Pelham's capitalization was increased to a half million dollars on October 29, 1929. By this time, the principal stockholders were Crigler, James P. Gossett, John P. Mitchell and W.C. Cleveland. Additional capital made it possible for Pelham to add new machinery. New dying machinery was installed in February 1930. The mill produced quilting thread and the knitting mill made sock tubing. Additional work was available for women in the village who were willing to complete socks for the ready-to-wear market, hand stitching the toes and heels at home.[236]

Cotton mill business deteriorated during 1930–31, eventually affecting production of all product lines. From the operative's point of view, the only material difference in his work schedule before the crash and after was the frequency of curtailment. The Depression's hardest year was 1932, when the annual wage for operatives, $495.18, came out to a little over $9.50 per week. With virtually no guidance nor assistance from the federal government, mill owners attempted to develop a plan. Many mills were ceasing all operations for one week per month. Upstate mill men met at Spartanburg in March and agreed to try for an eighty-four-hour workweek for mills with night shifts. Regularity would be less a hardship on the employees and also keep them near in case of sudden economic improvement.[237]

Depression-related curtailment may not have cost the average mill hand much more lost time than he had been used to. The six-day, fifty-five-hour workweek gave the worker a theoretical 306 days a year. The South Carolina average during the Depression was almost 247 days. Moreover, some members of the mill family, the essential workers in management and maintenance, were retained full time while machine operators might be idled for weeks at a time. Averages do not mitigate the extremes that some operatives experienced. By late 1932, despite being part of a work culture with built-in expectation of curtailment, there were instances of hardship to the point of malnutrition among the mill population of the county. The tenth Southern Textile Exposition, held during the depths of the Depression, was the smallest show ever with 123 exhibitors, little more than half the usual number.[238]

Of the textile mills of Greenville County, only two failed during the Depression. Those that survived took whatever measures necessary to avoid financial collapse while at the same time retaining employees for the time when business would again improve. Frances Poe Manufacturing Company was in doubtful condition during the Depression. Nevertheless, it apparently found sufficient funding and combined that with the improving economy in order to remain in business. Brandon, financially "teetering" years earlier, managed to survive the Depression. So did Camperdown, which was near failure when it was reorganized in 1930 as Camperdown Company, Incorporated. Under new management it continued to operate another twenty-six years.[239]

To keep the mill going and retain a cadre of skilled workers, Greer Mill laid off over half its workers in early 1932, retaining one employee per household on full

$1.00 *Greenville,* No. 123884 A
 S. Car.

Received of **DUNEAN STORE** *coupon book good for*
ONE DOLLAR IN MERCHANDISE.
I hereby agree that said coupons are not transferable and shall be re-
deemable only in merchandise at said company's store when said book,
with coupons attached, is presented by myself or by a member of my
family. Further I hereby direct DUNEAN MILLS to charge my ac-
count on pay roll
ONE DOLLAR FOR MERCHANDISE
and to pay said sum to DUNEAN STORE.

..(SEAL)

BY..THIS..............DAY OF193.....

Dunean Mill store coupon book.

time in addition to necessary skilled and managerial help. A year later, as new order slowly trickled in, additional workers were called back as needed. For the Victor Monaghan Company, 1934 and 1935 were years of mostly regular work, but fraught with issues of low pay and unfair wages and labor rights. The company was on the rebound after the middle of the year in 1936. Value of a share of stock increased from 26 percent par to 38 percent par in a matter of weeks. By late 1939, a share had risen to 45 percent of its original value. By the mid-1930s, after the worst of the Depression, Greenville County ranked first in the state with almost $39 million invested in textiles.[240]

PELHAM AND FRANKLIN

The only two Greenville County mills that failed during the Depression were Pelham and Franklin. Pelham's fortunes dried up beginning in 1931, forcing extreme cutbacks. Enoree Converting was closed when Pelham ceased making thread. Pelham continued to operate on a partly curtailed basis manufacturing twine until May 18, 1935. Since owners saw no possibility for reopening the plant, the machinery was junked, houses were later sold and the buildings rented for cotton warehouses. When Pelham closed, some mill hands obtained work with federal agencies, others went on relief. At closing, some three hundred operatives were out of work, representing about ninety families in Spartanburg and twenty in Greenville Counties. Relief programs were set up in early June, estimated to cost up to $400 a week to provide

for the unemployed.[241]

Franklin's capitalization was increased to $120,000 on July 29, 1930, nine months after the stock market crash. Thereafter, Franklin's business diminished and debts piled up. Edward Shanklin, president, kept the plant operating at between 50 and 60 percent capacity until failed health forced his retirement in 1935. Franklin went into receivership on January 20, 1934. The general textile strike in September of the same year pointlessly closed down the plant for a few days. Accused of mismanagement, Shanklin's actions seem to point to the contrary. Franklin was able to stave off collapse of the mill by his own efforts and advice taken by his successor. Shanklin's own money, combined with that of other creditors, postponed any collapse of the mill until wartime economy finally brought the plant back to life. Shanklin died May 28, 1936, after an illness of eight months. During his last years he worked at a reduced salary, infusing his personal savings into the plant to continue operations. He remained a major creditor of the mill at the time of his death. E.R. Stall ran the mill until business improved enough to interest a buyer.[242]

THE STRIKE

The Bedeaux system, or "stretch-out," as it was known among mill operatives, was deeply resented because workers produced more goods but were paid no more wages. Deriving from Taylorism, job analysis by efficiency experts led to revolutionary changes in American industry after 1915. Widespread application of the practice in the textile industry occurred during the 1920s. A weaver who had been responsible for twenty looms before the stretch-out might find himself responsible for twenty-five afterward, a net increase of 25 percent more work output from the same employee.[243]

Opposition to the stretch-out became a unifying theme in 1929; unions began to gain strength in the Southeast. Strikes in Tennessee and North Carolina evolved into violent confrontations, but the issue was obscured when the union lost control of its members. Greenville walkouts at Brandon and Mills Mill had been less confrontational. Tension between opposing unions, one Communist-led, the other anti-Communist, helped to postpone development of the Southern labor movement. Continued application of the stretch-out, combined with curtailment and the accompanying hardships brought about by the Depression, created a disgruntled and frustrated workforce, many of whom were ready to take action by 1934. The United Textile Workers of America (UTWA) positioned itself to lead the Southern masses. The South had become a proving ground for the labor movement.[244]

On June 16, 1933, the National Industrial Recovery Act (NIRA) became law. Codes were implemented to create a fair wage standard. By late 1933, the minimum wage was twelve dollars for forty hours. While the federal government withheld action on the use of the stretch-out, workers saw some wage improvement. This law endeared the Roosevelt administration to many ordinary mill hands who had not seen twelve dollars in a single week for some time. Stretch-outs, meanwhile, continued.[245]

The NIRA was designed to return stability to industry by drawing up rules or codes for each major industry. The codes were written by industry personnel and administered by the National Recovery Administration (NRA), headed by Hugh S. Johnson. The key element of this program was Section 7(a) of the NIRA, which gave workers grievance rights. An amendment added on July 1, 1933, to the textile industrial code provided that the stretch-out would be held at status quo.[246]

A committee was set up, however, headed by Robert Bruere, to investigate possible abuses of the stretch-out. Mill hands saw the stretch-out as a violation of New Deal principles; they had a right, guaranteed by the industrial code, to challenge it. The UTWA continued organizing efforts while the Bruere committee heard complaints. A procedural weakness of the textile code was that there was neither specific grievance procedure nor timetable for action.

In May 1934, the American Cotton Manufacturers Association (ACMA) met in Charleston. Tom Marchant, the president of Victor Monaghan Company, was retiring; Bruere was a keynote speaker. At about the same time, the Cotton Textile Code Authority proposed a 25 percent cutback in production. Just as mill management since the early days of the industry had curtailed to control markets and guarantee profits, the code authority found it an effective tool in the new regulated economy. The reduction was to be achieved by reducing the workweek from forty to thirty hours. Hugh Johnson, head of the NRA, approved plans for the proposed cutback. Francis Gorman, first vice-president of the UTWA, in turn, requested a 33 percent increase for operatives in order to maintain their standard of living and continue their buying power at previous levels. Two days later, before the Cotton Textile Code Authority had an opportunity to answer, Gorman threatened to call for a strike within two weeks if the order was given to cut back without a corresponding increase in wages.[247]

On May 31, President of the UTWA Thomas McMahon met with Hugh Johnson. McMahon agreed not to call the strike, allowing the curtailment to go into effect, but under the condition that the research division of the NRA study a possibility of a general wage increase for the industry. Despite the union perspective of the stretch-out, the reality was that under the NIRA, wages had gone up significantly for many mill operatives while hours had been diminished. The New Deal program had yielded a net gain for the industry's laborers. Meanwhile, the massive recruitment efforts of the UTWA continued.[248]

In mid-August the UTWA held a special convention to discuss dissatisfaction with NRA codes. By this time, union membership region-wide had increased almost seven-fold in less than a year. On August 15, the union convention resolved to call a strike unless section 7(a) of the NIRA was enforced more rigidly. Without waiting for NRA response, the convention voted to call a strike on or about September 1. McMahon announced general plans for the strike on August 15. The Southern office, which would serve as a central command post, was located in Greenville and manned by John Peel, who estimated that half the workers in the industry were

prepared to strike.[249]

The most immediate cause of the planned strike, the 25 percent curtailment, had expired on August 23. On August 30, workers in West Greenville, in the vicinity of Monaghan Mill, routed G.W. Smith, a union organizer, with a barrage of eggs, tomatoes and watermelon rinds. It began to look as if the strike would not affect Greenville if called at all. However, at 11:30 p.m., on August 31, UTWA officials announced that "the strike will go on." Tensions mounted throughout the area as workers took sides.[250]

An editorial appearing September 1 in the Greenville *News* predicted there would be no strike locally. Actually, Conestee, American Spinning and Dunean Mills had struck weeks earlier. There were no overt indications of wholesale preparation until the last minute. Victor employee Grady Powell said, "We were sitting on the porch after supper a little after the sun went down and several car loads of people drove through the village, yelling and beating on their doors, making a awful racket. They hollered for us not to go to the mill the next day." Powell didn't recognize any of the riders as being from Victor; they were most likely strike organizers from Spartanburg mills where union membership was large. During the weekend, pickets had already taken up stations at Saxon, Beaumont and Spartan Mills.[251]

Governor Ibra Blackwood informed the adjutant general, James C. Dozier, on September 3, the day before the strike was to begin, to ready his command for rapid mobilization. Authorities anticipated how the strike would be implemented in Greenville and Spartanburg Counties and took preparations accordingly. The Greer mills of Victor Monaghan Company, Apalache and Victor were located just inside of Spartanburg County. Although none of these plants was by any means organized, each had a chapter of the UTWA, Apalache Local 2218 and Victor Local 2190. These plants were located just off the National Highway (Highway 29) connecting Spartanburg to Greenville.[252]

Troops from the detachment of Company E sent to Victor were ordered to Greer Mill on Monday, where a machine-gun squad set up an emplacement in the grove to the west of the mill, presenting a field of fire covering the main entrance. Other troops were stationed at the rear of the mill to protect the railroad spur.

On the evening of September 3, two men visited Bob Blackwell at his home north of Apalache village. Blackwell, outside superintendent at the mill, was asked point blank to give them his keys to the entrance doors so there "would be no trouble in the morning." When he refused, they asked him to be ready to open the doors when they came to the mill the next day. He told them, "Men, I'm your friend, but I've got my job to do and I'm going to do it." Blackwell armed himself before reporting to the mill the next morning.[253]

On Tuesday, Sheriff Sam Henry of Spartanburg sent deputies to the Victor Mill, where pickets and a group of men inside the fence were trading taunts. Fighting erupted outside the mill gates at Victor; Sheriff Henry arrived about noon with more deputies. By noon, the crowd outside the mill had swollen to fifteen hundred who temporarily blocked the way of workers returning to the mill from lunch. At 3:45 p.m. strikers from out of town arrived to swell the crowd by another five hundred. Shortly after four o'clock, the

mill officials decided to close, not wanting to risk getting the night shift on the job. The strikers among the crowd, sensing victory, moved to shut down Franklin Mill about a quarter-mile across town.[254]

Pickets attempted to enter the mill and turn off the power to machines, all the while yelling at workers who watched from open windows to come out. There were no gates nor guards, troops, deputies or police assigned to protect Franklin. It was in receivership and not operating at full strength. A shouting match between the management and the strikers erupted. E.H. Shanklin, president, got the attention of the crowd. Placing himself between the crowd and the entrance door, Shanklin warned the crowd that the mill was protected by court order. "This mill is in the hands of Judge Oxner in Greenville and whatever he says goes." The workers, most of whom were women, began to leave the mill. It was cleared of operatives in a matter of minutes; the power switches were pulled, shutting down machinery. When the last of the workers was outside, J.O. Blum, secretary of the South Carolina Federation of Textile Workers, climbed onto the bed of a peach flat and spoke to assembled employees, urging them to join the union if they were not already members. The flying squadron then drove to Apalache, the smallest Victor Monaghan plant in Greer.[255]

Some Apalache union members had been out on the picket lines for a week or more "wildcatting" when it appeared the strike was imminent. When the flying squadrons arrived, Bob Blackwell met them at the main entrance as he had promised and blocked the doorway. There were several other entrances and despite mill officials' attempts to hold their ground, pickets pushed past them into the mill, found the power switches and turned off some of the machines. Intimidated workers came outside where Blum again addressed workers. At the end of the speeches, most Apalache employees went home, effectively shutting down the mill.

On Tuesday morning a few pickets had taken up posts in the streets and yards in front of Greer Mill. About twenty-five pickets from Victor Mill arrived by noon. Over the next several hours several laid-off mill hands and onlookers from the community joined them. Late in the afternoon, about three o'clock, another group arrived in a stake-side truck. The truck, coming from Victor village, cut off Palmer Dillard, a peach farmer who was driving his own vehicle down South Main Street: "They were hanging on all over it, laughing, yelling." By changing time, a crowd of one hundred or more, including the pickets, had assembled in front of the mill. Shouts of "Come on out if you know what's good for you" conveyed both persuasion and threat.[256]

Superintendent Claude M. Hemphill met with his overseers during the morning and decided on action to be taken. Overseers had already advised workers to use their own judgment about coming back after dinner. He closed the mill at changing time but asked his fixers and overseers to return on Wednesday to finish running the yarn that was in the mill. Sharp words were exchanged as the workers crossed the picket line, but there was no violence. By mid-afternoon Greer Mill ceased all operations. Wednesday evening, the picketing workers and sympathizers, confident of the strike's success, paraded over the mill villages chanting their slogans. By the end of the first day

an estimated 11 percent had participated in Greenville County; across the Piedmont 37 percent had joined the strike.[257]

In Greenville, tensions mounted and violence broke out at several mills. The guard was under orders to "shoot to kill" if the situation demanded. Some workers at Brandon and Poe armed themselves for self-defense. Brandon employees, despite having rushed to join the union five years earlier, turned away the flying squadrons with picket sticks, rifles and shouts when they arrived to close down the mill. Four women and one man were injured in a fight at Judson when a Flying Squadron from Spartanburg visited the mill. Mobs were turned back by the guard at Judson and Woodside. As of Wednesday, twenty-one units of the National Guard were under orders: seventeen were on duty with four in reserve to rush to trouble spots; four more were standing by. A shooting was reported at Judson on Thursday. John Black, a twenty-eight-year-old junk dealer, was killed on September 7 at Dunean by mill deputy Bob Putnam.[258]

High tension combined with personal enmity and inexperienced law enforcement personnel were factors in the greatest tragedy of the strike. Police and deputies opened fire on a surging crowd of strikers and sympathizers at Chiquola Mill in Honea Path on Thursday, September 6. Six people were killed and several wounded. As word spread of the shooting, the magnanimity of the event brought sobering reserve and caution to the villages.

When tension escalated and rumors abounded, Greenville Mayor M. Mauldin asked the governor to declare Greenville County under martial law. The governor requested help from the American Legion. He suggested these organizations in fifty-one trouble spots or potential trouble spots offer their services to the local sheriff. Deputy Commander of the American Legion William D. Schwartz telegraphed key posts of the organization asking their local officials to offer sheriffs their services in keeping order; there would be no taking of sides. The head of the Greenville Ministerial Union asked for prayer on September 9, asking for healing of the communities involved.[259]

While the drama of the strike unfolded differently at each affected mill community, friendships irrevocably broken, even death the final price for a principle during that first week in September, the lives of those in adjacent cities and towns continued without interruption. Schools opened, garden clubs met, church organizations functioned as usual. People not involved directly with the mills in some way either ignored the matter or paid it some idle curiosity. The events of the strike belonged to the mill people. The separateness of the communities is striking. All the commotion occurred in the designated area and affected or involved the designated people.[260]

The UTWA voluntarily disbanded the Flying Squadrons on September 11, in the interest of reducing violence; Peel announced that the strike was succeeding. Ninety-five mills were still closed; sixty-five, most of them in Greenville County, were open. Gorman called off the strike on September 22. The strike was a failure for the union and did not affect the application of the stretch-out. The governor announced plans for demobilization on September 26. Twenty-four units of the Guard were used

during the strike and its aftermath; seventeen hundred men had been mobilized. Virtually every mill in the county had had a taste of labor strife. At Piedmont, a wildcat strike before the general strike was called ended when the operatives formed a company union, the Employees Association of Piedmont Manufacturing Company, and worked during the strike.[261]

The strike did not introduce permanent disharmony within the mill villages but every facet of mill life was temporarily touched. Judson Baptist Church experienced internal discord after seeing considerable minor violence during the strike. Those closely affiliated with the union left the local area. The Southern Textile Exposition scheduled for October was delayed until 1935. Chronologically bracketing the strike was the South Carolina State Textile Baseball Tournament, beginning August 27 and ending September 11. Amazingly, it was little affected by events of the strike; most of the scheduled games were played. Judson defeated Whitmire by forfeit on the evening of the Chiquola shooting when the Whitmire team was unable to show up, putting Judson against the winner of the Lyman–Ware Shoals game. Lyman defeated Judson by a score of 5–2 on Monday, September 11, with all scores coming by homeruns.[262]

THE SPECTER OF FOREIGN COMPETITION

Textile activity increased dramatically during the late 1930s. Between 1938 and late 1939, manufacturing increased 28 percent; cotton consumption was up 25 percent. These increases were counted as effects of the war in Europe. To the east, another power was emerging.[263]

When Piedmont enjoyed its first significant successes marketing its products outside of South Carolina, it was the Orient, primarily China, which bought great quantities of Piedmont goods. Japan, open to the West only a quarter of a century, was finding its way toward modernization. That was in the works as early as 1913 when Japan had mills operating 2.3 million spindles, or about the equivalent of forty cotton mills the size of Monaghan. By 1938, Japan's spindlege had increased almost 500 percent. During the same time period, South America was increasing its spinning capacity dramatically as well. Between 1910 and 1920, Japanese and British-Indian textile operations had replaced America as suppliers to China and other Eastern markets.[264]

While New Deal policies had been successful in controlling supply and demand within the domestic cotton textile industry through approaches largely approved by industry leadership, there was not much America could do to protect its foreign markets. In this less complicated time, the cures were less obvious and limited to diplomacy, attempted trade agreements, tariffs and quotas similar to those established by Great Britain. The question of Japanese textile competition waned as a topic of interest as larger Japanese issues began to crop up during the later 1930s.[265]

Chapter Eight

TEXTILES IN WAR AND PEACE

GEARING UP FOR WAR

Amid the growing crisis, fifty-three German textile executives attended the twelfth Southern Textile Exposition in April 1937. The drift of American foreign policy toward support of the free nations of Europe during the 1930s suggested the eventuality of a war with Germany. After the invasion of Poland on September 1, 1939, this likelihood increased dramatically. Effects on the mills began to show up in 1940 when the draft began to take men away from school, community and the workforce in anticipation of war. Women filled jobs formerly occupied by men. The textile industry was dubbed a war industry and supplies of canvas, gauze and uniform materials took precedence over the usual output of sheetings, shirtings and drills. Cotton remained the principal textile raw material.[266]

As the war raged in Europe, America came ever closer to direct involvement. Our sympathies registered in the Gallup Poll and local reaction were clearly with the British and their allies. During the Southern Textile Exposition of 1941, the last show held until 1948, a dance in honor of exhibitors was transformed into a benefit to raise funds to support the Bundles for Britain program, a relief effort. A London Fire Marshal was a special guest.[267]

GREENVILLE TEXTILES DURING THE WAR YEARS

The war brought an end to the Depression. Military orders led to increased industrial activity, created more jobs, many requiring overtime work, and guaranteed full-scale operation of every plant. The federal wages and hours legislation of 1938 assured mill workers of consistent wages. As the effects of the Depression waned, mill workers experienced economic improvement. Union activity declined in the wake of prosperity and the appeal of patriotism.

Some men operatives received deferments from their selective service board to perform

necessary work, particularly if they were skilled mechanics, fixers or machinists. Liaison officers were appointed to work with mill management to achieve production quotas. Because of the recent labor unrest within the industry, particular effort was made to encourage rather than coerce workers to meet sometimes-difficult quotas. Early in the war, mills ran seven days a week when possible to meet increasing demand. Patriotism, sacrifice and teamwork were common themes put before employees by management and the military to encourage cooperation and reduce absenteeism, the goal being to defeat an enemy in the workplace as well as on the battlefield.

As employees of wartime industries, mill workers were required to wear identification badges as a security measure. Mill villages were organized and subject to the same drills and regulations as other communities once the Civilian Defense program was implemented. Mill management encouraged operatives to grow victory gardens as they had during the previous world war and to buy war bonds that could be purchased by payroll deduction. Companies guaranteed jobs after the war to men who were drafted and served honorably. Textile Hall was opened as a recreation center for local and passing servicemen in mid-1942.[268]

The wartime economy aroused interest in the Franklin Mill, limping along under receivership since the mid-1930s. The Court of Common Pleas of Greenville County authorized receiver Stall to sell the property in March 1942 to Victory Textiles, a corporation formed by Roy McCall and W.W. Pate and capitalized at $40,000. McCall, Pate and H.E. Jones acquired control of Victory Fabrics of Greenville the next year. McCall, a North Carolinian, had been a cotton buyer and banker, serving as a director of Easley Bank. Victory Textiles acquired military contracts and maintained full-scale operations through the end of the war. The mill company prospered once again and in mid-July 1943 made its last payment to the estate of E.H. Shanklin.[269]

The village houses at Pelham Mills community were sold during the war years by J.P. Williamson and M.S. Merritt & Rush Realty Company. The Pelham houses were priced modestly and could be bought on terms. Dennis Grubbs was living on J Street when the opportunity came for him to buy the house in which he had lived for years. He bought his house and lot overlooking the Enoree River for $260, financing the purchase through the realtor with a down payment of $15 and $6 payments at 6 percent interest. Payments were made directly to the realtor in the Pelham Mill office, which had remained open to receive rent payments and settle accounts since the mill closed. Claude B. Cannon, office clerk, remained as an agent for the realty company to receive monthly payments through the war years. The only restrictions on the property were that the buildings could not be removed without consent of the seller nor could any conveyance, lease or occupancy by a colored person be permitted.[270]

Corporate changes affecting the Greenville textile industry continued to occur during the war but with a reduced frequency. Reedy River Manufacturing Company had sat idle for several years before W.M. Skelton and Henry Williman bought it in July 1943. By the onset of war, Southern Weaving had added a bleachery to its operation. The old Vardry Mill, formerly Sampson & Hall, saw its last use as a waste paper warehouse and burned

on November 9, 1943. Furman University owned it at the time of the fire.[271]

Military needs dictated different product lines during the war. Duck cloth or canvas was produced at Brandon and Victory Textiles, which also had contracts to manufacture medical gauze and, late in the war, twill for uniforms. Duck cloth was turned into gun coverings, tents, hammocks, jeep tops and boots. Uniform twill fabric was produced at many mills including several of the Victor Monaghan plants. Japanese control of the silk trade disrupted production in certain departments of Judson and Slater. Slater rayon weavers, in the wake of a silk shortage produced by the Japanese seizure of China, developed and contributed ideas and sent for military evaluation prototype samples of new materials designed for use as cartridge cloth in 1941. Southern Weaving produced nylon webbing for parachutes during the war. That company's peak year was 1943 when 4,016,157 pounds were produced.[272]

World War II brought the realization to leaders of Greenville's textile community that the workforce of the county was in short supply of trained personnel in key managerial positions. J.E. Sirrine and a number of mill executives put the challenge to the South Carolina Cotton Manufacturer's Association in 1943. The challenge consisted of establishing a foundation to fund textile education, training and research. Chartered in October, the Sirrine Foundation set about to raise a million dollars to endow the organization.[273]

The war effort required the services of the entire hierarchy of the mill community, from yarn boy to superintendent. Often the supervisory personnel were too old for active service but the younger, college-educated mill men were sought to fill the officer ranks as America built its military. There is no compilation of the mill personnel who served the country and therefore it is not possible to commemorate the heroism of all individually. Among those representing the best patriotic efforts was Captain Alfred J. Folger of Judson Mill who was killed in action in France July 15, 1944. Just four days earlier he had been nominated for the Silver Star for actions while leading an assault on a German position. The award was made posthumously.[274]

The war at home was also recognized by the military. The War Department created the Army-Navy award for efficiency that was given to plants that maintained near-perfect production schedules. "E" Badges were awarded to all employees of mills that met production quotas. Mills Mill and its two subsidiary plants, Mills Mill of Woodruff and Fairforest Plant, were awarded the Army-Navy badge for excellent war production on March 27, 1943. J.M. Reeves, one of the owners and president of the plants, received the honor on behalf of the labor force. The company had expanded its weaving operations specifically to accommodate the needs of the army, navy and marines. Union Bleachery was awarded the Army-Navy badge twice within a six-month period, first in late 1943 and again in March 1944. A white star was added to the second award. The plant also flew a Minute Man flag to show 100 percent participation of the workforce, totaling almost one thousand in the war bond drive.[275]

The day-to-day ordinary work of the cotton mills became part of an extraordinary effort for four years. Production of war materials took on an importance and often special personal significance for workers that domestic cloth production did not have; this was

World War II
identification
badges.

especially true for those parents and wives who continued to work in the mills after receiving those dreaded telegrams informing of the loss of a loved one.

WAR'S END AND CHANGE

In summer 1946, Victor Monaghan stock soared, July prices alone rising some 20 percent, on talk of a possible merger with J.P. Stevens Company. When J.P. Stevens Company bought Victor Monaghan, it became the state's largest textile employer and immediately began to change the way textile companies operated in South Carolina. Greenville area mills affected included Piedmont, Dunean, Slater, Monaghan, Victor, Greer and Apalache. Total capitalization of the new conglomerate was almost $82 million. Competition from home and abroad required the company to eliminate cost and correct inefficiency. Stevens sold the mill villages and immediately began a massive modernization undertaking at existing plants. Village property was sold beginning in 1947 and continuing into the early 1950s. New machinery was introduced where needed; windows of older plants were bricked up to help control the manufacturing climate. In time, the enlarged conglomerate restructured its administrative organization and set about to develop new markets and diversify its product lines.[276]

Organized by John P. Stevens on August 1, 1898, in New York as a selling agency to handle the products of M.T. Stevens & Sons, successors to a woolen mill founded by Nathanial Stevens in 1813, J.P. Stevens Company's first South Carolina connection began in 1910 when it represented the Glen Lowry Mill of Whitmire. In 1911, Stevens became associated with Adger Smythe, founder of Dunean. The company was reorganized in 1923, 1930 and 1946. In its final form, it was established as a multi-state textile corporation with thirty-three plants manufacturing a diverse range of products including cotton, wool and synthetics. The Stevens Company sought competent college-educated textile engineers to run its operations; it eventually located its operations center in Greenville and retained only its sales offices in New York. It did no less than create a new paradigm for the "model mill" in postwar America and thrived for a generation by rigid adherence to a management scheme that allowed little delegation of authority.[277]

The late 1940s saw several major corporate changes, although none of the magnitude of the Stevens accomplishment. Victory Textiles became McCall Manufacturing in 1949, reflecting the ownership by Roy McCall and Roy McCall Jr. Capitalization was increased under the McCalls to $500,000 on May 2, 1949. In the interest of economy, the company followed the lead of larger firms and sold the village by the middle of the same year.[278]

The controlling interest in Brandon Corporation was purchased by Greenwood conglomerate Abney Mills in December 1946. At the time, Brandon consisted of four mills and operated over 170,000 spindles. Thomas Charles, a Furman graduate and

Dunean from Badger Street.

former secretary of Pelzer Manufacturing, continued to operate Conestee for almost twenty-nine years until his death in 1938. Blackington Mills then purchased Conestee Mill in 1946, possibly for use as a woolen and dye plant. Southern Pile Company and Brooks Brothers were absorbed by Brookline Fabrics in 1948.[279]

In late 1948 plans were announced for a $4 million mill to be located on the White Horse Road by Maverick Mills of East Boston, Massachusetts. Plans called for a 200,000-square-foot plant with 480 looms and 28,000 spindles. There would be 350 to 400 employees. This would be the first mill added to Greenville since the Slater Mill was built in the late 1920s, a very good sign that Greenville was making progress again. The home office of Maverick Mills quickly pointed out that this mill represented an expansion rather than a move south.[280]

The same year, Woodside Mills, headquartered in Greenville, acquired plants in Easley and Central, South Carolina, and three years later, the company acquired the Haynsworth plant in Anderson. Woodside added a mill in Easley, one in Anderson and two in Liberty after World War II to become a major player in the industry. Union Bleachery was sold in 1947 to Aspinook, the Lawrence Printworks and the Arnold Printworks. Deering Millikin became owner of Judson by 1948.[281]

By 1948, textile employment in Greenville County steadied around 21,400. With the consolidation of the county's eighty-odd districts into a unitary school district by act of the county commission in 1951, mill schools passed into educational history. The most significant change that the mill operatives of Greenville County experienced, however, was neither the school passage nor the enlarged corporations for whom many of them worked by the 1950s, but the alteration of their way of life

Things to Remember

1. Always take your book with you when you make your payments and see that you get the proper credit.

2. Enjoy the use and possession of your lot; plant a garden or shrubs and trees. Don't build unsightly buildings on it. Keep the weeds down.

3. Remember that this is a formal contract and binds both the seller and the buyer. Make your payments regularly and keep your part of the agreement just as you expect him to keep his.

CONTRACT

J. P. Williamson, M. S. Merritt and Rush Realty Co.,
hereinafter designated as "the Seller," agrees to sell
and *J. Dennie Grubbs and Minnie Grubbs* of

No. _____ Street,

City of *Pelham*

hereinafter referred to as "the Buyer," agrees to buy Lots

No. *6* and the house or houses

thereon in *Pelham, S.C.*

for the sum of *Two Hundred Sixty*

($ *260.00*) Dollars to be paid as follows:

PAYMENTS:— _____

($ *15.00*) Dollars on the execution of this con-

tract and _____ ($_____)
Dollars on or before each and every Saturday from the

date hereof or _____

($ *6.00*) Dollars on or before the last day of
each and every month hereafter until the purchase price
has been paid in full. Said payments to be made at the
Pelham office of the seller or at such other place as seller
may designate. Said payments shall first be applied to the
payment of interest, taxes and insurance and any balance
credited upon the principal.

INTEREST:—The unpaid portion of the purchase price
shall bear interest at the rate of six (6%) per cent per
annum to be computed and paid weekly-monthly. Interest
'not paid when due to bear interest at the same rate as
principal.

Contract to buy a Pelham Mill
house. *Courtesy of Minnie Grubbs.*

derived from the sale of the villages and collateral changes.

SALE OF THE VILLAGES

Mill owners' decision to divest themselves of the villages was based on economics rather than in the interest of social improvement. The aging villages were expensive to maintain. The cheap rents were not realistic nor were the scope of improvements required to justify a more realistic rental schedule. The Loper Report of 1935 estimated the cost of housing to the mill companies to be many times the rent received. In 1935, the average cost to the mill was put at $4.56. By 1946, rents ranged from $0.15 to $0.75 per room per week. It was just a matter of timing when the villages would be offered and how.[282]

The idea of operative ownership was not new even among mill presidents. Lewis Parker and Bennett E. Geer took steps toward this objective without much success. By the end of the Second World War, the villages of Greenville were virtually intact. Reformers had continued pressure on the textile mills to eliminate company housing. Bishop James Cannon Jr. launched a program in March 1927 to eliminate the cotton mill villages. He and forty other Southern bishops appealed to factory leaders to allow the mill and community at large to merge. If the South would heed his advice, "the South will avoid the waste and bitterness of industrial conflicts and the intensity of the class struggle." During the New Deal, presidential advisor and South Carolina native James F. Byrnes called for the transfer of the villages to the hands of the operatives. Judson offered fifty-three houses of its village to the operatives in 1939. Liberal and socialistic philosophy underpinned much of the criticism and promoted the leveling and amalgamating effect on society that would derive from selling the villages. But in the end, it was the financial accountability to stockholders that prompted liquidation of company housing.[283]

After the sale of Pelham village during the war years, Judson offered its remaining houses. In 1948, Dunean announced it would sell its houses. The news was received positively by a majority of the operatives, who foresaw no real change in their way of life. The purchase of several county mills by J.P. Stevens hustled onto the market hundreds of relatively inexpensive housing units by 1950. Francis W. Poe Manufacturing sold its village, commencing in August 1950 and continuing to sell houses through the mid-1950s. The sale of Mills Mill village in Woodruff was completed by June 30, 1955; 116 houses were sold for about $400,000. The village at Union Bleachery, which became a property of Cone Mills in 1952, was sold in 1959. Most of the houses were bought by their tenants. Some were purchased for resale or for rental property. Within a twelve-year period close to 90 percent of the county's mill houses had been sold.[284]

Along with village housing went properties held to maintain and sustain the village such as landfills, company farms, shops and company stores and materials warehouses.

Outside crews were either dismissed or found work, if possible, in opening rooms or product warehouses. The villages, no longer qualifying for municipal tax agreements accorded plant owners, were available for annexation to the tax base of Greenville and other mill towns of the county.

Changing Traditions

Many of the women who first found jobs in mills during the war continued to work in peacetime. While the company store was gone as such, often the presence of the store persisted in the form of independent merchants who set up business on the periphery of the village. J.P. Stevens Company awarded the lunch concession to an independent store or café in the vicinity of each mill. For several years until vending machines were installed, the "dope wagons" continued to roll the spare floor of each department about midway through each shift, the attendant selling sandwiches, crackers and soft drinks.

The fraternal brotherhoods once so common on mill hills gave way to other social organizations, some affiliated and others not affiliated with the mills. At Brandon and Monaghan the Masons continued to meet. The Junior Order of United American Mechanics, Red Men, Oddfellows and other social organizations were not so long-lived. Agreements with YMCAs were allowed to expire. Mill churches often remained intact and at the same location through the generosity of the company, who most of the time conveyed the title to the trustees for a nominal sum. Fishing clubs became popular organizations at several mills during the 1950s. Annual fish fries were held as award suppers to honor those catching the largest fish of each of several categories. The Woodside Fishing Club membership took its annual contests so seriously that members went to court to settle the question of who won the catfish division in the 1954 contest.[285]

Textile basketball continued to surge in popularity after the war, partly because of its expansion to include players not affiliated with mills and partly because of the timing of the season and tournament. The tournament was not held from 1942 until 1946 because of the war. In 1947, six thousand watched the finals after eighty-six teams representing perhaps one thousand players, coaches and managers had been eliminated to two. Crowds became large enough that by the end of the 1950s, the tournament moved from Textile Hall to the Memorial Auditorium.[286]

Easily by the second half of the century, many if not most players on mill league teams had never doffed a beam nor marked filling nor swept lint nor creeled nor wove nor even set foot inside a mill. Many were local college athletes who played to gain practice time and showcase their abilities. When textile basketball included teams representing industries that had little if anything to do with textiles, only a shadow of the old tradition remained. Each passing generation knew a little less about the roots that supported the yearly competitions; knew a little less about the kind of folk who originally lived in the quaint collection of houses located around the periphery of the

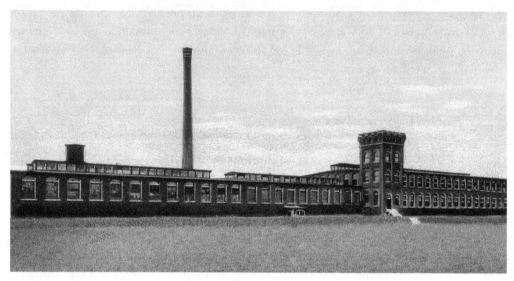

Union Bleachery.

city and in the small towns of the county. By 1970, the tournament was the largest event of its kind in the world.[287]

Textile baseball was hard hit by the war and almost ceased during the war years. After the war, it surged with renewed interest as lights were installed at many stadiums. By 1948, one hundred games a week were played among mill teams. Night games became something of a fad; several parks were equipped with arc lamps. In the Western Carolina League, Brandon, Woodside and Monaghan had lighted parks. The only park in the Greenville League with lights was Slater. Like basketball, textile league baseball had its season, peaking in 1949.[288]

By 1950, even with some two thousand players in twenty leagues, attendance began to fall off. A number of factors played a part in the decline of textile league baseball. The dissolution of the village culture, which was ushered in with the removal of company-owned housing, churches, schools, stores and meeting halls, removed the sense of community and camaraderie. Television with its broadcasts of national sporting events was likely a factor. There were also international problems that Americans now had to face and worry about: the bomb, the cold war and Communism. Textile baseball gradually withered, each passing year bringing fewer teams to competition. Most Greenville County mills continued to field into the mid-1950s; local teams played in three different leagues in 1955. The last year of competition was 1971.[289]

ASSIMILATING THE MILL CLASS

Each generation of mill folk developed more and deeper connections with the adjacent town and its people. The process between 1920 and 1940 was gradual but irreversible as two

cultures became increasingly similar. The changes that swept over mill communities after the Second World War brought about the final phases of assimilation. The mill class was freed, not of any malignant paternalism foisted upon it by mill owners, but freed of their own recently evolved traditions and expectations. Whatever paternalistic devices existed during the first decade of the century had been largely removed through the application of progressivism. Up until 1918 or so, transience among employees had been a significant problem for the mills. The number of "floaters" had declined; compelling reasons to stay in one place included possibility of advancement within the company and community, welfare programs and availability of social institutions. Once settled in a village, operatives and their families developed customs and rituals, incorporated the language of textiles into their speech patterns and built expectations based upon their day-to-day experiences in the mill.[290]

Various levels of legislation served to equalize schools and public health and reduce the incidence of child labor. Mutual economic dependency between mill folk and others pecked away at the class barriers. Early social interaction between classes achieved noticeable results even by the end of the 1920s. Yet the residents of both town and village continued to see the mill class as a different and lesser culture.[291]

By the early 1950s, traditions were in flux, out with the old, in with the new. Wartime prosperity enabled those who wished to escape from the village to do so. The ultimate arbiter of class distinction was economics. The new taxpayers who retained their jobs in the mills and found themselves suddenly transformed into townspeople gradually adapted to their new roles as best they could. Their children, the baby boomers, invariably left the village and the industry behind. Criticism of the mill village system had been valid in part. The degree of difference in culture between the mill and town folk of 1900 was not as much as one might think. In terms of education, sanitation and labor, both groups were not far apart at all. The principal reason for this mutual non-recognition was isolation of the mill village.

Assimilation is constant; it is mutual and proportionate to the relative size of the groups interacting, since the mill village constituted a separate, other town. Parallel economies operated to perpetuate separation of the classes, much in the same way that similar forces perpetuated racial segregation.

THE SOUTHERN TEXTILE EXPOSITION

The Southern Textile Exposition in 1941 was the last show held until 1948. It was postponed in 1946 while the industry focused on meeting consumer demand accumulated during the war. By 1948, physically unable to deal with the rigors of planning and organizing the show on a full-time basis, William Sirrine, president of the exposition since its inception, stepped down. Many of the old-timers who had been involved with planning the shows of the 1920s and 1930s were no longer around. Responsibility for organizing and promoting the exposition fell to the corporation's secretary and Sirrine's longtime assistant, Bertha Greene. During the planning phase, many of the exhibitors

questioned whether Greenville was the best place to continue the show; some wanted to move to a larger, more convenient location. After due consideration, a majority of the directors decided the exposition would remain in Greenville. Greene then had the unenviable task of rebuilding support for the show plus carrying out her regular day-to-day workload. Miss Greene, with twenty-five years' firsthand experience, in-depth knowledge of the textile industry and personal acquaintance with many exhibitors, was able to persuade many regulars to return as well as recruit new participants. For her efforts, she was given directorship of the exposition.[292]

Chapter Nine

Greenville as the Textile Center of the World

Greenville became the "Textile Center of the World" on October 15, 1962, when the final link was complete joining the city with the rest of the world. The Southern Textile Exposition opened to thousands from across the country and around the world just hours after the first aircraft landed at the Greenville-Spartanburg Jet Port. Where cotton had once reigned as king was now the seat of a textile empire.

The next two decades, beginning with 1950, saw the Greenville area textile industry almost continuously expand physically and influentially. By fiscal year 1949–50, Greenville's textile output accounted for over three-fourths of its industrial product. During the twenty-five-year period after the Second World War, textile investment in Greenville County more than quadrupled. The era of the old-time cotton mill, however, had ended. Mills dedicated exclusively to the manufacture of cotton products were dwindling. The development of cotton blends, introduction of new fibers, novel application of textiles and, above all, concern for rising costs required manufacturing companies to plan long and diligently before new startup operations. Fewer mills were built during this period as manufacturers focused upon modernization of existing structures. Those plants constructed after 1950 were technologically advanced, single-story and laid out to maximize convenience for operations, shipping and receiving. They also required fewer but increasingly skilled employees to operate them.[293]

The new face of textiles in Greenville County also included a surge in the garment industry component. A number of apparel plants were located in Greenville during the period from 1948 to 1958, quadrupling the number of employees to eight thousand.[294]

Industrial Changes and Corporate Development,

1950–1980

The makeup of the local workforce shifted from well mixed to one that was increasingly female, largely because of the appeal of the apparel plants. In the upstate 88 percent of the apparel workers were female by 1968. Greenville's first garment factory was established in 1910 but apparel industries arrived in force about 1930. By 1968, there were forty apparel plants located in Greenville and Pickens Counties. Other than a trend toward manufacture of finer yarns, apparel represented the first major diversification of the textile industry in Greenville.[295]

By the mid-1950s, increasing demand for products manufactured from synthetic fibers brought new opportunities to Greenville County as well as a much broader definition of the term "textiles." J.P. Stevens Company's corporate structure reflected this trend within the industry, assigning mills in the county to synthetics or cotton products divisions, those in the cotton division tending to be older operations. Piedmont and Apalache of Greer were devoted exclusively to cotton manufacturing. Dunean and Slater produced exclusively synthetics. Victor, also at Greer, was a rayon plant. In 1960, the American Cotton Manufacturer's Institute became the American Textile Manufacturer's Institute, further indicating the direction the industry was taking. Woodside Corporation's Simpsonville plant, also a synthetics manufacturer, posted a sales increase of 33 percent over the next five years beginning in 1959.[296]

For Woodside Mills, the early 1950s represented something of a turning point. Like other companies facing a changed postwar world, Woodside discontinued the company store and sold a majority of its houses before the remaining community took a step backward to preserve its character and avoid higher taxes. In July 1950, Woodside village voted to incorporate as a town by a vote of sixty-three to six. The new town of elected town officials included a mayor and police chief who accepted nominal salaries. The town limit stretched over the last fifty village houses owned by the company; city hall was an office in the Woodside Mills community building.[297]

Corporate changes during the fifties consisted primarily of mergers and reorganization. Two startup projects, however, got underway at the beginning of the decade. Fairview Mills, portending the trend of the textile industry of the future, was under construction in the latter half of 1950 at Fountain Inn. The local Boosters Club raised money and donated a thirty-five-acre tract for the construction of a tricot knitting, dying and finishing plant. It was completed by 1951 at a cost of $2 million. By 1960, it was an operation of Beaunit. White Horse Mill, a division of Maverick Mills, announced in 1948, was built during 1950–951, eventually running 1,300 looms and 69,000 spindles.[298]

Southern Bleachery and Print Works had operated continuously since 1936; founder Harry R. Stephenson retired in December 1953. In 1954, the company was

Part of second shift, Greer Mill, 1954.

bought by Ely and Walker Dry Goods Company of St. Louis. Ely and Walker also bought Francis W. Poe Manufacturing Company in December 1957. Fifteen months later, Burlington Industries bought the plant from Ely and Walker. Blackington Mill, formerly Conestee, operated until 1953, when it was purchased by Wyandotte Worsted of Maine. Woodside Mills was bought by Dan River Mills of Danville, Virginia, in 1956 and continued to operate as a division of the Dan River Company. Mills Mill, owned by Reeves Brothers began a modernizing program at the end of the war that continued through 1964. Projected costs of improvements were in the area of $12 million. The final phase of the project was the addition of air conditioning. American Spinning, owned by Florence Mills, was sold in 1953 to Cone Mills, which operated the plant through 1990.[299]

By the 1950s, Riegel Textile Corporation had acquired Virginia Manufacturing at Fork Shoals. A small operation at 4,400 spindles, it was expanded to 14,000 spindles. The small plant was part of the Ware Shoals division and manufactured cotton yarns. In 1955, McCall Manufacturing was reorganized, becoming Greer Manufacturing Company; it was chartered June 1, 1955. Under the direction of Superintendent Miller West, McCall produced cotton sheetings, twill, industrial fabric and cotton specialties. Union Bleachery had become a Cone Mill property by 1955 and expanded the work floor that year by 30,000 feet. Woodside Mills merged with Dan River Mills of Virginia in 1956. In 1957, the company enlarged the manufacturing floor of its Fountain Inn

plant. Woodside Mills acquired the Cateechee plant of Norris Manufacturing in Central in 1959.[300]

By the 1960s, a number of textile suppliers including textile machinery companies had established branch offices or had moved operations to South Carolina. While Greenville County did not attract a major manufacturer of textile machinery, it already contained a company that began as a repair service for the textile industry and evolved into one of the world's leading textile machine manufacturers. John D. Hollingsworth on Wheels, Incorporated, eventually absorbed Platt-Saco Lowell, which had migrated south to Easley, lock stock and barrel in the late 1950s. The Hollingsworth Company became known particularly for its contributions to the carding process.[301]

Corporate activity continued at an optimistic pace during the 1960s. White Horse Mills, a division of Maverick Mills, by 1960 employed 600 and had over 69,000 spindles and 1,300 looms. It was sold to J.P. Stevens after operating twelve years. The largest single investment to date in Greenville County textile history was the construction of the Woodside-Beattie Plant, which represented an investment of $11 million. Under construction in 1962, it was the state-of-the-art mill in America. It was also the largest industrial building in the county with a ten-acre roof and a startup workforce of 350 hands.[302]

Man-made fibers had been around for decades but the scope of operation envisioned by Nylon Industries in 1964 was far beyond previous textile investments in the county. The textile industry was enjoying a period of prosperity in 1964. Two thousand new textile jobs had been added to Greenville County when Nylon Industries announced an anticipated investment of as much as $100 million. The plant was expected to be operating within two years with upwards of a thousand start-up workers. Nylon Industries was acquired by Fiber Industries in 1965 and the new plant, located on Interstate 85, was given the corporate name. Greenville's textile employment remained steady for the decade of the sixties, averaging close to twenty thousand employed.[303]

Burlington Industries bought Southern Bleachery and Print Works in early 1965 and closed the plant in six months, throwing one thousand workers out of a job. J.P. Stevens Company bought the plant in March 1966 and reopened with two plants at a single site. Stevens No. 1 manufactured cotton sheetings; Stevens No. 2 manufactured tufted carpet and fine gauge synthetic fabrics and cotton sheeting. [304]

Greer Manufacturing Company, specializing in cotton sheeting, twills, industrial fabrics and specialties, gradually lost ground in a declining market. By 1967, it had reduced its workforce by half and was manufacturing only cotton sheeting. The company was unable to meet its obligations. Its principal creditor sued. The mill ceased operations and was sold in early 1970.[305]

America's role in the international textile trade was governed by issues in the larger world. The 1960s were a time of evolving complex relationships involving America, its allies and its enemies. There was reluctance or perhaps an inability on the part of

AMERICAN

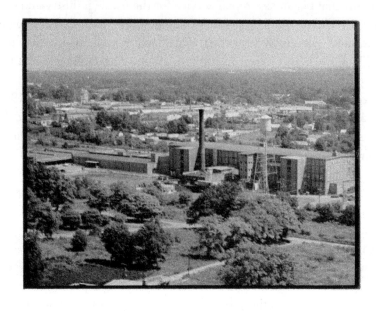

★ SPINNING

Cone Mills Corporation

Cone Company employees' handbook for American Spinning.

Modernizing the timekeeper's work.

Congress to stop importation of cheap foreign textiles through tariffs. Explanations were couched in diplomatic terms combined with assurances that the quality of the product would protect the American industry from that developing abroad. Textile companies tried to protect themselves through greater diversification, cutting labor costs, mergers or constant modernization. Textile mergers peaked during the 1960s. Restricted by federal guidelines that no mergers could result in a company that had above $300 million in annual sales, companies shifted emphasis once again to expansion and modernization.[306]

The 1970s saw worldwide competition coupled with new federal environmental and health regulations severely crimp the industry. Once common for some companies, expenditures of the size required to respond to these latest challenges was out of the question. Wyandotte Worsted held Conestee Mill until 1971 when the old mill was leased to Spanco Industries of North Carolina for five years. Spanco broke the lease the next year and Wyandotte leased to UPD, Incorporated, of New York. UPD later owned the property for a short time before selling to Standard Textile Mills in 1973. Five years later, Standard sold to J&B Associates of Greenville. Brandon Mill of Greenville, an Abney plant, reduced its workforce by 300 in October 1969. In March 1977, the plant closed with a job loss of 400. Renfrew was sold by Abney in 1979 to Kerr Finishing Division of Allied Products; the outlook for the plant called for continued operations with a workforce of between 100 and 150. [307]

Mills Mill, owned by Reeves Brothers of New York since 1918, closed the plant and offered it for sale. As recently as 1976, some 335 employees worked there. Layoffs in 1977 of the weaving department reduced the number of hands to 136. Poor markets and large quantities of imports were problems cited by officials of the company. Mills Mill was the eighth Greenville area closing in eighteen months. This event portended similar divestments of mills that followed in the next two decades. Southern Worsted was purchased by Stillwater, Incorporated, of Rhode Island in 1975. At the time, the

Southern Bleachery.

company employed 300 workers and specialized in top dyed fabrics. Westboro Weaving continued to operate through the 1970s.[308]

J.P. Stevens had reduced its workforce in Greenville County beginning in the early 1970s. One of the largest employers in the state, beleaguered by foreign competition, costly attempts by labor to organize its plants, federal regulation and demands for performance from stockholders, Stevens doggedly resisted union organization of its plants, mostly outside of South Carolina. It moved its operations headquarters from New York to Greenville and began holding annual shareholders meetings here in 1979. In 1971, Stevens opened up a new version of the company store on White Horse Road. Operating as Stevens Store, it offered finished goods for sale to consumers with Stevens's employees and retired employees receiving discounts. A second location on Laurens Road was open by 1974.[309]

PREPARING A NEW WORKFORCE

The Sirrine Foundation had been created for the purpose of training needed personnel for the wartime textile industry. At war's end, South Carolina had more than a third of the nation's spindles and produced over a third of the nation's linear yards of cloth. To maintain this position, it was necessary to keep the industry current in terms of strategies and technology. Clemson remained the center for textile training, turning out scores of mill executives. Between 1944 and 1960, the foundation contributed over one-third of a million dollars to the Clemson School of Textiles.[310]

Before the Second World War, the vast majority of textile managers from superintendents down received their textile mill education on the work floor under an informal apprenticeship system. In the yarn preparation department of a typical operation, sweepers and yarn boys learned to mark filling or order yarn for the quillers or winders. The next step up was the job of fixer. The fixer learned the job of the assistant shift overseer. The assistant overseer could rise to department overseer on the third shift and work his way to first shift over a period of years. Serving as overseer or assistant overseer in several departments would ultimately qualify him for superintendent. The system varied according to mill and department. No educational background or skills other than basic mathematics, reading and writing were required; many mill managers did not possess a high school diploma. Ability to interact with employees at every level was critical; unsuited apprentices remained fixed at the level on which they performed best.

Textile companies increasingly sought managers with formal training after the Second World War, reflecting, particularly by the 1960s and 1970s, the level of complexity to which the industry had risen. The School of Textiles at Clemson College had evolved with the industry since its creation in 1898. The original course of study had been called simply "Textile Industry." By the 1920s, one could major in weaving and designing or textile chemistry and receive a textile engineering degree. In 1946, the weaving major was cut and in 1957 "textile science" replaced "textile engineering." Still, college-trained men in the Greenville mills remained scarce after the end of the Second World War.[311]

Things changed. The apprenticeship program could take years to produce a white-collar overseer. The rapid growth of the textile industry after 1950 demanded a fast-track system to fill the need not only for qualified managers but also for the machine operators of the future. For each job created during the mid-1960s, the estimated investment was between $30,000 and $50,000. By 1964, mill companies were looking for applicants among the pool of high-school graduates. The future held fewer jobs because of increasing automation; the textile worker of the future needed to be versatile, able to pick up the skills to enable the operation of modern machinery that was subject to frequent modification. New technology also required a higher level of skill among the mechanics, fixers and technicians; and shift overseers and superintendents needed to know what their employees were doing in order to be effective.[312]

South Carolina had instituted the Technical Education System in response to the increasing need for trained technicians in all areas of industry. Greenville's Technical Education Center (TEC) was set up in 1962. Here, students could learn specific technology without frills in a matter of months or a couple of years. The textile program was set up in 1965. To meet the specific needs of the textile industry a two-year textile program was set up under the supervision of R.B. McKinney, an eighteen-year textile veteran.[313]

ESTABLISHED 1887

PROVIDENT
LIFE AND ACCIDENT INSURANCE COMPANY
CHATTANOOGA, TENNESSEE

(Herein called the Insurance Company)

CERTIFIES THAT the person named on the filing back of this certificate, an Employee of

J. P. STEVEN

(Herein call

is insured for the Major Medical Expense ⋯ ⋯ ⋯ ⋯ ⋯ ⋯ ect to
the terms and conditions of the group p⋯
this certificate.

Maximum Reimbursement for the E⋯

 This certificate on its effect⋯
Insurance certificate or certificates⋯
and supplement described on the filing ba⋯
icy providing Major Medical Expense Is⋯
certificates are void.

 The provisions of the group policy and supplement described in t⋯ well
as all other provisions, conditions and agreements contained in the group polic⋯ upple-
ment, apply to the insurance evidenced by this certificate. The group policy and supplement
and the applications therefor constitute the entire contract between the parties.

 The Effective Date is the date shown on the filing back of this certificate, provided the
Employee is actively working for the Employer. If the Employee is not actively working on
that date, the effective date shall be automatically changed to the date the Employee re-
turns to active work for the Employer.

President.

MAJOR MEDICAL EXPENSE INSURANCE

Form F-9826—1st Ed.—2000—7-54—(Maj. Med. Suppl.—S.O.P.)

[Overlaid card:]

EMPLOYEE

PLANT 245

Grady Belcher

J. P. Stevens & Co., Inc.

EMPLOYEE STORE PURCHASE CARD

1971

This card, issued to an employee is to be used only by such employee
or any member of his immediate family, when making purchases at the
Stevens Employee Store. This card must be presented when making
purchases and becomes void when employee terminates service with the
purchases. A new card is issued each year.

Grady L. Belcher

EMPLOYEE SIGNATURE

Latter day benefits: insurance and discount shopping.

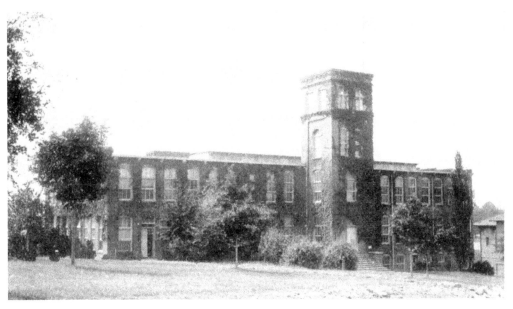

Clemson Textile building.

An Integrated Workforce

The state legislature had accepted the prevailing argument of the era that Negroes, by nature, were unable to work under the discipline of the factory system. That assumption coupled with other concerns over potential racial interactions led to the enactment of the 1915 statute that had prohibited blacks and whites from working in proximity with each other. The prohibitions were demanding, requiring separate facilities for the races including entrance doors and even pay windows. By 1935, black workers accounted for less than 4 percent of the textile jobs in Greenville. Black women were virtually excluded except as housekeeping staff, representing one-fifth of 1 percent of the workforce.[314]

Before the reality of the civil rights movement was recognized, a management tool often used to counter employee complaints and restiveness was the threat of replacing white workers with cheaper black labor. This would not happen as long as the present workforce remained loyal to the company. Loyalty meant many things: working whatever schedule was necessary, accepting pay increases given rather than asking for them—perhaps the final tradition lingering from the good old days—and manifestly staying clear of all contacts with trade unions. These understandings were not necessarily part of any official policy but they were conveyed to the workforce by hint and innuendo through departmental meetings on the work floor. Care was taken never to come right out and forbid participation but the innuendoes were crystal: do not join a union, or if you do, let that be the limit of your participation. Unions were not welcome. Companies could shut

1— Construct a corkscrew twill by rearranging the $\frac{8}{3}$ twill, I R.E.W.

2. Construct a corkscrew twill by rearranging the $\frac{6}{3}\frac{1}{1}$ twill I R.E.W.

3— Construct a corkscrew twill by combining the $\frac{7}{4}$ & $\frac{6}{5}$ Twills in I R.E.W.

Problems in skip twills; Clemson student's assignment, 1938.

down, employ a black workforce or fire troublemakers.

By 1970, government and business and social leaders in South Carolina had achieved common understanding after witnessing a decade of resistance against the civil rights movement across the South in places like Arkansas, Mississippi and elsewhere. A riot at Orangeburg had given a blooding to South Carolina. The necessity of preserving the state from violence coupled with recognition of the level of desperation in the black community led to dialogues among black and white leaders across the state. Barriers once legal and later, customary, slowly were removed and the races moved toward an integrated society in schools, government and the workplace.

In the real world of day-to-day society and commerce, the level of racial integration in the South and in Greenville County was much more real than apparent. Outside of the mills and other factories, blacks and whites bought and sold and worked in a single society at least part of the time. There were boundaries, but those became less distinct with time. Visits across the racial lines were not unknown in churches and in play. Before the Greenville County schools integrated, the Southern Textile Basketball Tournament had players of both races on its rosters by the mid-1960s. Talent was a great equalizer.[315]

Blacks found jobs on the work floor of the textile industry slowly, but after almost a half-century of denial, things seemed promising. In 1960, the figure remained low, standing at 3 percent. By 1969, it had climbed to 14 percent, which exceeded the 10 percent average for manufacturing in general and approached the racial proportion in the overall population. Still, the percentages do not reveal the degree to which progress had or had not been made toward an integrated workforce. In late 1972, for instance, the National Association for the Advancement of Colored People filed suit against the J.P. Stevens Company for hiring only "token Negroes" at its plant in Taylors. The suit further alleged that the jobs given minorities tended to be low-end positions often given to faithful but unqualified whites.[316]

Ironically, the textile workplace was finally racially integrated at about the time the textile industry began a steep decline. Neither the social conservatism nor business strategy of the companies were related to the weakening of textiles. Stevens met its domestic competition head-on in terms of product quality and prices, its chief rivals being Burlington and Springs Industries. Foreign competition, however, and advancing technology created noticeable change by the 1970s. Curtailment returned in the form of the temporary layoff. Permanent workforce reduction and perennial retooling only delayed the effects of the fundamental market forces.

Labor Organization

Other changes on the local level were about to occur as well. Unions gained a toehold in Greenville again during the 1950s. This time union presence was less boisterous and more professional than in 1934. Local groups formed during the

1950s were still in a precarious situation. While mere membership in a union was insufficient to merit discharge from the job, virtually any mention of the subject on mill property during the work shift could be construed by management as dereliction of the job and was subject to disciplinary action. Where numbers of unionists were small, which was every mill in the county save Woodside plant, members were furtive in their activities and wary of company spies who attempted to infiltrate meetings and obtain names.

Business meetings of locals were not aimed at immediate remedies of specific complaints but rather at long-range goals such as building sufficient strength to approach the company. It was a slow process and, of local companies, J.P. Stevens was an early target of unions. While an all-out campaign to organize Stevens began in the mid-1960s, plants at Greer and Taylors had small organizing movements underway in the 1950s. Two workers at Greer Mill who spoke to fellow workers during the work shift about the benefits of the union were summarily discharged in 1954. Personnel records indicated poor performance on the job as the reason for discharge.[317]

A chapter of the United Textile Workers of America (UTWA), Local No. 268, was organized at Woodside by 1950. Headed by Jess Mitchell, the union struck for almost two months from August to October 1950. Woodside was the only Greenville plant to become unionized. The UTWA and the Textile Workers Union of America (TWUA) both sought to represent the workers. An election was scheduled to be held in March 1953. The TWUA withdrew from participation, leaving only a choice between the existing union, local 268, and no union representation. Almost 95 percent of the workers voted in the National Labor Relations Board–officiated election. The plant accepted the union by a vote of 571 to 450. It remained existent but with little activity through the end of 1954.[318]

Jake Howard worked at Southern Bleachery in the print mill from 1935 to 1956, when he joined the UTWA. Outspoken and better educated than some of his coworkers, he became a leader at the county level and was sent to Washington, D.C., over the Easter weekend in 1956 to confer with officials at the national office. He lost no time from his job. When he returned to Taylors on Monday, he was reassigned to a different job on another shift, a lesser job than the one he previously had. He understood the reassignment was temporary. After six weeks, he approached his overseer and questioned the reassignment. He was asked to meet in the plant office with the boss printer. "When I went in there, there was the boss printer, the superintendent and several others. They told me the mill management didn't approve of employees being involved in the union." Jake was discharged at that point. "They had figured up my time and paid me off on the spot."[319]

J.P. Stevens Company, consisting of some fifty-four plants and employing thirty-four thousand in the Southeast, was among the largest publicly traded textile manufacturers and became a prime target of labor organizers when a drive was organized in July 1963 at Columbia to unionize the company. Over the next eleven years, the union lost a dozen

Union dues card.

or more elections. Within the same time period, the National Labor Relations Board found unfair labor practices that, in turn, led to multiple lawsuits against the company. Finally, in 1980, Chairman Whitney Stevens, descendant of the founder, agreed to a contract with the union. Three more years were required before the final form of the agreement was reached. Greenville County workers were largely unaffected as the company's workforce was in decline.[320]

THE SOUTHERN TEXTILE EXPOSITION

The Southern Textile Expositions of the 1950s grew progressively larger in terms of both exhibits and attendance. Attendance also began to reflect the considerable international interest in what Greenville was assembling every other year. Foreign visitors had attended the show since at least 1917. With the growth of interest in the show came the quest for additional space. Textile Hall required seven annexes plus leased space to accommodate the 1960 exhibition. Some restrictions on attendance

Unused checks, Local 268A United Textile Workers.

had been in effect since 1939. Tickets were required during the 1950s but available to interested mill operatives as well as managers. Beginning in 1960, shows were open only to those who had invitations. The 1966 exposition was closed to the public. Ticketed visitors included agents for 589 exhibits from thirty-two states and twelve countries and close to 40,000 textile people.[321]

While Greenvillians took immense pride in the worldwide renown of their city, foreign travelers sometimes found it inconvenient if not difficult to find it. Irene Selent, a travel agent in Montreal during the late 1960s, recalled the frustration of the president and vice-president of Montreal Mills in having to make two or more connections at Charlotte, Raleigh and/or Charlottesville before arriving at the local airport. Uncertain of the dependability of the tiny Southern Airways, they booked separate flights to be certain their company could function in case of a plane crash. In terms of modern transportation, relative to other Southern cities, the upstate was not much changed from the days of the cotton mill campaign.[322]

Nonetheless, Greenville attracted interest from the American Textile Machinery Exposition (ATME), which had held shows for sixteen years in Atlantic City. ATME wanted to concentrate all textile shows in Greenville. Agreement was reached in

1967. Additional space was constructed to accommodate the exhibitors of the 1968 show, who numbered 638. The American Textile Machinery Exhibition-International brought over 3,000 foreign visitors from fifty-six nations, further solidifying Greenville's claim to Textile Center of the World. By 1974, the nature of the exhibition was so profoundly international, a name change was in order to promote the event to the world: ITEX-74.[323]

For fifty years the Southern Textile Exposition had been the single most important factor in promoting Greenville's position as the textile center. Textiles had drastically changed in many ways during that time. The cotton mill was something of an artifact. Bringing to Greenville exhibitors and wares relevant to cotton production was no longer enough. The postwar years saw the rise of an international textile market that included much more than consumer products. The American Textile Machinery Association and CEMATEX, the European association of European textile machinery builders, developed an agreement with the Southern Textile Exposition to create an international cycle of shows after the 1968 show.[324]

COMPETITION FROM ABROAD

Between 1933 and 1935, Japanese textile imports increased by a factor of eight. During the next year, imported Japanese goods increased almost five times. As tensions between the United States and Japan increased in other areas, Japan agreed to a voluntary textile quota in 1937. Other issues, of course, led to war. Afterward, the United States rebuilt Japan pretty much in the American economic image, solidifying American presence in the Far East but at the same time guaranteeing the vitality of later Japanese competition. Ten years after the defeat of imperial Japan, that country was producing for the American market men's good quality shirts at a cost of $0.60 a dozen, which were then retailed in New York stores for about a $1.50 each, compared with the retail price of $3.00 each for similar American-made shirts. Camperdown Mill closed August 1, 1956, after twenty-six years, in direct response to foreign competition. Sydney Bruce, president and treasurer, blamed imports of Japanese gingham. Some 250 workers lost their jobs. The mill was razed by the end of February; some 400,000 bricks from the mill were sold to an Anderson contractor, who recycled them into construction of new homes.[325]

Broader Japanese competition was significant by the 1960s and within a decade became a perceived threat to the American textile industry. Robert Small, president of Woodside, spoke at the groundbreaking for the Beattie Plant on June 18, 1962: "The textile industry is a healthy, vigorous and competitive industry…We are not going to sit idly by and see any foreign country or other state take the textile industry away from South Carolina." Still, however, the textile industry was entrenched in Greenville and Greenville laid firm claim to the title of Textile Center of the World. In 1963, Greenville accounted for 45 percent of all new industrial construction in

Illustration from employees' gift catalogue, J.P. Stevens, 1962.

the state, a figure then equal to the combined construction in Virginia and Maryland. By 1964, Greenville County boasted twenty thousand textile employees, of whom 38 percent were female. Over two-thirds of the county's industrial payroll came from textiles. According to Robert Small, still optimistic about Greenville's textile future, "Textiles are a dynamic industry. Our future is bright and Greenville sits right in the driver's seat."[326]

Beyond Local Control

In 1970, the import rate by late October was double what it had been a scant five years earlier and three times the rate of 1960. Japan was the leading competitor, having been largely responsible for a trade imbalance of almost $1.5 billion. The result of the flood of Japanese and other Oriental textile imports was a deep recession within the industry. Local plants went on short time as demand dried up in the wake of imports. J.P. Stevens's synthetics division laid off a significant number of employees over the next year.[327]

Government policy during the 1950s and 1960s was, at best, inconsistent. In 1961, the Internal Revenue Service allowed speedier depreciation of machinery, from twenty-five years to as few as twelve years. After Lyndon Johnson became president, the investment credit clause of the tax code was cancelled.[328]

At a meeting of the Greenville County Historical Society on Sunday, October 18, 1970, A.M. Cross, vice-president of Dan River Mills, spoke about the legacy of the industry to future historians. Noting that over the past year and a half some eighty-five thousand textile and textile-related jobs had been lost to foreign competition, he told the group that historians of the future would see 1970 as a crucial year for the industry. Stopping short of gloom, he characterized Greenville's industry as "modern, big, diversified, strong and the lifeblood of this county" and at a critical point in its history.[329]

In addition to the market forces that demanded a new approach to an old industry, regulation of industry by new administrative bodies appeared in the 1970s, as the fact was finally recognized that technology influences the environment as well as economy. The Occupational Safety and Health Administration (OSHA) also provided oversight to protect employees whose working environment might prove to be hazardous to life and limb. Regulations proved expensive to comply with and this sort of thing became a factor in decisions that left fewer employees and abandoned mills for the Caribbean. The creation of OSHA in 1970 produced financial hardship on Southern mills already burdened with a battle for the market with Oriental competitors. Dust standard compliance and noise reduction equipment were estimated to cost $1.1 billion over a period of six years, ending in 1984 when the first dust standards were to be met. In August 1978 Reeves Brothers announced the closing of Mills Mill because of the federal standards on cotton dust.[330]

South Carolina's textile labor force declined by over 14 percent between 1968 and

1979. In Greenville, the decline was dramatic; from a decade-long average of 19,250 during the 1960s, Greenville's textile employment stood at 13,200 by 1983. In 1985, a report to the Planning Commission by economic analysis projected the continued decline of textiles in the county's economy. By 1985, the impact of technology, foreign competition and the attractiveness of Greenville to non-textile industries would reduce the percentage of textile employees (including apparel workers) to just over 22 percent. And by 2000, the figure would be less than 20 percent.[331]

Chapter Ten

END OF AN ERA

To say that America's textile industry is in decline would be general, unfair and imprecise. That it has experienced massive employee reductions over the past fifty years is accurate. To say that it has redistributed a significant portion of its operations to locations outside the United States in the interest of cost savings is also accurate. It is also correct to characterize the existing textile industry as largely state-of-the-art. And, because of the complexities of international business organization, it is difficult to delineate with precision just which part of the industry is exclusively American.

Greenville County has witnessed firsthand practically all phases of American textile history continuously, from its origins to the present. While the fundamental concepts remain the same, the fibers, processes, machinery, products, financial requirements, markets, scale and workforce have undergone dramatic change. So much change has taken place within the industry, even at the local level, that those who have worked or did work in the industry are filled with both nostalgia and awe when contemplating their labors.

A CHANGING INDUSTRY

By the 1970s, the turning point in the industry had arrived. Imports continued to increase; overall employment figures were on the decline. Only certain corners of the textile industry remained strong. The niche markets served by generally smaller companies fared well. Piedmont Plush Mill, from its founding in 1925, had remained independent and locally owned and produced a product with little variation in its marketability. In fifty years, its workforce had tripled. The 140 employees earned at a rate equal to or above that of other textile employees in the county. A job there had security; an investment there was almost impossible, as its stock rarely came on the market.[332]

The mainstream textile industry in Greenville during the 1970s continued to be the manufacture of some sort of woven goods. Cotton had given way to a

variety of fibers but remained, thanks to the American Cotton Council and other promoters, important in domestic manufacture. But the 1970s saw a considerable decline in the number of workers employed in the industry. Decline in employment was dramatic: from a decade-long average of 19,250 during the 1960s, Greenville's textile employment stood at 13,300 by 1983: approximately a 30 percent decline in fourteen years. The state as a whole experienced a textile employment drop of over 14 percent in eleven years, ending in 1979. A 1976 projection presented to the Planning Commission anticipated the continued decline of textile production in the county's economy. By 1985, the impact of technology, foreign competition and the attractiveness of Greenville to non-textile industries would have reduced the percentage of textile employees (including apparel workers) to just over 22 percent. The actual percentage of textile and apparel workers in 1985 was 11.6.[333]

Mill after mill closed its doors or reduced its workforce. As the change was taking place, Greenville was neither oblivious to it nor could Greenville, nor the state for that matter, do much to reverse it. Imports in 1983 stood at 23 percent larger than in 1982. South Carolina blue laws, in force for three hundred years, were relaxed in 1983, permitting industrial plants to work, if need be, fully staffed continuously. Previously, many textile plants had operated in technical violation of the laws, which were overlooked during times of national crisis or when companies held valid governmental contracts. Federal government might have done more through tariff changes or trade agreements, upon which the government focused between 1978 and 1992, but as the industry represented a decreasing segment of the voting public, little more than rhetoric was accomplished. The fact also remained that the textile industry was doing more with less. Nationally during most of the 1980s, productivity increased 27 percent while employment dropped.[334]

CORPORATE DEVELOPMENTS, 1980–2000

Southern Worsted closed in January 1980. In August, officials announced it would not reopen. The closing came after half the workforce was laid off during the previous summer. Government contracts for uniform fabric had accounted for 40 percent of Southern Worsted's business.[335]

Several J.P. Stevens plants had fallen outside of the company's strategic plan by the early 1980s, whether because of a poor profit picture or excessive projected expenses. Apalache, a corduroy mill, was closed in 1981. Greer plant had been assigned to an apparel fabric division of the Stevens Corporation by 1982, employed less than two hundred and was being refitted at a cost of $17 million to weave corduroy. By 1984, however, the mill was on the market and sold to Delta-Woodside in 1986. As a part of Delta Woodside, Greer Mill operated for seven more years. Victor closed production in 1982 but was refurbished as administrative offices. By late 1982, it was

operating as Victor Center, serving as the financial headquarters for a portion of the company and employing as many as Victor had in its heyday as a cotton mill. The Stevens Company sold its weaker divisions and closed Victor Center by the end of 1986. Taylors No. 1 was closed in January 1982. It had manufactured sheets and pillowcases. Layoffs had begun at Taylors in late 1980, reducing the workforce from 500 to 121 by late 1981.[336]

J.P. Stevens Company acquired the former Sears-Roebuck building on Stone Avenue by early 1981. It was renovated beginning in the spring and became the company operations center. Stevens Technical Center, the research and development facility, was scheduled to move to Greenville and possibly set up the Apalache Mill as a specialty weaving and pilot plant. The operations center eventually employed a larger white-collar force in Greenville than that at the company's home office in New York.[337]

The Stevens Company had reached its zenith by 1984 when its sales peaked at $2.1 billion. Its corporate strategy for several years involved selling off smaller, older and less profitable plants. In order to enhance its profitability, the company decided to divest itself of weaker divisions. In 1985, Stevens sold its Woolen and Worsted Division. It announced also in 1985 plans to sell its four finished fabric divisions. At the time, the company employed fifteen thousand in the state, of which over six thousand worked in Greenville County. In October 1987, Stevens's stock was selling for $28.50. Fearful of a hostile takeover, Stevens's management tried to take the company private and started a bidding contest, which ended in the breaking up of the company. Stevens had twice averted takeovers in recent years. When Gulf and Western appeared to be moving toward a leveraged buyout in 1983, Stevens responded by buying up almost $100 million of its stock in one of the largest transactions in the history of the stock exchange. A year later Stevens bought almost a million shares of its stock to prevent another takeover scheme. In May 1988, it was divided among Odyssey, Bibb and West Point-Pepperell. Its Greenville County holdings at the time were the White Horse, Simpsonville, Dunean, Taylors (Southern Bleachery), Monaghan and Slater plants. At the time of its breakup, Stevens remained the largest textile employer in the county with thirty-seven hundred employees.[338]

LEGACY OF THE MILLS

For each locale where once stood a cotton factory or textile plant, there remains a particular legacy known best to the residents of that place. When textiles are discussed today with several generations present, each has its own conception of the meaning of the term and the richest memories are those that are the longest. The mill towns of Greenville County, including Greenville itself, which have seen their

cotton mills come and go, have had to reinvent themselves, find new directions, new visions, recruit new industry while at the same time resisting the social and economic forces that chip away at remaining traditions and local identities established decades ago. Each town's individuality was molded in part, at least, by its textile heritage.

The cotton mill legacy of Fountain Inn is the town itself, a case of the mill coming before the town. A farming community before, Fountain Inn's new industry

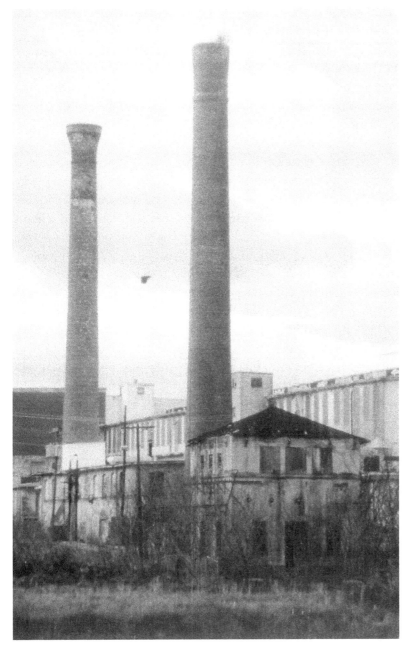

Victor smokestacks.

concentrated capital and attracted newcomers to the advantages of regular work, regular pay. Fountain Inn Manufacturing Company operated some eleven years before the town of Fountain Inn was incorporated.[339]

The Marietta community had not changed much between 1880 and 1927, when the Slater plant was built. A couple of stores, a gin house and a church distinguished Marietta from the surrounding countryside. The building of the mill created the unitary community of Slater-Marietta in which the village provided the larger identity element. The Slater Mill village of approximately 170 houses is unique in Greenville County. S. Slater & Sons, Incorporated, was one of the last textile operations to be constructed as a package in Greenville County. It was also the first textile company in the county to discard the long-standing cotton mill tradition of company ownership of housing. Thirteen years after the plant was built the company sold the houses to workers. The original community is still physically intact and attractive, although the mill is now JPS Glass Fabrics; the recreation hall is a unit of Greenville County Parks and Recreation Department.[340]

Taylors, a farming community with a depot and a small cotton market, awakened during the 1920s in response to the arrival of Southern Bleachery, a paved highway and a new bridge. The bleachery brought into Taylors several hundred new citizens who brought, in turn, other small businesses and two doctors. Churches and schools expanded, two mill churches were added and Taylors High continued to educate students until 1962. The arrival of Piedmont Print Works in 1928 on property adjacent to the bleachery did not detract from the aesthetic setting of Taylors. The merger of the two plants assured the community of a stability that cotton mills could not. Taylors did not grow further as a commercial nor industrial center once it had matured by the mid-1930s. It remained surrounded by trees and pastures for another forty years, aided by a route shift of the National Highway (Highway 29), an island of progress, offering its citizens a peaceful blend of the rustic and the industrial way of life.[341]

Greer was a product of the vision of one man combined with the arrival of the railroad. Greer's Depot, as it was originally designated, grew prosperous because of the cotton trade. Once a mature set of merchants had extra cash on hand, they built their first mill. General prosperity attracted an increasingly larger population that, in turn, created a larger tax base exclusive of the mills that remained outside the town limits. Greer was able to provide more public services that made it more attractive for settlement. A second mill was followed by a third, then a fourth, all within a mile of the center of town, all enhancing growth. Greer became dependent upon the mills in the sense that growth became key to Greer's viability, especially as the cotton trade declined and finally ended. When the mill villages sold in the 1950s, Greer annexed them, adding to the tax base. Greer's expansion has continued into the twenty-first century, creating a Greer approximately as large as Greenville in terms of corporate limits but without the population or commercial development of Greenville.

Travelers Rest welcomed the arrival of a cotton manufacturing company, in this case, the bleachery built by Brandon Corporation in 1928. The Renfrew Bleachery did not seem to have the cultural impact upon the town that other mill towns experienced. Travelers Rest continued to maintain its physical integrity well into the 1990s, despite vastly improved nearby highways. Its consumer base had historically been broad and it did not suffer a traumatic loss of commerce as Renfrew declined and disappeared. Renfrew was relatively small, arrived late in the era of mill building and meshed with rather than challenged local culture. Travelers Rest was something of a bedroom community when the bleachery arrived, residents who were mill hands commuting to one of the Greenville plants. Travelers Rest's experience with industrialization laid a foundation for its ease into the increasingly complex world after the Second World War.[342]

Renfrew Methodist (top) and Baptist churches.

Victor under demolition, 2006.

Epilogue

THE PROBLEM OF HERITAGE

Monuments, museums and historical parks are useful in objectifying history, adding dimensions of understanding. To be valid, there should be a continuum of such means to present the full range of human experience. As to the cotton textile experience, there is little to show from the past except rapidly changing physical structures, shells housing, if anything, different processes and products than those

for which they were built. Each year, fires and demolition claim mills, usually the older, obsolete, abandoned places that hover over a potential site for a restaurant or parking lot or a mall. It is correct that change occur, but it would be wise to preserve something of this particular era, ideally in working order, refurbished to resemble a way of life long gone but because of its former magnitude, worthy of remembering in the best way possible.

Other approaches exist. Archaeological examination proved fruitful at Sampson village and could be useful, especially at the sites of the oldest mills. Oral history offers a way to assemble fairly complete accounts, especially of newer operations, while the resources are available and memories still clear. The emotional component of oral history is often revealing on a deeper level. The loss of a mill is permanent; for those whose lives were lived on the village and whose livelihood was made at the loom or the spinning frame, in the spooler room or in the shop, it is like a death in the family.[343]

Community seems to offer the best hope for preserving knowledge of the cotton mill culture. Progress has been made with this approach. Since 1983, Dunean mill folk have gathered at least five times to reminisce and collect data. The Victor, Greer and Apalache villages, all at one time part of Victor Monaghan Mills, have published histories of their mills and communities. Pelham and Batesville combined for a similar effort.

Other Mills

Approximately half of Greenville County's old mills remain standing after a century. Judson, Brandon and Dunean are business sites. Monaghan and Mills Mills have futures as residential or commercial property. Woodside is a national treasure, as is Mills Center, both having been placed on the list of National Historic Sites.

Two of Greer's five mills remain intact, as does Simpsonville's Woodside plant, which is undergoing renovation. Huguenot Mill was remodeled and incorporated into the Peace Center for the Performing Arts.[344]

After closing down during the Depression, Pelham Mill was rented to cotton buyers from Greer who used it as a warehouse. An estimated 750 bales belonging to Greer Cotton Oil Mill were stored there along with an undetermined number of government-owned or controlled bales when intruders started a fire that burned out of control, destroying the last mill at Pelham in January 1943. The Batesville Manufacturing building was used for a while by Harris Pump Company during the 1930s. Finewear Manufacturing Company, formed in 1947, occupied the location for three years. The building remained vacant for years before being remodeled as a restaurant, first as the Old Mill Stream Inn, later as Fatz Café, and was again vacant when it burned on January 3, 1998.[345]

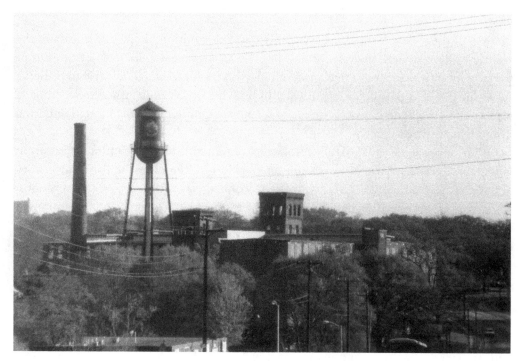

Mills Mill, 1990.

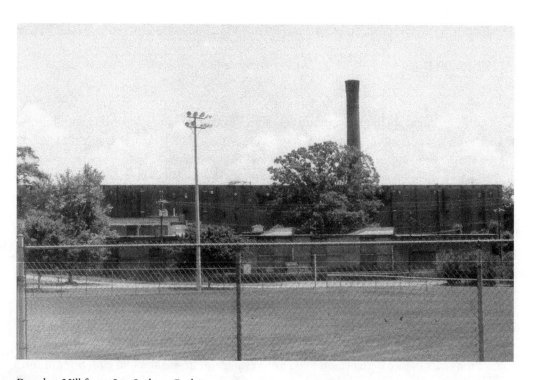

Brandon Mill from Joe Jackson Park.

Of the Greer plants of Victor Monaghan, later J.P. Stevens Company, Greer Mill and Apalache Mill remain standing; both are occupied by textile-related firms. Victor was closed in 1982, remodeled as an office complex and operated as Victor Center for JPS until 1986. It was then sold to a developer in 1988 and has been used variously as a warehouse and an apparel plant after it was closed in the early 1980s. Demolition began in 2004 to create space for an anticipated housing complex.[346]

Renfrew Bleachery at Travelers Rest was sold by Kerr Division of Allied Products in 1984 to Rocky Mountain Industries, which operated it until 1988. It was later demolished. The Greenville County portion of Piedmont Manufacturing Company was partly renovated in 1960 and eventually relegated for use as warehouses. They burned on October 26, 1983. The Woodside Mill at Fountain Inn, formerly Fountain Inn Manufacturing Company, closed in 1984. In mid-1999, citizens of Fountain Inn began a project to identify and preserve areas of the town that were of historic significance. The mill village was one of those areas targeted. The mill itself was demolished. Greer Manufacturing, operating in the old Franklin Mill, ceased operations and was sold to Heritage Industries May 4, 1970. Heritage Industries used the location for two years and closed. It was demolished; the site became the location of the business and operations center of the Greer Commission of Public Works.[347]

Pelham burns, 1943. *Courtesy of Minnie Grubbs.*

F.W. Poe Mill, a Burlington Industries plant, closed in 1977, laying off some seven hundred personnel; it was sold to Poe Mill Corporation for one dollar and then to Poe Mills Associates. The mill was again sold to LGL Investments in 1987. Abandoned, it was partially destroyed in May 2002 and completely gutted in a second fire in June 2003. Reigel Textile Corporation held Virginia Manufacturing until about 1981, when certain mill properties were divested. Reigel merged with Mount Vernon Mills in 1987.[348]

Brandon Corporation, which was acquired by Abney Mills in 1946, continued to operate for another thirty years as Abney made adjustments under increasing market pressures to keep it viable. In 1977, the Brandon plant was closed and later sold for use as a warehouse. Brandon, closed in 1977 as a full-scale operation, was in use by a new company, KM Fabrics, as of 2004. Monaghan, operating as a JPS Apparel Fabrics Mill, closed in 2001 and is currently being restored as an apartment complex.[349]

Franklin Dyed Yarns plant, formerly Franklin Process Mills, was sold in 1996. Originating in Greenville seventy-seven years earlier, it had passed through the hands of five owners including Meridian Industries of Milwaukee, the latest owner. The 325 employees were retained. The new owner downsized Franklin to 130 by 1999, when it was announced that the plant would be closed.[350]

Mills Manufacturing Company, which began in 1894, has been renovated into condominiums; the character of the mill has been preserved and in that sense, its history as well. Southern Weaving continued to operate under that name although with different ownership. It was sold to partners from Aiken, South Carolina, in

Pelham ruins; view from Enoree River. *Courtesy of Minnie Grubb.*

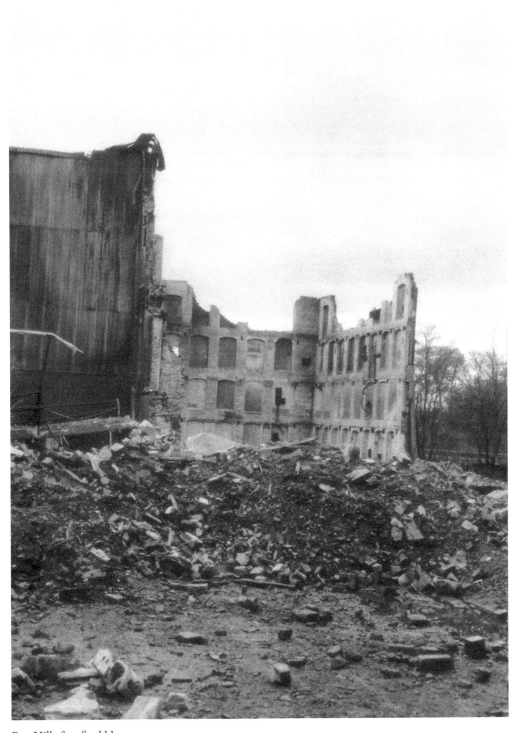

Poe Mill after final blaze.

Simpsonville Manufacturing under renovation.

1997. The company has expanded in the Greenville area and employs 250. It is doing in excess of $25 million worth of business per year.[351]

On midnight June 27, 1990, American Spinning shut down operations. Donald Sims, who had worked there since 1948, summed up the feelings of many a hand when he said, "The friends I have here have been real good—like family." Dunean closed in 1996, a victim of foreign competition; it had been a part of JPS Textiles group. The Woodside Mill at Simpsonville, formerly Simpsonville Manufacturing Company, closed in June 1989 after operating eighty-one years. Initial planning to renovate the mill as Cotton Mill Place, a residential/commercial site, was revealed to the public in June 1999. Final plans for the development called for preliminary work on the project to begin in early 2004. The project is currently underway. Woodside closed in 1984 citing low prices for its product, polyester/rayon, which was being imported in great quantities; 350 employees were laid off. The Woodside Mill in Greenville was nominated for the National Historic Register in 1994.[352]

Notes

Chapter One

1. Ernest McPherson Lander Jr., *The Textile Industry in Antebellum South Carolina* (Baton Rouge: Louisiana State University Press, 1969), 14–30.
2. Greenville County Register of Mesne Conveyance (GCRMC), *Deed Book* L, 118–21, 153.
3. GCRMC, *Deed Book* L, 250.
4. Lander, *Textile Industry*, 16–17; GCRMC, *Deed Book* Q, 268.
5. *Papers and Proceedings of the Greenville County Historical Society* (*PPGCHS*), "William Bates."
6. GCRMC, *Deed Book* L, 111, 145, 197.
7. Seventh Decennial Census, 1850.
8. GCRMC, *Deed Book* Y, 661; *Southern Enterprise,* January 15, 1863.
9. Mann Batson, *A History of the Upper Part of Greenville County, South Carolina* (Taylors: Faith Printing, 1993), 351.
10. Lander, *Textile Industry*, 14; *Carolina Spartan*, May 18, 1892.
11. *Greenville Enterprise-Mountaineer,* June 22, 1887; Mann Batson, *Water Powered Gristmills and Owners: Upper Part of Greenville County, South Carolina* (Taylors: Faith Printing Co., 1996).
12. GCRMC, *Deed Book* R, 79, 80, 199.
13. Lander, *Textile Industry*, 19–21; GCRMC, *Deed Book* T, 268.
14. Batson, *A History*, 353; *Enterprise-Mountaineer,* October 2, 1889.
15. Seventh Decennial Census, 1850; Tenth Decennial Census, 1880.
16. *Greenville Mountaineer*, March 14, 1845; GCRMC, *Deed Book* U, 490; Record of Postmaster Appointments, Microfilm, Greenville County Library (GCL); Batson, *A History*, 353.
17. Greenville County Estate Papers (GCEP), Apartment 22, File 36; Batson, *A History*, 169; Jean Martin Flynn, *An Account of Taylors, South Carolina 1817–1994* (Spartanburg: The Reprint Company, 1995), 21.
18. GCRMC, *Deed Book* L, 165.
19. Lander, *Textile Industry*, 18–19; Seventh Decennial Census, 1850.
20. *Journal of Negro History* 38, no. 2: 170; Laurens County *Deed Book* L, 152; Lander, *Textile Industry*, 19–21; *PPGCHS*; GCRMC, *Deed Book* U, 486; GCRMC, *Deed Book* T, 128; GCRMC, *Deed Book* S, 207.

21. James M. Richardson, *History of Greenville County South Carolina* (Atlanta, 1930), 97; GCRMC, *Deed Book* V, 612, 426; *PPGCHS*; G.G. Williamson, "The South Carolina Cotton Textile Industry From 1865 to 1900," in *Textile Leaders of the South*, ed. L.P. Walker (Anderson: J.R. Young, 1963), 501–45.

22. Tenth Decennial Census, 1880; Lander, *Textile Industry*, 77; *PPGCHS*.

23. Richardson, *History of Greenville County*, 97; Eighth Decennial Census, 1860.

24. Richardson, *History of Greenville County*, 97; *PPGCHS*; *Greenville News*, January 5, 1998; GCRMC, *Deed Book* Z, 676–79.

25. Roy McBee Smith, *Vardry McBee: Man of Reason in an Age of Extremes* (Laurel Heritage Press, 1997), 100–12, 170–72.

26. J.W. Reid, *History of the Fourth Regiment of the S.C. Volunteers* (Greenville, 1892), 136; Smith, *Vardry McBee*, 199.

27. Smith, *Vardry McBee*, 265; Seventh Decennial Census, 1850.

28. Smith, *Vardry McBee*, 264; Eighth Decennial Census, 1860.

29. Smith, *Vardry McBee*, 309; GCRMC, *Deed Book* Z, 264; *Southern Enterprise*, May 15, 1862.

CHAPTER TWO

30. *Spartanburg Journal*, August 2, 1904.

31. L.L. Arnold, "A Story of Textile Greenville," *Cotton*, 80, no. 12 (October 1915); *Handbook of Agriculture*, 1883; Ninth Decennial Census, 1870; *Keowee Courier*, April 15, 1880; *Greenville Daily News*, May 3, 1922; "Textile pioneers of Greenville: Civil War to World War I," talk by Malcolm A. Cross, Sunday, January 18, 1976, Greenville County Library, Greenville, South Carolina; Acts of 1900 of the State of South Carolina.

32. GCRMC, *Deed Book*, 902, 904; Joseph Walker, *Almanac*, quoted in August Kohn, *Cotton Mills of South Carolina* (Columbia: S.C. Department of Agriculture, Commerce and Industries, 1907).

33. GCRMC, *Deed Book* AA. 755, 756; GCRMC, *Deed Book* II, 611; GCRMC, *Deed Book* UU, 779.

34. Walker in Kohn; GCRMC, *Deed Book* HH, 611; GCRMC, *Deed Book* UU, 779; GCRMC, *Deed Book* II, 606.

35. *Charles Emerson's Greenville Directory: Being a Complete Index to The Residents of the City* (Greenville: Greenville Dailey News Job Office, 1876), 104–05; GCRMC, *Deed Book* EE, 163, 215; *Southern Enterprise*, December 31, 1870; Walker in Kohn.

36. GCRMC, *Deed Book* KK, 583; *Enterprise Mountaineer*, February 18, 1880.

37. *Enterprise and Mountaineer*, February 18, 1880.

38. Greenville County Court Charter; Statutes of Large, State of South Carolina, 1882, Act 12; *Carolina Spartan*, March 20, 1889.

39. *Mountaineer*, June 3, 1891; Evelyn George, Dot Howard, Frances Merritt, Evelyn Satterfield, Harold Satterfield Jr., Fred Smith, Joyce Smith, Virgil Smith, *Memories of Pelham and Batesville*.

40. *Mountaineer*, August 16, 1893.

41. Walker in Kohn; Archie Vernon Huff, *Greenville: The History of the City and County in the South Carolina Piedmont* (Columbia: University of South Carolina Press, 1995), 185; *PPGCHS*; GCRMC, *Deed Book* JJ, 763; *Spartanburg Herald*, October 15, 1879.

42. *Mountaineer*, June 9, 1897; *Herald*, February 18, 1880; *Enterprise and Mountaineer*, February 18, 1880, March 9, 1881.

43. *Mountaineer*, May 25, 1881.

44. *Enterprise and Mountaineer*, May 26, 1886.

45. *Mountaineer*, June 9, 1897; *PPGCHS*, "Four Sisters"; *Enterprise and Mountaineer*, January 28, 1880.

46. *Enterprise*, June 29, 1870, September 27, 1871, April 8, 1872.

47. Broadus Mitchell, *The Rise of Cotton Mills in the South* (Baltimore: The Johns Hopkins Press, 1921), 60–62, 114; William B. Hasseltine and David L. Smiley, *The South in American History* (Inglewood: Prentice Hall, Inc., 1960), 401, 402.

48. Huff, *Greenville*, 223.

49. Richardson, *History of Greenville County*, 102–05.

50. *Enterprise*, June 29, 1870; William P. Jacobs, ed., *The Scrapbook: A Compilation of Historical Facts About Places and Events in Laurens County* (Laurens: Laurens County Historical Society and Laurens County Arts Council, 1982), 354.

51. *Charles Emerson's Greenville Directory*, 104–05; Huff, *Greenville*, 186; GCRMC, *Deed Book* DD, 569; Tenth Decennial Census, 1880; *Keowee Courier*, April 15, 1889.

52. *Handbook of Agriculture*, 1883; GCRMC, *Deed Book* PP, 862.

53. Mitchell, *Rise of Cotton Mills*, 143.

54. Samuel B. Lincoln, *Lockwood Greene: The History of an Engineering Business* (Brattleboro: Stephen Greene Press, 1960), 95; www.thewilliamstonjournalonline; *Greenville Daily News*, February 17, 1905.

55. S.S. Crittenden, *The Greenville Century Book: Comprising an Account of the First Settlement of the County and the Founding of the City of Greenville, S.C.* (Greenville: Press of Greenville News, 1906), 66; Mitchell, *Rise of Cotton Mills*, 152; Thomas R. Navin, *The Whitin Machine Works Since 1831: A Textile Machinery Company in an Industrial Village* (Cambridge: Harvard University Press, 1950), 207–08.

56. Navin, *Whitin Machine Works*, 209; *Keowee Courier*, August 18, 1881; Crittenden, *Greenville Century Book*, 66; Mitchell, *Rise of Cotton Mills*, 152.

57. Richardson, *History of Greenville County*, 78; Crittenden, *Greenville Century Book*, 67.

58. Huff, *Greenville*, 188–89; Mrs. B.T. Whitmire to Mr. Haithcock, October 8, 1971, Greenville County Library Vertical Files.

59. *Greenville Daily News*, October 29, 1916.

60. Ibid.; *Enterprise and Mountaineer*, February 18, 1880; Arnold, "A Story"; *Keowee Courier*, April 15, 1880.

61. *Handbook of Agriculture*, 1883.

62. Mitchell, *Rise of Cotton Mills*, 190, 198.

63. Acts of 1885; GCRMC, *Deed Book* RR, 1.

64. *Enterprise and Mountaineer*, February 20, 1895, June 1, 1895.

65. Mitchell, *Rise of Cotton Mills*, 158; *Historical and Descriptive Review of the State of South Carolina Including the Manufacturing and Mercantile Industries of the Cities and Counties of Abbeville, Anderson, Greenville, Newberry, Orangeburg, Spartanburg, Sumter, Union, Camden, and County of Kershaw and Sketches of Their Leading Men and Business Houses* (Charleston: Empire Publishing Company, 1884), 77; *Enterprise and Mountaineer*, May 31, 1882.

66. *Mountaineer*, February 7, 1900; Arnold, "A Story."

67. *Mountaineer*, May 11, 1895.

68. *Mountaineer*, July 11, 1896, October 3, 1894, GCRMC, *Deed Book* BBB, 596; *Greenville News*, January 25, 2006; Crittenden, *Greenville Century Book*, 68; Arnold, "A Story."

69. *Mountaineer*, April 10, 1895, September 11, 1895; GCRMC, *Deed Book* ZZ, 570; Arnold, "A Story."

70. *Mountaineer*, February 7, 1900.

71. Ibid., February 16, 1895, January 4, 1895.

72. Ibid., September 11, 1895, April 24, 1895; Arnold, "A Story."

73. Spartanburg County Register of Mesne Conveyance (SCRMC), *Deed Book* 1, 119; *Greenville Daily News*, August 6, 1901; Insurance Map, 1904.

74. Acts of 1899; Caroline Coleman and B.C. Givens, *History of Fountain Inn, Fountain Inn, South Carolina* (Fountain Inn: Tribune Times Company, 1965), 26–27; Huff, *Greenville*, 237.

75. *Handbook of Textile Corporations*, 1912 (Boston: Frank P. Bennett & Co., 1912); Arnold, "A Story"; *Greenville News*, October 3, 1948.

76. *Greenville News*, April 4, 1937; *Greenville Mountaineer*, February 7, 1900.

Chapter Three

77. *Handbook of South Carolina* (Columbia: The State Department of Agriculture, Commerce and Industries, 1907), 434; Mitchell, *Rise of Cotton Mills*, 190.

78. *Handbook of South Carolina*, 435.

79. Kohn, *Cotton Mills*, 200, 202.

80. *Handbook of South Carolina*, 434.

81. Huff, *Greenville*, 239.

82. Thomas T. Fetters and Peter Swanson Jr., *Piedmont and Northern: The Great Electric System of the South* (San Marino: Golden West Books, 1974), 239.

83. *Greenville Piedmont*, March 19, 1958.

84. *Greenville News*, November 12, 1915; Lincoln, *Lockwood Greene*, 155–56, 192.

85. *32nd Annual Report of the State Superintendent of Education of the State of South Carolina 1901*, 283 *Greenville Mountaineer*, July 27, 1898; Michael Leonard, *Our Heritage: A Community History of Spartanburg County, South Carolina* (Spartanburg: The Herald-Journal, Inc., 1983); *Greenville Daily News*, December 21, 1910, June 11, 1915.

86. *32nd Annual Report*, 283.

87. GCRMC, *Deed Book* 30, 82; *Greenville Daily News*, August 25, 1911; George, *Memories of Pelham and Batesville*, 54.

88. *Spartanburg Journal*, September 6, 1906, January 14, 1906; GCRMC, *Deed Book* QQQ, 143.

89. Dennis Grubbs, interview with author, May 2, 1993.

90. *Greenville Daily News*, August 26, 1908; *Greenville News*, January 2, 2000; Map of Batesville.

91. *11th Annual Report of the Department of Agriculture, Commerce and Industries*, 10–11; Dennis Grubbs, interview with author, May 2, 1993; GCRMC, *Deed Book* 30, 82; *Greenville Daily News*, July 6, 1919.

92. *32nd Annual Report*, 283; Huff, *Greenville*, 240.

93. *Mountaineer*, July 22, 1900; *Daily News*, May 21, 1902, December 2, 3, 1903, July 4, 1905, December 9, 1906.

94. GCRMC, *Deed Book* 563.

95. Acts, 1901; GCRMC, *Deed Book*, 820; GCRMC, *Deed Book* 12, 151; GCRMC, *Deed Book* 65, 26, 27; *Report of the Secretary of State*, January 1, 1919, to December 31, 1919; *Handbook of the Department of Agriculture, Commerce and Industries*, 1913, 44; *Handbook of the Department of Agriculture, Commerce and Industries*, 1915.

96. Arnold, "A Story"; Acts and Resolutions, Volume 26; *Greenville News*, July 27, 1939; *Handbook of the Department of Agriculture, Commerce and Industries*, 1913, 41.

97. Kohn, *Cotton Mills*, 88, 109, 94.

98. GCRMC, *Deed Book* MMM, 80; Arnold, "A Story"; Acts, 1905.

99. Arnold, "A Story"; *Greenville Daily News*, October 29, 1916.

100. *Mountaineer*, April 24, 1895; Arnold, "A Story"; GCRMC, *Deed Book* 53, 540; GCRMC, *Deed Book* 30, 0; *Greenville News*, October 11, 1964, October 2, 1960.

101. Arnold, "A Story"; Crittenden, *Greenville Century Book*, 68.

102. *Greenville Daily News*, June 30, 2004.

103. GCRMC, *Deed Book* MM, 124; Arnold, "A Story"; GCRMC, *Deed Book* 30, 294; *Greenville News*, October 2, 1960, October 11, 1964, June 26, 1962.

104. *Textile Corporations*; GCRMC, *Deed Book* GGG, 664.

105. *Mountaineer*, January 13, 17, 1900; Arnold, "A Story"; *News*, October 11, 1964.

106. Huff, *Greenville*, 236; Arnold, "A Story."

107. *Textile Corporations*; Arnold, "A Story."

108. *Textile Corporations*.

109. Company Billhead, 1910.

110. Arnold, "A Story"; *Greenville Civic and Commercial Journal*, October 1925.

111. Ibid.

112. *7th Annual Report of the Department of Agriculture, Commerce and Industries*, 1920, 10–11; Yates Snowden, ed., *History of South Carolina* (Chicago: The Lewis Publishing Co., 1920), 1183–88.

113. Greenville City Directory, 1919; GCRMC, *Deed Book* 33, 577; *Reports and Resolution of the State of South Carolina*, 1921.

114. *Greenville News*, June 26, 1919.

115. Richardson, *History of Greenville County*, 205; Arnold, "A Story."

116. *Greenville News*, October 11, 1964, October 2, 1960; *Reports and Resolutions*, 1946–47; Greenville City Directory.

117. Greenville City Directories 1917–1924; GCRMC, *Deed Book 30*, 321.

118. *Greenville Daily News*, December 18, 1910.

119. GCRMC, *Deed Book 1*, 93; *Greenville Daily News*, February 18, 21, 1911.

120. *Greenville Daily News*, May 28, 1916.

121. SCRMC, *Deed Book 2*, 303; *Greenville Daily News*, January 19, 1912.

122. *Mountaineer*, January 4, 1905, June 28, 1908, November 4, 1914.

123. *Greenville Daily News*, November 14, 1914, January 7, 1915.

124. *Greenville Daily News*, June 29, 1911; Huff, *Greenville*, 237; *Acts and Joint Resolutions of the General Assembly*, Volume 26–27.

125. *Greenville News*, May 3, 1922.

126. *Greenville News*, May 28, 1916; SCRMC, *Charter Book 1*, 530–31.

127. *Greenville News*, February 20, 1917.

CHAPTER FOUR

128. *Greenville Mountaineer*, February 7, 1900.

129. *Greenville News*, November 2, 1915.

130. Ibid., December 11, 1917.

131. Yancy Gilkerson, *Textile Hall's First 60 Years* (Greenville: typescript compiled by Yancy Gilderson from the records of Textile Hall Corporation, 1975).

132. *Greenville Daily News*, June 10, 1911; *Greenville News*, May 1944; Andrew Bielecki, "The Cotton Panic of 1914," *Textile History Review* (October 1863): 172–77.

133. *Greenville Daily News*, January 7, 1915.

134. Gilkerson, *Textile Hall*; *The Spartanburg Journal and the Carolina Spartan*, September 13, 1915; *Greenville Daily News*, November 23, 1915.

135. Gilkerson, *Textile Hall*; *Greenville News*, September 3, 1918.

136. *Greenville News*, August 6, 1917; *Proceedings of the Semi-Annual Meeting of the Southern Textile Association*, June 21–22, 1918; *Greenville News*, October 14, 1962.

137. *Greenville Observer*, August 5, 1932.

138. *Greenville News*, February 22, 1921; Benjamin Franklin Lemert, *The Cotton Textile Industry of the Southern Appalachian Piedmont* (University of North Carolina Press, 1933), 124.

139. Huff, *Greenville*, 295.

140. *Greenville Piedmont*, July 3, 1923.

141. GCEP Will of Thomas F. Parker; *Greenville Piedmont*, July 13, 1923, September 13, 1923.

142. SCRMC Book B-1, 440; Interview with Mrs. J.R. Vaughn, August 29, 2000; *Report of the Department of Agriculture, Commerce and Industries*, 1920, 11; *Greenville News*, March 30, 1927, November 10, 1943.

143. *Greenville News*, June 26, 1967, May 4, 1922, September 7, 1925, October 2, 1925;

Mill News, 1920; *Greenville News*, October 11, 1964; Huff, *Greenville*, 295; *Mildred Gwen Andrews, The Men and the Mills: A History of the Southern Textile Industry* (Mercer University Press, 1987), 182.

144. Huff, *Greenville*, 296; *Greenville News*, October 11, 1964, October 2, 1960; Reports and Resolutions, 1921; Greenville City Directory, 1946–47.

145. Greenville City Directories, 1913–1923; *Greenville Mountaineer*; GCRMC, *Deed Book* 162, 164.

146. GCRMC, *Deed Book* 60, 435; *Greenville News*, September 1, 1921; *Report of the Secretary of State*, 1922, 40; GCRMC, *Deed Book* 81, 89, 374; *Greenville News*, January 6, 1929.

147. GCRMC, *Deed Book* 147, 234; Minnie Grubbs, interview by author, August 5, 1999.

148. GCRMC, *Deed Book* 81, 124; Richardson, *History of Greenville County*, 295.

149. GCRMC, *Deed Book* 130, 117.

150. Flynn, *Account of Taylors*, 72–78.

151. *Greenville News*, April 8, 1923, June 26, 1919; GCRMC, *Deed Book* 103, 288; *Davison's Textile Blue Book* (Orlando: Davison Publishing Co., Inc., 1947).

152. *Greenville News*, June 26, 1962, October 11, 1964, April 18, 1946.

153. *Greenville News*, June 26, 1962; *Greenville News-Piedmont*, August 3, 1975; *Greenville News*, February 28, 1926.

154. GCRMC, *Deed Book* 132, 66; *Greenville News*, June 26, 1962; Flynn, *Account of Taylors*, 71–80.

155. GCRMC, *Deed Book* 124, 95; *Davison's Blue Book*, 339; *Greenville News*, June 26, 1962.

156. *Greenville News*, September 2, 1996.

157. *Greenville News*, May 12, 1924; Undated Clipping, Greenville County Library Vertical File.

158. Huff, *Greenville*, 295; *Greenville News*, November 12, 1926.

159. Huff, *Greenville*, 295; *Greenville News*, November 20, 1941, February 1, 1946; *Greer Observer*, November 11, 1932.

160. *Greenville News*, October 3, 1948.

161. Mildred W. Goodlett, *The History of Travelers Rest* (Travelers Rest, 1966), 111.

162. *Greenville News*, October 17, 1920, October 14, 1962.

163. Gilkerson, *Textile Hall*; *Greenville News*, November 14, 1962.

Chapter Five

164. Kohn, *Cotton Mills*, 55; *Greenville News*, June 26, 1962.

165. Ibid.

166. Thomas F. Parker, "The South Carolina Cotton Mill Village—A Manufacturer's View," *South Atlantic Quarterly* 9 (1910): 122–30.

167. *Evening Observer*, March 16, 1900; Linda Holloway, interview with author, October 15, 1999.

168. Kohn, *Cotton Mills*, 154.

169. Ibid., 169–70.

170. David English Camak, *Human Gold From Southern Hills* (Greer, 1960), 73–74, 88, 97.

171. *Greenville Civic and Commercial Journal*, October 1925.

172. William Hayes Simpson, *Southern Textile Communities* (Durham: Dowd Press, 1948), 51–53.

173. John Hammond Moore, *South Carolina Newspapers* (Columbia: University of South Carolina Press, 1988), 120–25.

174. Greenville City Directories, 1910–1923; Joe Madison King, *A History of South Carolina Baptists* (Columbia: General Board of the South Carolina Baptist Convention, 1964), 403.

175. *Greenville Daily News*, March 20, 1919.

176. Thomas K. Perry, *Textile League Baseball: South Carolina's Mill Teams 1880–1955* (Jefferson, NC: McFarland & Co., 1993), 274; George, *Memories of Pelham and Batesville*.

177. Richardson, *History of Greenville County*, 250; *Greenville Daily News*, January 8, 1911, November 9, 1917.

178. Huff, *Greenville*, 245; *Greer Mill, A Community Remembered* (Prepared for the Greer Mill Reunion, May 1, 1993).

179. *Greenville News*, October 23, 1920, February 22, 1934.

180. Ibid., December 23, 1940.

181. *Greenville Daily News*, July 5, 1904.

182. Ibid., September 2, 1910, June 30, 1904, September 16, 1937.

183. *Greer Tribune*, June 21, 1930; *Greenville News*, October 14, 1962, April 6, 1934.

184. Huff, *Greenville*, 196; *Greenville News*, May 23, 1929; Fred Greene, interview with author, November 17, 1995.

185. *Greenville News*, October 14, 1952.

186. *Greenville Daily News*, April 14, 1906.

187. Huff, *Greenville*, 342; J.T. Barton, interview with author, May 1988.

188. Jim McAllister, *Down Yonder in the Carolinas* (Greenville, 1979), 40; *Greer Observer*, July 13, 1934.

189. GCRMC, *Deed Book* 185, 353; GCRMC, *Deed Book* 53, 593.

190. The President's Committee of the American Cotton Manufacturer's Association, Mill Stores Committee in Cooperation with the Piedmont Textile Retail Stores Association; *The Cotton Mill Worker and His Needs*.

Chapter Six

191. Harriet Herring, *The Passing of the Mill Village: Revolution in a Southern Institution* (Chapel Hill: University of North Carolina Press, 1949), 4.

192. *Keowee Courier*, August 18, 1881.

193. *Enterprise and Greenville Mountaineer*, May 15, 1889.

194. David Carlton, *Mill and Town in South Carolina, 1880–1920* (Baton Rouge: Louisiana State University Press, 1982), 105.
195. SCRMC, *Deed Book* 5K, 109; *Greenville Daily News*, May 16, 1909; Mary G. Ariail and Nancy J. Smith, *Weaver of Dreams: A History of the Parker District* (Columbia: R.L. Bryan).
196. *South Atlantic Quarterly* 8 (1909): 82–109.
197. Parker, "Cotton Mill Village."
198. Minnie Grubbs, interview with author, March 13, 1998, January 1999; Kohn, *Cotton Mills*, 59.
199. O.T. Holloway, interview with author, June 25, 1990.
200. *Spartanburg Daily Herald*, July 19, 1906.
201. George Brown Tindal, *The Emergence of the New South, 1913–1945* (Baton Rouge: Louisiana State University Press, 1967), 16, 321.
202. Minnie Hollingsworth, interview with author, June 1976.
203. *Greenville Mountaineer*, May 18–21, 1898.
204. Kohn, *Cotton Mills*, 187.
205. Palmer and Constance Dillard, interview with author, January 34, 1998; Flynn, *Account of Taylors*, 71–80.
206. *Yearbook of the Department of Agriculture, Commerce and Industries*, 1926, 91–92.
207. *Greenville Daily News*, January 17, 1917.
208. *Mountaineer*, March 12, 1898, March 23, 1898.
209. Greenville *Semi-weekly News*, May 24, 1912; *Greenville Daily News*, April 20, 1917.
210. *Greenville News*, October 13, 1918.
211. Carlton, *Mill and Town*, 149–50; Act 497, *Statutes at Large*, 22, 1896–1898; Richardson, *History of Greenville County*, 126.
212. Grady Belcher, interview with author, February 10, 1982.
213. *Greenville Daily News*, February 20–22, 1901, June 24, 1902; *Greenville News*, March 16, 1929; David Belcher, interview with author, April 7, 1986.
214. *Greenville Daily News*, April 30, 1901.
215. *Greenville News*, May 1, 1906, January 11, 1906.
216. Act 69 Volume 29 *Statutes at Large*, 1914–1916; Kohn, *Cotton Mills*, 24; Greer City Directory, 1915–16.
217. *Spartanburg Herald*, October 14, 1911.
218. Brown Mahon, "Greenville, The Textile Center of the South," *Greenville Civic and Commercial Journal* (October 1922): 9.
219. *Spartanburg Daily Herald*, July 17, 1906.
220. *Mountaineer*, September 19, 1900.
221. *Greenville Daily News*, August 2, 1893; *Greenville Mountaineer*, August 23, 1893; *Free Lance*, October 9, 1903, September 18, 1903; *Greenville Daily News*, October 4, 1909; George, *Memories of Pelham and Batesville*, 53; *Greenville Daily News*, December 21, 1910; Dennis Grubbs, interview with author, May 2, 1993.
222. *Greenville Daily News*, January 18, 1911, June 10, 1911; *Greenville News*, October

23, 1923, February 26, 1924, March 1, 1924, May 29, 1924, August 24, 1924, May 4, 1926; *Greenville Piedmont*, May 4, 1926.

223. *Mountaineer*, January 20, 1900, February 7, 1900.

224. Steve Dunwell, *Run of the Mill: A Pictorial Narrative of the Expansion, Dominion, Decline and Enduring Impact of the New England Textile Industry* (Boston: David R. Godine, 1978), 147.

225. Melton Alonza McLaurin, *Paternalism and Protest: Southern Cotton Mill Workers and Organized Labor 1875–1905* (Greenwood Publishing Corporation, 1971), 86–89.

226. *Greenville News*, July 22, 1900.

227. Carlton, *Mill and Town*, 251; *Greenville Daily News*, July 12–17, 1914.

228. *Greenville Daily News,* January 14, 1916, November 22, 1915, December 11, 19, 1915, October 23, 1915, November 17, 1915; *Spartanburg Journal and Carolina Spartan*, November 10, 1915.

229. *Greenville News*, March 6, 1921.

230. Ibid., June 4–8, 1929; Thomas Tippett, *When Southern Labor Stirs* (New York: Jonathan Cape & Harrison Smith, 1931), 187; Tindal, *Emergence of New South*, 349; *Greenville News*, May 12, 1929, June 30, 2004.

231. Ibid., March 6, 1930, August 24, 1929; Tindal, *Emergence of New South*, 349–50; *Greenville News*, March 26, 1929, March 30, 1929, April 4, 1929; Tippett, *Southern Labor*, 187.

CHAPTER SEVEN

232. *Greenville News*, November 2, 1915, October 17, 1929; *Report of the Department of Agriculture, Commerce and Industries*, 1927, 59; Tindal, *Emergence of New South*, 97.

233. L.C. Pearson, interview with author, May 1, 1978; Dennis Grubbs, interview with author, May 2, 1993; Luther Hester, interview with author, May 18, 1972.

234. Tippett, *Southern Labor*, 184–85; *Greenville News*, October 14, 1928.

235. *Parker Progress*, June 25, 1927; *Greenville News*, July 9, 1929, January 29, 1930, April 24, 1930; Huff, *Greenville*, 334.

236. *Greenville Daily News*, January 11, 1920; GCRMC, *Deed Book* 81, 447; *Greenville News*, January 29, 1930, February 10, 1920; Dennis Grubbs, interview with author, May 2, 1993.

237. *Greenville Piedmont*, March 3, 1932.

238. Tindal, 361–62; University of South Carolina Publications, *South Carolina: Economic and Social Conditions in 1944* (Columbia: The University of South Carolina Press, 1944), 61, 82–83; Constance Dillard, *Of Days and Times Remembered* (Private Memoir, author's possession); *Greenville News*, October 14, 1962.

239. Judith T. Bainbridge, *Greenville Communities* (Greenville: Bainbridge, 1999); GCRMC, *Deed Book* 124, 218; GCRMC, *Deed Book* 153, 516.

240. GCEP, Apartment 441, File 1; GCEP, Apartment 351, File 24; GCEP, Apartment 416, File 13; *Report of the Department of Agriculture, Commerce and Industries*, 1934–35, 132.

241. *Greenville News*, June 2, 1935.

242. GCRMC, *Deed Book* 81, 449; *1934–1935 Yearbook of the Department of Agriculture, Commerce and Industries of the State of South Carolina* (Columbia: Joint Committee on Printing of the General Assembly of South Carolina); GCEP, Apartment 349, File 26.

243. Tindal, *Emergence of New South*, 340.

244. Huff, *Greenville*, 302–03; Tindal, *Emergence of New South*, 14; Herbert Jay Lahne, *The Cotton Mill Worker* (New York: Farrar & Rinehart, 1944), 153–54.

245. *American Historical Review* 91 (April 1986): 276.

246. *Textile World*, October 1934, 73.

247. Ibid., July 1934, 76; *New York Times*, May 9, 27, 29, 1934.

248. *New York Times*, June 3, 1934; Tindal, *Emergence of New South*, 435.

249. *American Historical Review* (April 1986): 277; *New York Times*, August 16–20, 1934; *Greenville News*, August 27, 1934; *Greenville Piedmont*, September 3, 1934.

250. Columbia *State*, August 31, 1934, September 1, 1934.

251. Huff, *Greenville*, 353; Grady Powell, interview with author, June 29, 1976; *Spartanburg Herald*, September 2, 1934; *Greenville News*, September 5, 1934.

252. *Greenville Piedmont*, September 4, 1934; G.C. Waldrep III, *Southern Workers and the Search for Community* (Urbana and Chicago: University of Illinois Press, 2000).

253. Bob Blackwell, interview with author, June 1983.

254. Huff, *Greenville*, 353; *Greenville News*, September 5, 1934.

255. J.G. Hayes, interview with author, June 1976; *Greenville News*, September 5, 1934.

256. Palmer Dillard, interview with author, June 20, 1997.

257. *Greenville News*, September 4, 1934.

258. *Greenville News*, June 30, 1904; *Spartanburg Herald*, September 6, 1934; Marc Miller, *Working Lives: The Southern Exposures History of Labor in the South* (New York: Pantheon, 1980), 235; *Spartanburg Herald-Journal*, September 7, 1934; *Greenville Observer*, September 7, 1934.

259. *Spartanburg Herald-Journal*, September 7, 1934.

260. Ibid.

261. *Spartanburg Herald-Journal*, September 12, 1934; *Greenville News*, September 28, 1934; *Greenville Observer*, October 26, 1934.

262. *Greenville News*, September 6, 7, 10, 11, 1934.

263. Editorial, *Greenville News*, November 14, 1939.

264. *Greenville News*, April 2, 1939; Lemert, Cotton Textile Industry.

265. *Greenville News*, April 1, 1935.

CHAPTER EIGHT

266. *Greenville News*, October 12, 1962.

267. Gilkerson, *Textile Hall*.

268. *Greenville News*, June 23, 26, 1942; Thomas McAbee, interview with author, October 30, 1995; *Greenville Observer*, June 16, 1944; *Greenville Piedmont*, June 6, 1942.

269. GCRMC, *Deed Book* 253, 352; GCRMC, *Deed Book* 175, 123; GCRMC, *Deed Book*

374, 238; GCEP Apartment 349, File 26.

270. Pelham Mill Village Contract.

271. *Greenville Piedmont*, November 8, 1946; *Greenville News*, October 11, 1964, June 26, 1962, November 10, 1943.

272. GCRMC, *Deed Book* 253, 352, GCRMC, *Deed Book* 175123; GCRMC, *Deed Book* 374, 238; *Greenville News*, April 18, 1946.

273. *The History of the J.E. Sirrine Textile Foundation, Inc.* (Greenville: The J.E. Sirrine Textile Foundation, Inc., June 1961).

274. *Greenville Observer*, August 25, 1944.

275. *Greenville News*, October 6, 1960; *Greenville Piedmont*, March 27, 1943; *Greenville Observer*, March 30, 1944.

276. *Greenville News*, August 16, 1946; J.V. Belcher, interview with author, May–June, 1976; GCRMC, *Deed Book* 318, 342.

277. *Greenville News*, October 3, 1948.

278. GCRMC, *Deed Book* 386, 380; GCRMC, *Deed Book* 385, 339; *Greenville News*, May 16, 1938; *Greenville Piedmont*, March 8, 1946; *Greenville News*, June 11, 1964; *Greenville News*, undated clipping, August 16, 2005, October 3, 1948.

279. *Greenville News*, May 16, 1938, March 8, 1946.

280. Ibid., November 12, 1948.

281. Ibid., June 26, 1962, October 11, 1964; Arnold, "A Story"; Bainbridge, *Greenville Communities*.

282. Simpson, *Southern Textile Communities*, 29–33, 125.

283. *Greenville News*, March 29, 1927, July 23, 1933; Huff, 354.

284. *Greenville Piedmont*, June 30, 1948; GCRMC, *Deed Book* 418, 72; *Greenville Piedmont*, June 30, 1955; *Greenville News*, October 11, 1964; GCRMC, *Deed Book* 624, 424.

285. *Greenville Piedmont*, June 30, 1955.

286. *Greenville News*, October 3, 1948.

287. Mack C. Kilpatrick and Thomas K. Perry, *The Southern Textile Basketball Tournament, A History, 1921–1997* (Jefferson, NV: McFarland and Company, Publishers, Inc., 1997).

288. *Greenville News*, October 3, 1948.

289. Perry, *Textile League Baseball*, 85.

290. *Greenville News*, April 2, 1939.

291. Kilpatrick, *Southern Textile Basketball Tournament*.

292. Gilkerson, *Textile Hall*; *Greenville Piedmont*, April 23, 1971.

Chapter Nine

293. Huff, *Greenville*, 389; *Tribune-Times*, October 10, 1973; *South Carolina Statistical Abstract*, 1975 (Columbia: A publication of the South Carolina Division of Research and Statistical Services, 1975).

294. *Greenville News*, October 11, 1964, October 18, 1968.

295. Ibid., October 18, 1968.

296. *20th Annual Report of the Department of Labor of the State of South Carolina, 1954–1955* (Columbia, 1955), 35–36; *Greenville News*, October 1, 1960, October 11, 1964.

297. *Greenville News*, January 22, 1953.

298. Ibid., June 26, 1962.

299. GCRMC, *Deed Book* 594, 233; GCRMC, *Deed Book* 627, 87; GCRMC, *Deed Book* 496, 295; *Inside Woodside*, undated pamphlet published by Woodside Mills Corporation; *Greenville News*, October 11, 1964, October 2, 1960; GCRMC, *Deed Book* 469, 523; GCRMC, *Deed Book* 596, 227; *20th Annual Report of the Department of Labor, 1954–1955*, 36.

300. *20th Annual Report of the Department of Labor, 1954–1955*, 35–36; GCRMC, *Deed Book* 528, 127; *Greenville News*, October 11, 1964, June 24, 1957, June 26, 1962.

301. Huff, *Greenville*, 391–92; www.jdhow.com.

302. *Davison's Blue Book*, 217; Memorandum, JPS Public Information Office, November 9, 1976, GCL Vertical Files; *Greenville News*, June 26, 1962, June 22, 1953; *Inside Woodside*; *Greenville News*, October 11, 1964.

303. *Greenville News*, October 11, 1964; GCRMC, *Deed Book* 739, 148, GCRMC, *Deed Book* 879, 497; GCRMC, *Deed Book* 780, 81; *South Carolina Statistical Abstracts*, 1972.

304. Flynn, *Account of Taylors*, 80; *33rd Annual Report of the Department of Labor of the State of South Carolina* (Columbia, 1968), 46; *Greenville News*, December 28, 1981.

305. *Davison's Blue Book*; GCRMC, *Deed Book* 936, 437; GCRMC, *Deed Book* 988, 735.

306. *Greenville News*, October 19, 1970.

307. GCRMC, *Deed Book* 1075, 488; *Greenville News*, undated clipping; Bainbridge, *Greenville Communities*; *The Travelers Advisory*, spring 1980.

308. *Greenville Piedmont*, August 7, 1978; *Greenville News*, August 9, 1978; *Greenville News-Piedmont*, April 13, 1975.

309. *Greenville Piedmont*, undated clipping, GCL vertical file.

310. Sirrine Textile Foundation.

311. *Greenville News*, October 2, 1960.

312. Ibid., October 11, 1964, October 18, 1968.

313. Ibid., October 18, 1968.

314. Act 69, Volume 29 *Statutes at Large* 1914–1916; *Report of the Department of Agriculture, Commerce and Industries*, 1934–35, 134.

315. Kilpatrick, *Southern Textile Basketball Tournament*, 60, 63.

316. *Greenville News*, October 19, 1970, October 20, 1972.

317. "Rick," interview with author, January 1990.

318. *Greenville News*, March 12, 1953; Huff, *Greenville*, 389.

319. James C. Howard, interview with author, September 17, 1995.

320. *Charlotte Observer*, April 26, 1988.

321. *Greenville News*, October 2, 1960, October 17, 1966.

322. Irena Selent, interview with author, June 14, 2006.

323. Gilkerson, *Textile Hall*.

324. Ibid.

325. Southern Textile Association, *Book of Proceedings*, Spring and Fall Meetings, Charlotte, 1955, 119; Mildred Gwin Andrews, *The Men and the Mills: A History of the Southern Textile Industry* (Macon, GA: Mercer University Press, 1987), 109; *Greenville News*, October 21, 1956, July 24, 1958, February 20, 1959.

326. *Greenville News*, October 19, 1970, June 26, 1962, October 11, 1964.

327. Ibid., October 19, 1970; Gilkerson, *Textile Hall*.

328. Andrews, *Men and the Mills*, 218.

329. *Greenville News*, October 19, 1970.

330. Andrews, *Men and the Mills*, 226; *Greenville News*, August 9, 1978.

331. *South Carolina Statistical Abstract*, 1972, 1980, 1984; *The Economy of Greenville County: A Report for Greenville County Planning Commission* (Lawrence H. Shaw, Economic Analysts, May 1976).

CHAPTER TEN

332. *Greenville News-Piedmont*, August 3, 1975; *Greenville News*, February 28, 1926.

333. *South Carolina Statistical Abstract*, 1972, 1984; Brenda Watkins and Sonja Veal, *Economic Profile of Greenville County, SC* (Appalachian Council of Governments, 1990), III–6.

334. *Greenville News*, December 31, 1989; Ed Childs, interview with author, 1965; *Greenville News*, undated clipping.

335. *Greenville News*, August 6, 1980.

336. Ibid., January 27, 1997, April 16, 1986, December 28, 1981.

337. Ibid., May 13, 1988.

338. Columbia *State*, March 5, 1986; *Greenville News*, July 16, 1986, March 5, 1986; Andrews, *Men and the Mills*, 276; *Charlotte Observer*, April 26, 1988; *Greenville News*, May 26, 1988.

339. *Greenville News*, August 26, 1951.

340. Ibid., February 1, 1946.

341. Flynn, *Account of Taylors*, 71–80.

342. *Greenville News*, undated article, 1970.

EPILOGUE

343. *Spartanburg Herald*, August 15, 2001.

344. *Greenville Daily News*, September 9, 1903.

345. GCRMC, *Deed Book* 307, 444, GCRMC, *Deed Book* 446, 197; *Greenville News*, October 3, 1948, January 4, 1998.

346. *Greenville News*, May 13, 1988.

347. Ibid., October 27, 1983, June 2, 1999.

348. Ibid., March 26, 1978; GCRMC, *Deed Book* 1195, 74; GCRMC, *Deed Book* 1205, 1, *Greenville News*, February 3, 2002, June 28, 2003.

349. *Greenville News*, June 30, 2004, November 26, 2003, August 5, 1904.

350. Ibid., September 27, 1996.

351. Ibid., April 15, 1997.

352. Ibid., September 4, 1994; *Greenville Piedmont*, June 25, 1990; *Greenville News*, August 29, 1996, June 9, 1999, February 20, 2004.

Index

W

Visit us at
www.historypress.net

Printed in the USA
CPSIA information can be obtained
at www.ICGtesting.com
LVHW071459041223
765647LV00008B/154